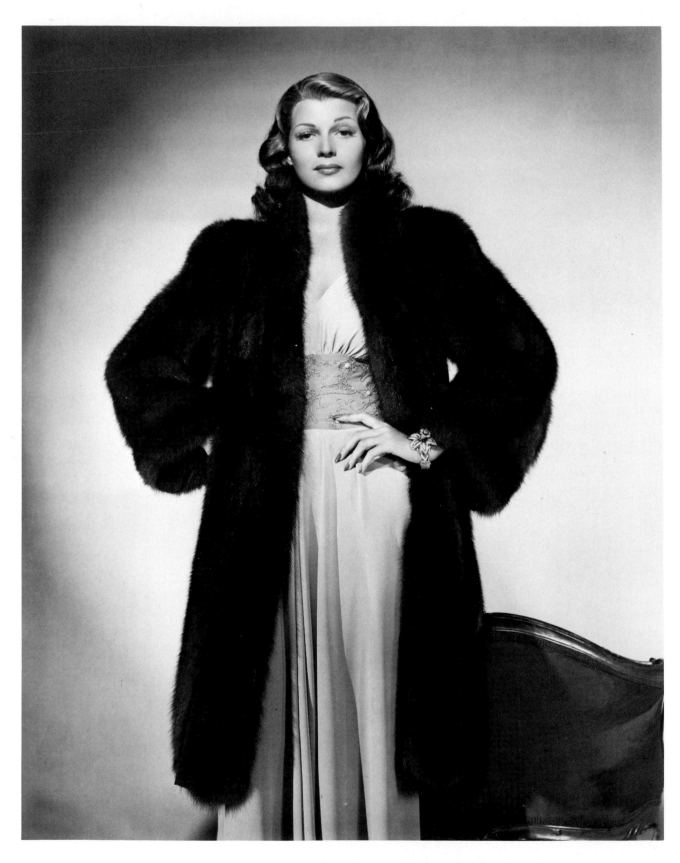

Rita Hayworth, 1940. Photo: A. L. ("Whitey") Schafer, for Columbia.
Costume by Kalloch. Publicity shot for *Angels Over Broadway*.

MOVIE-STAR PORTRAITS OF THE FORTIES

163 Glamor Photos

Edited by
JOHN KOBAL

Dover Publications, Inc.
New York

For Loretta Young

ACKNOWLEDGMENT: Editor and publisher wish to thank Bill Chapman for his contribution to this gallery.

Published in Canada by General Publishing Company, Ltd., 30 Lesmill Road, Don Mills, Toronto, Ontario.

Movie-Star Portraits of the Forties; 163 Glamor Photos is a new work, first published by Dover Publications, Inc., in 1977.

International Standard Book Number: 0-486-23546-7
Library of Congress Catalog Card Number: 77-80118

Manufactured in the United States of America
Dover Publications, Inc.
180 Varick Street
New York, N.Y. 10014

Introduction

"I never paid much attention to the glamor bit. Dietrich is Glamor! The Queen. Like Crawford. Like Garbo was, still is, glamor. There's a mystery to them—but I never had *that*, dear. I don't think any American personality of my generation had the glamor that was Dietrich and Garbo. I certainly didn't have it. That "oomph" bit was just a publicity stunt with me. None of us girls . . . Lana, Rita, Dorothy Lamour . . . we couldn't possibly touch it. Those are sweaters you're talking about, darling, that's not glamor. We were all well-dressed, well-made-up motion-picture actresses. But we never had the mystery, the touch, these other women had. And never would."—Ann Sheridan.

The forties began with a bang. A big one. Halfway through 1939 the outbreak of war slammed the door on the Thirties and, with them, on the richest era of the American cinema. The Depression, it now appeared, had only been the lull before the storm.

Although the war touched everything, it was not always with the same disastrous results. The moguls whose business it was to produce movies and fabricate dreams never had it so easy. Anything went. American movies had for too long been dismissed as pap for unthinking masses by critics who saw the film image as poor literature, merely punctuation to a sentence. The charge simply was irrelevant. The medium and its practitioners had been too exhilarated in their explorations and discoveries for that sort of predominantly pseudointellectual putdown. Yet, now it was to become true.

The great war created an environment for one long fool's summer for the monolithic film companies, which, as surely as the munitions factories, thrived on man's inhumanity to man. The war years were a time of plenty, of rich profits embarrassingly easy to gather, of films needing little thought and even less talent to produce. Therein lay the seed of the studios' own eventual destruction. In retrospect, the grandiose aspirations of the Thirties filmmakers seem to have been an attempt to raise the film to a higher plane approaching the level of opera in music or the nineteenth-century novel in writing. Such ambitious extravaganzas as *The Wizard of Oz, The Thief of Bagdad,* and especially *Gone With the Wind,* would soon be scaled down by limited budgets and misguided patriotism to the problems of the war effort and puerile entertainment. The

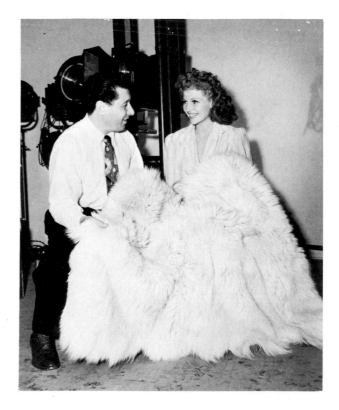

(A) Photographer George Hurrell with Rita Hayworth at Columbia, 1942.

seeds of so much of today's artistic nihilism were sown then. While the hawks of war ruled the sky, the hacks of Hollywood flourished below.

Not that this wasn't a fun time anyway, or that many of those overripe Technicolor fantasies weren't hugely enjoyable. Some pictures were much more than that—*Casablanca, Mildred Pierce* and wild folies d'amour like *Gilda, Laura, Leave Her To Heaven, Humoresque* . . . Filmgoers still had a strong sense of what good films and traditional art have always been about. Charm, good nature, a sense of mystery and romance in life and the energizing, life-enhancing effects of physical beauty were still viable commodities that the public had not yet grown to distrust. Going to the movies was still an occasion, whereas to today's insecure, illiterate, television-educated audiences, movies

are just one more form of entertainment. Yet, by and large, the bellicose Forties were already a decade of the banal for the Hollywood studios, from the highest to the lowest, from MGM to Monogram. Orson Welles's *Citizen Kane* and David O. Selznick's *Gone With the Wind* weren't the heralds of a new era approaching, but the embodiments of the best that had gone before.

Stars who a year earlier were thought supreme now were peremptorily tossed from the illuminating shadows of their glamor to sink or swim in the garish spotlight of the pinup and the beefcake. The public's focus, previously enthralled by a mystery enthroned in Garbo's eyes, now concentrated on the hydraulics that held up Jane Russell's breasts. Old favorites were stripped of their mystique, scaled down or mass-produced in more exploitable proportions. Dietrich's legs made way for Betty Grable's pins; the image of Hedy Lamarr was transformed into a more prosaic, albeit delightful, popcorn-fed siren like Yvonne De Carlo; Clark Gable was replaced by a pale James Craig; and Carole Lombard's screwball glamor now ranged across Cass Daley's facial contortions and Carmen Miranda's vocal ones. There weren't many survivors from the Thirties. Garbo wasn't the only departure, though more has been made out of hers than most, for Norma Shearer, Jeanette MacDonald, Eleanor Powell and a host of others left about the same time. Only a few of last decade's giants kept their hold on the public, notably the magnificent, turbulent, tortured and progressively more and more lonely Joan Crawford,

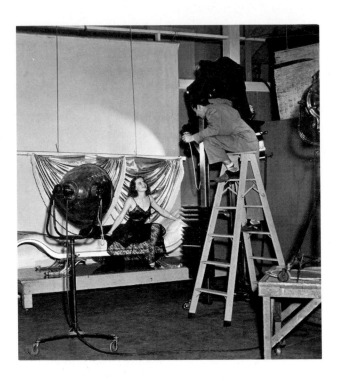

(C) Scotty Welbourne (on ladder) shooting Ann Sheridan at Warner Bros. (photo by Madison Lacy).

who held on to her hard-fought-for beachhead in Hollywood's galaxy—as blood-red and battle-soiled as any that John Wayne ever trod. Crawford, along with Davis, Stanwyck and Hepburn, was a survivor—a superb monument to surviving and popular for it, but not representative of this decade's spirit in the way she had been earlier. At their most fantasmagorical and absurd the war years were symbolized by the Siren of Babylon, working under the name of Maria Montez in the deserts around Palm Springs. This was her generation as much as, if not more than, that of the Hayworths, Turners and Garlands, for Montez was what this Hollywood was about.

Unlike the stellar employees of the industry, the creative forces at work behind the scenes were less exposed to the vagaries of fame, but they too had to adjust to the new mood. Some, like designers Travis Banton and Adrian, couldn't or wouldn't, preferring instead to free-lance or set up in business on their own. Many of the established photographers now moved from studio to studio in search of conditions to suit their styles in an era that lacked one. This change is evident in their work from this period. And yet, even if their subtle play with light and shade generally had to be stamped out, they still had to be able to create fantasies out of flesh and blood to keep the public satisfied that all was well and the stars still shining bright in their heavens. But if there was as yet no shortage of beautiful women with striking personalities, the men were beginning to prove another matter. The "bland" appeal of so many of the leading men soon to be manufactured with stunning slick by Universal

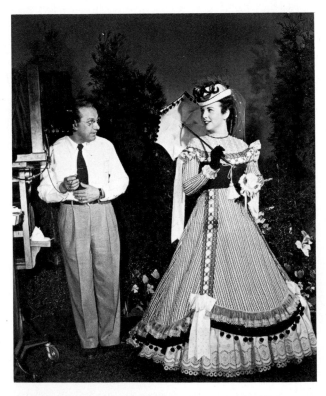

(B) Ray Jones photographing Deanna Durbin for *Up in Central Park*, Universal, 1948.

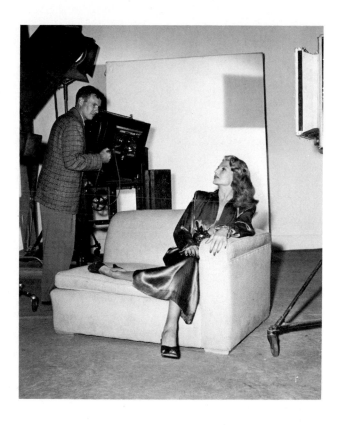

(D) Robert Coburn doing a publicity shot of Rita Hayworth for *Down to Earth*, Columbia, 1947.

charisma of their predecessors, though they, in turn, towered over the Rock Hudsons, Tony Curtises and George Naders that would follow. These were truly the tired threads of an old, worn-out spool. Or so one would have thought. But who could have anticipated that the Seventies would usher in a whole galaxy of cartoon Clark Gables—led by Pacino, Stallone, Falk, Blake and Savalas—with the decade in danger of being remembered as the era of "the Fonz" and his whole mangy crew of "dese, dem's and dose" leading men, with ugliness of face and Brooklyn ghetto sincerity being accepted for character and talent. Admitted that it is easy to praise the past while losing sight of the virtues inherent in one's present, still it is hard to believe seriously that future books will wax nostalgic over the general run of males in the Fifties movies. There were Brando and Dean. Period.

Newman, McQueen, Eastwood, Redford, Kristofferson and Warren Beatty, most of whom grew up in the movies-orientated Forties and started their careers in the late Fifties as inheritors of the James Dean image, today have virtually to isolate themselves in their own personally produced, tailor-made opuses—certainly no part of any mainstream—like endangered species in charge of their own preservation. The phasing out of the beautiful woman may yet prove only a prelude to the disappearance of the handsome man.

This turn of events has dispensed with women stars in Seventies films. The solitary female, Barbra Streisand, while perhaps a likable comedienne, remains at best

in the Fifties, was signaled in the breed of heroes the studios conscripted to fill the yawning gaps left when the Gables, Robert Taylors, Tyrone Powers and Henry Fondas signed up.

Initially the war was to blame. "What's good is in the army, / What's left will never harm me" were the ironical Frank Loesser lyrics Bette Davis sang with understandably wry panache in *Thank Your Lucky Stars*—since the sentiments applied to the studios' stables as much as to the ordinary homes throughout the land, not to mention her own films. But after the war, with potential male stars plentiful again, it was suddenly clear that the significant wartime popularity enjoyed by Sonny Tufts, James Craig, Dick Haymes, Lee Bowman, Turhan Bey *et al.* had not been merely an accident to be ascribed to the manpower shortage. For not only were an ever increasing number of the new males surprisingly lackluster vis-à-vis the women, but there was a disturbingly built-in strain of weakness in the up-and-coming postwar screen idols, who were uniformly morose, masochistic, alienated, misogynistic. This perverse shift on the public's part toward strong-shouldered women and diluted men reflected the morass the nation's subconscious had dug itself into, and cut off any hope of a return to the clear-cut glamor and romance that had been, and the issues they had embodied. Glenn Ford, Dana Andrews, Victor Mature, John Hodiak, Burt Lancaster, Farley Granger —joan-crawford-ing, the lot of them—were without the

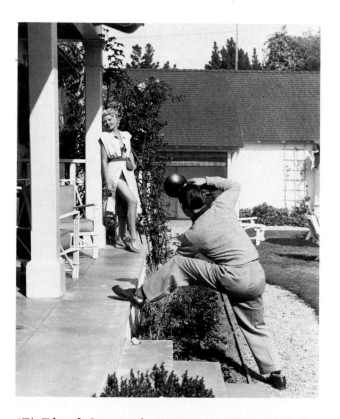

(E) Edward Cronenweth snapping Rita Hayworth at her Santa Monica home, 1948 (photo by Robert Coburn).

a cartoon version of the female star. At any rate, our present dearth could not be gathered from any omen in the Forties, when movies still depended on extraordinarily beautiful women for their appeal.

There was the "hybaceous" part-American Indian Linda Darnell, who sighed often in dark and passive splendor; the vibrant Irish-born redhead Maureen O'Hara, who set the Spanish Main aflame; while the exotic Gene Tierney, like the lyrebird she brings to mind, glistened with an alluring Eastern brilliance in every film and all over the stills taken of her at 20th Century-Fox. The producer David O. Selznick was not alone in sensing something extraordinary in his future wife Jennifer Jones, who, with her liquid, thick-browed eyes and full, savage mouth with just a hint of provocative sloppiness about it, was equally ideal whether cast as whore or mystic. Neither was silky Veronica Lake's long hair all there was to admire in this blonde, Brooklyn-born beauty, for it focused attention on piercingly keen mocking eyes and on a mouth cut for even sharper lines than she was given. The Forties Harlow was Lana Turner, same color hair, same studio, the original soda-fountain cutie whom elevator operators selected as the girl they would most like to be stuck in a lift with. Photographs are needed to do Ava Gardner's beauty justice, and photographs were taken— of her and of others, for these Hollywood craftsmen

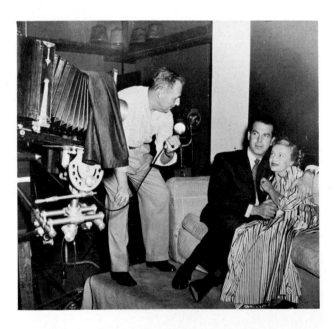

(F) Madison Lacy photographing Fred MacMurray and Madeleine Carroll, Paramount, 1939.

were still the best in their field, creating vigorous, exciting images both in black-and-white and in the color portraits most magazines now preferred, even though, as I've already implied, less was demanded from them and the advent of photojournals like *Life* and *Look* created a competition that was discouraging for them to have to meet.

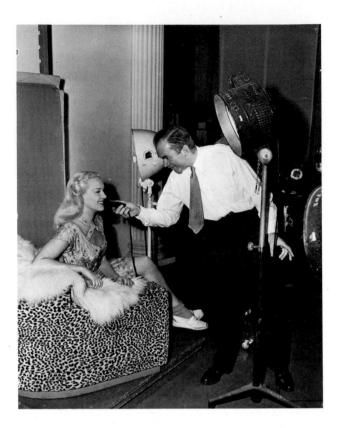

(G) Photographer Frank Powolny doing a portrait of Betty Grable for *Diamond Horseshoe*, 20th Century-Fox, 1945.

The magnificent photographer Hurrell, who gave us the spectacular sight of Jane Russell beside the hay, between his other free-lancing assignments in the prestigious pages of *Esquire,* brought the prettily drawn Petty Girls to a lusher form of life and subsequently inspired the *Playboy* centerfolds of another generation. "Whitey" Schafer, whose alluring portraits and pinups enhanced many a Columbia star, was to take over Paramount's portrait gallery with no diminution of skill in photographing Ladd and Lake, Dorothy Lamour, Paulette Goddard and Lizabeth Scott. He made Marlene Dietrich look as good in 1947, after she came back from her tour of the war fronts, as he had before she left, six years earlier. His death in a motorboat accident robbed his profession of a master. Ray Jones, assisted by Roman Freulich and Bill Walling, worked wonders at Universal, where he had mostly Deanna Durbin and Maria Montez to glamorize, and Scotty Welbourne and Bert Six did no less at Warner Bros. Bob Coburn, Sam Goldwyn's glorifier of beauty, now headed the gallery at Columbia, where he concentrated with spectacular success on the only star under contract there; even without shadows and in the obligatory cheesecake poses, Rita retained her mystery. Oldtimers like Madison Lacy and John Miehle, along with Hurrell's former assistant Al St. Hilaire, were working on the big films Selznick and others released through UA. Frank Powolny and Gene Kornman were still the men responsible for art at 20th, where the best known

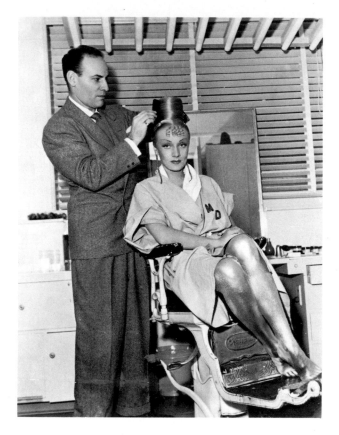

(H) MGM's top hairdresser, Sidney Guilaroff, working with Marlene Dietrich for *Kismet*, 1944.

Bogart, Gary Cooper's finely weathered pioneer beauty, Loretta Young's pre-Raphaelite aura and Ann Sheridan's homespun, philosophical brand of "oomph." They all possessed that indefinable quality the camera loved and a generation was inspired by.

Here too can be studied the unsung but invaluable artistry of the hairdressers and makeup wizards, who were the good bushes to the good wines, as well as the alluring creations of the high priests of glamor, the dress designers. This era was the last gasp for their sort of genius. Soon the photographers, the beautiful women and their glamorizers would turn to TV or the modeling business for employment.

Events looming around the studios were conspiring toward an end that was first announced by a massive whimper and then slowly proceeded to gag the industry. The kind of "safe" entertainment they were reduced to after their humiliating surrender to the U.S. Senate was something television could do as well, for much less and with a lot more pizzazz. The tragedy was not that ten screenwriters went to jail for their cause, but that Hollywood went to sleep for fear of one —this, at a moment in its affairs when it was imperative as never before that all hands be on deck—alert, adventurous, daring all to win—and to survive. Yes, survive, because simultaneously the Supreme Court's antitrust decision of 1948 meant that the five major studios (MGM, Paramount, Warner Bros., RKO Radio and 20th Century-Fox) had to hire off their theaters, thus removing the one certain outlet for their product. Sadder still than the industry's demise was the realiza-

pinup of all was taken. An accident really. At the end of a long session Powolny asked Betty Grable for just one more pose and she looked over her shoulder as if to say, "Oh, really, Frank!" And that was it.

Though MGM, still with "more stars than there are in heaven," had lost Harlow's favorite photographer, Ted Allan, to the radio networks (who had their own demanding publicity departments), they still had C. S. Bull, Eric Carpenter—so popular with their new stars— and the versatile Laszlo Willinger. The latter's skill at enhancing women's feminine allure by imbuing them with thoughtful intelligence as well as their obvious beauty, predictably made him very popular with Metro's high-powered, competitive female stars from the moment he arrived there in 1936 until he left to free-lance in the mid-Forties. The more striking of the movie-magazine covers in that period were most likely to be his work.

The pictures these photographic artists made, featured in these pages, were the dreams reflected in the bathroom mirrors of their generation, spanning the period from the outbreak of World War II to the Korean conflict of 1951 and with it, as if in answer to a need, the advent of Marilyn Monroe, star-struck orphan of the movie-hungry Thirties who became the ultimate symbol and last chord of the studio-based star system. Here again we find the clean-scrubbed northern glow of Bergman, the romantic cynicism of

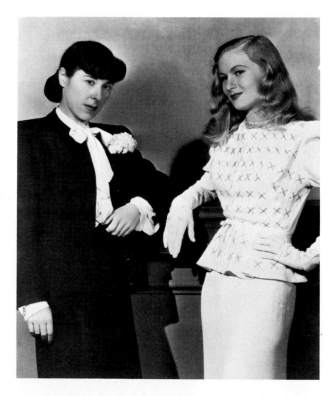

(I) Paramount dress designer Edith Head with Veronica Lake, 1942.

tion that the movies, the one true art form of the people, encouraged, dictated and inspired by the people, were to become a thing of the past because of these events. By the time a new generation rediscovered them, they were history. The Forties were the years of Old Hollywood's last stand, though the people concerned didn't know it. Today there are fewer, and some would argue, better movies, but one thing is clear—they are no longer "our" movies.

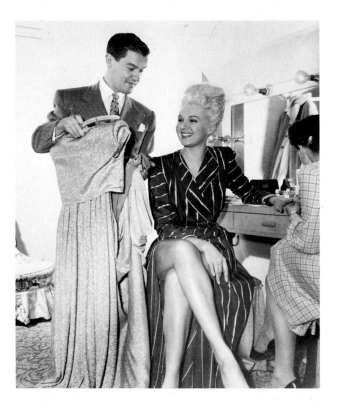

(J) Columbia dress designer Jean Louis shows Adele Jergens a costume for *A Thousand and One Nights*, 1945 (photo by Edward Cronenweth).

Alphabetical List of Stars

The letters A through J refer to the pictures in the Introduction.

Alphabetical List of Photographers

The letters A through J refer to the pictures in the Introduction. An asterisk indicates that the photographer is shown in the picture.

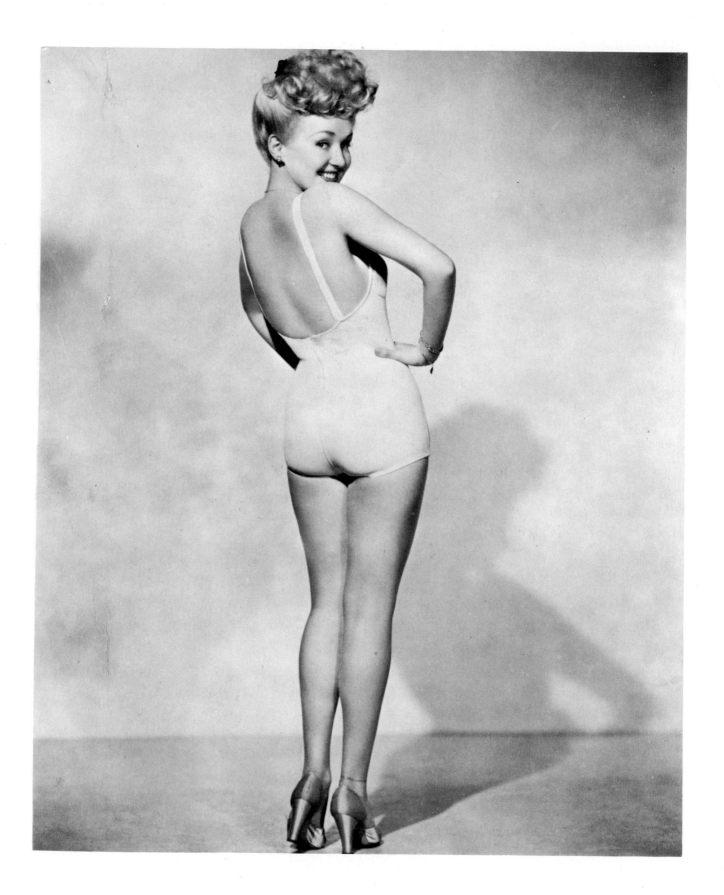

Betty Grable, 1941. Photo: Frank Powolny, for 20th Century-Fox.

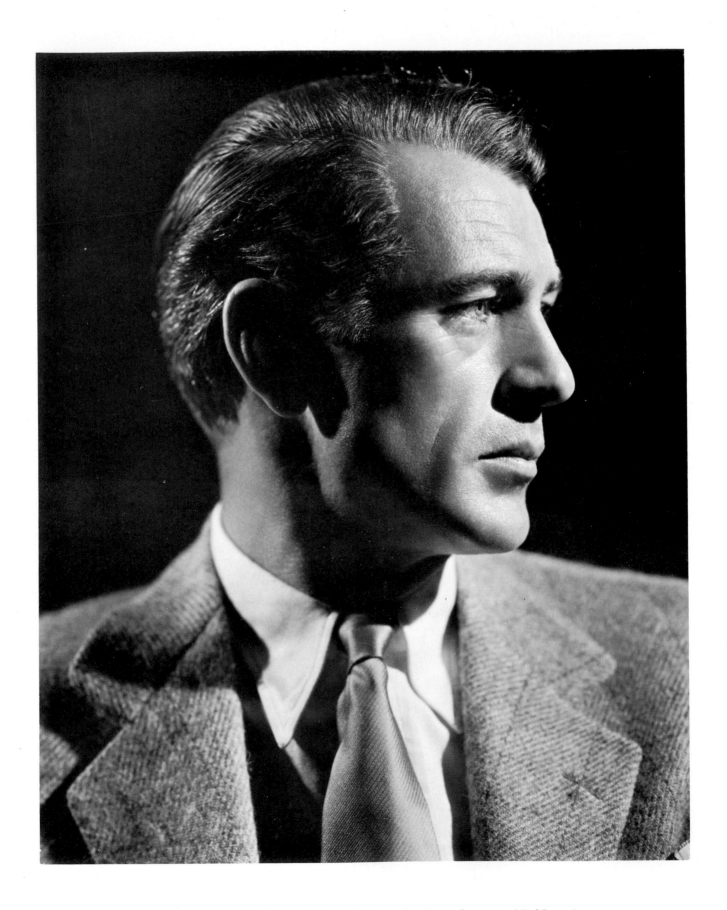

Gary Cooper, 1939. Photo: Robert Coburn, for United Artists (Goldwyn).
Publicity shot for *The Real Glory*.

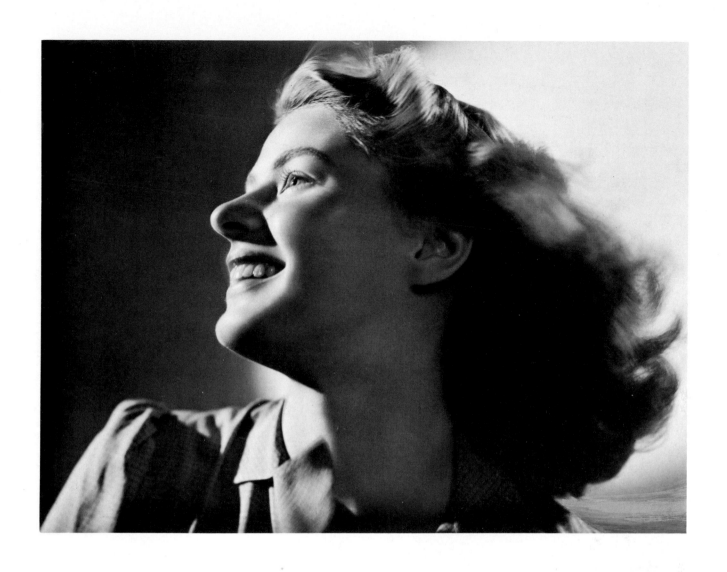

Ingrid Bergman, 1938. Photo: Robert Coburn (?), for United Artists.

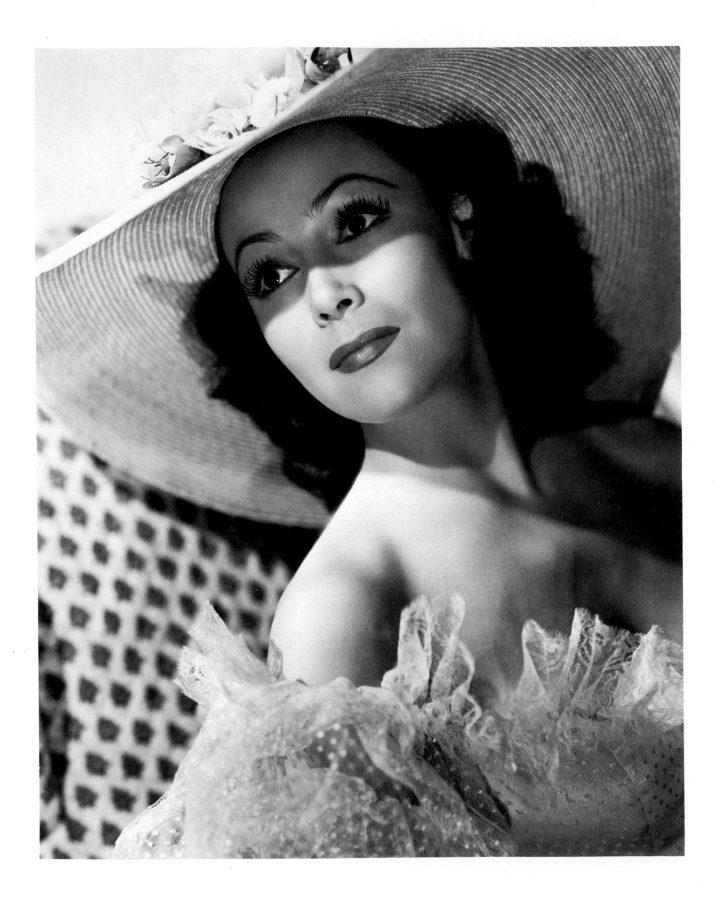

Dolores Del Rio, 1940. Photo: Laszlo Willinger, for MGM. Publicity
shot for *The Man from Dakota*.

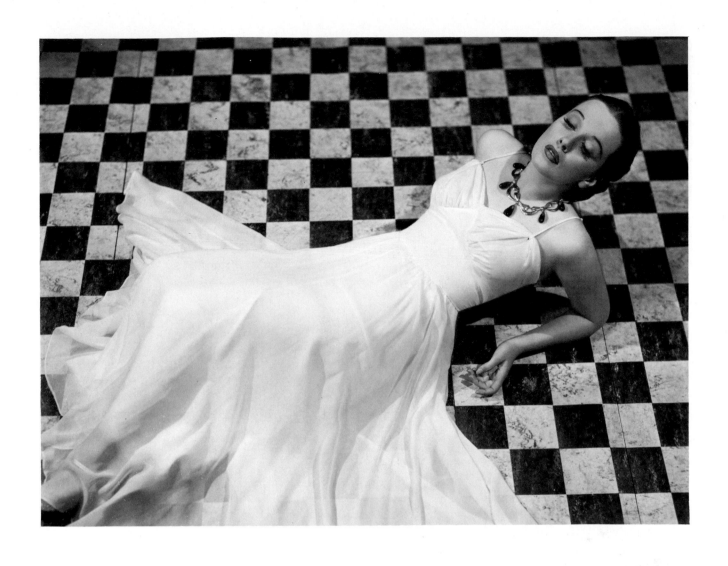

Patricia Morison, 1940. Photo: William Walling, for Paramount.

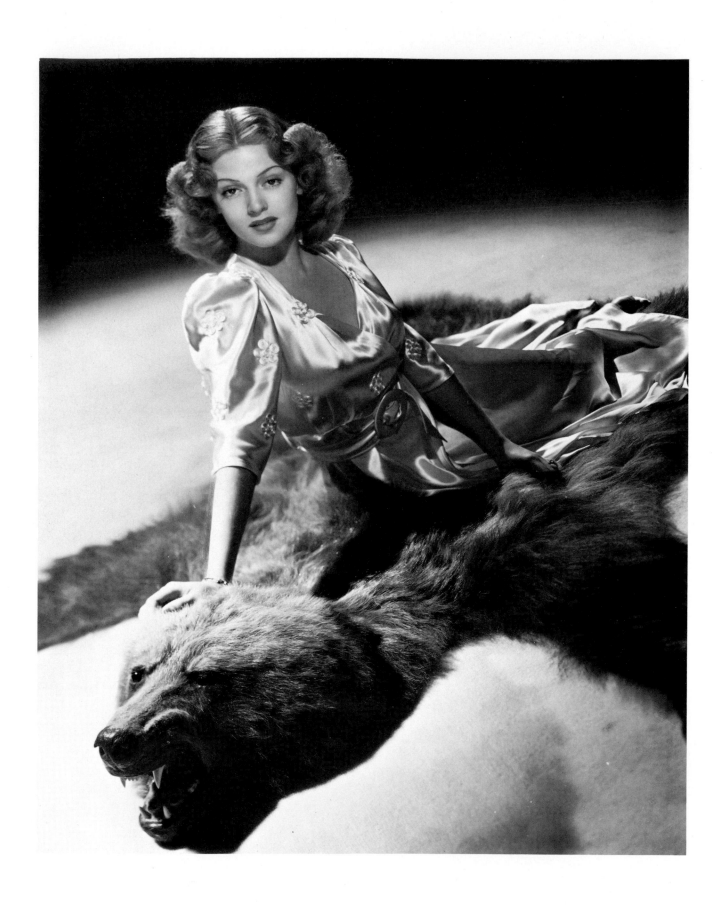

Lana Turner, 1939. Photo: Laszlo Willinger, for MGM.

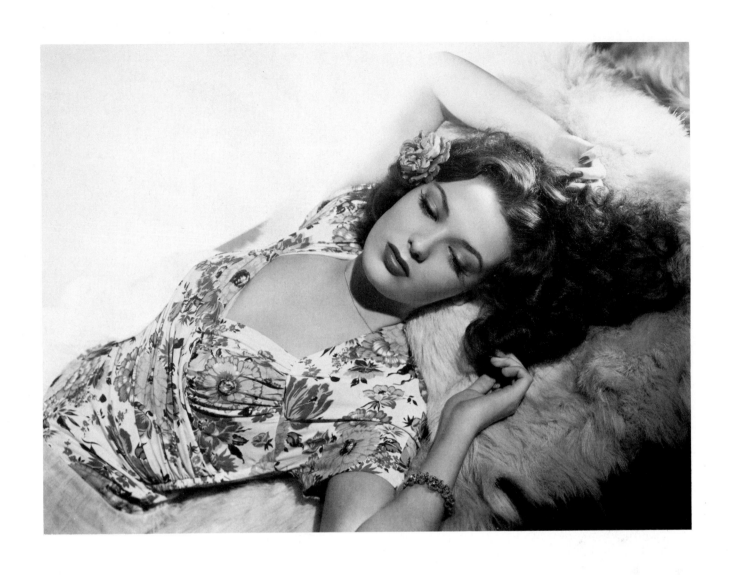

Linda Darnell, 1941. Photo: George Hurrell, for 20th Century-Fox.

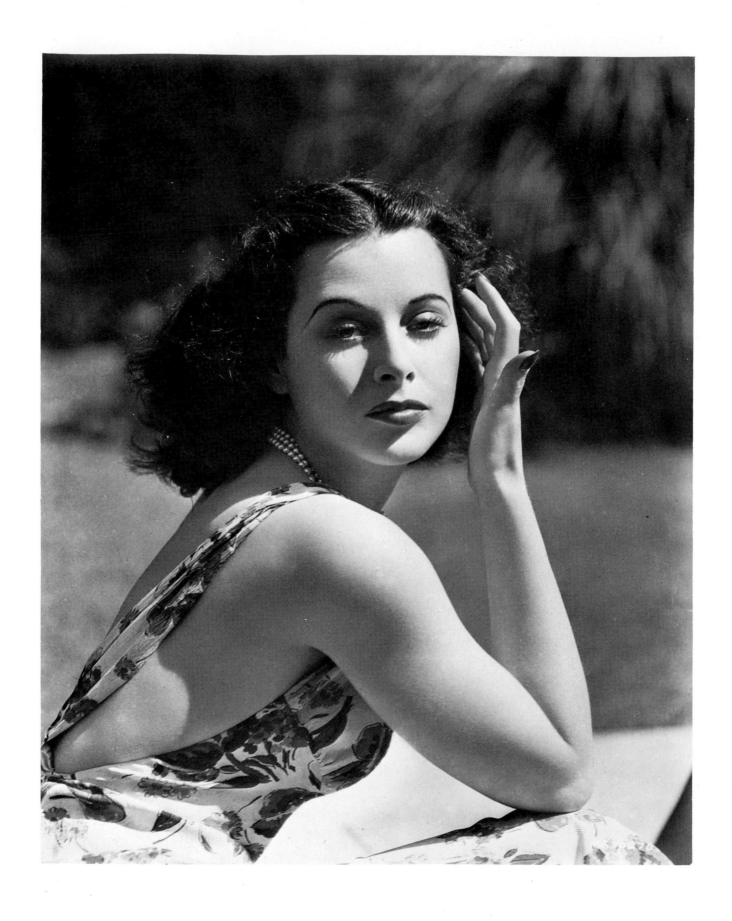

Hedy Lamarr, 1940. Photo: Bud Graybill.

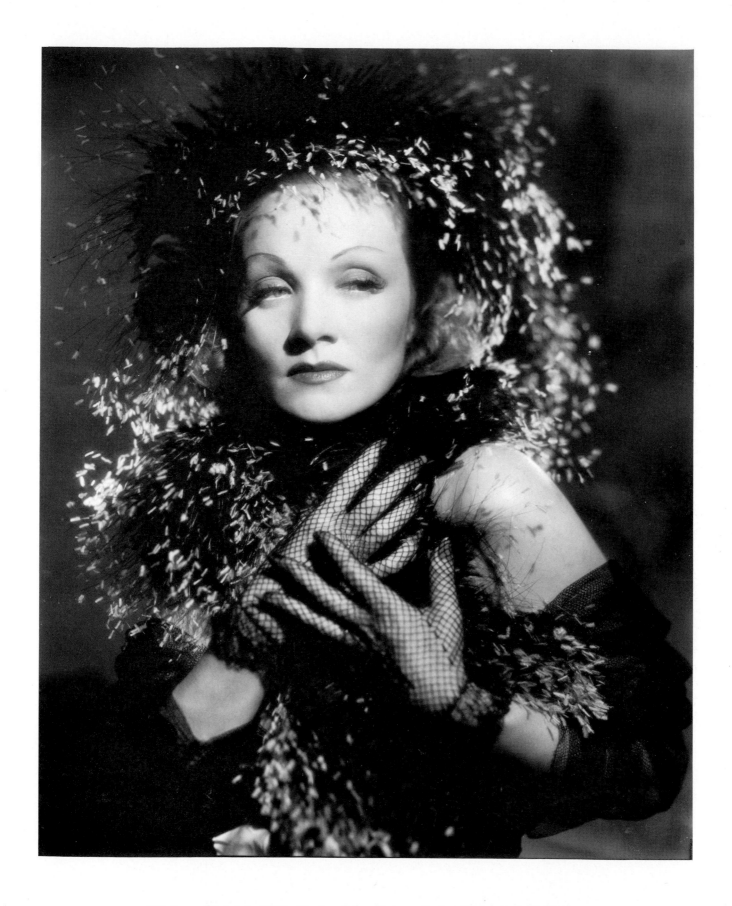

Marlene Dietrich, 1940. Photo: John Engstead, for Universal. Publicity shot for *Seven Sinners*.

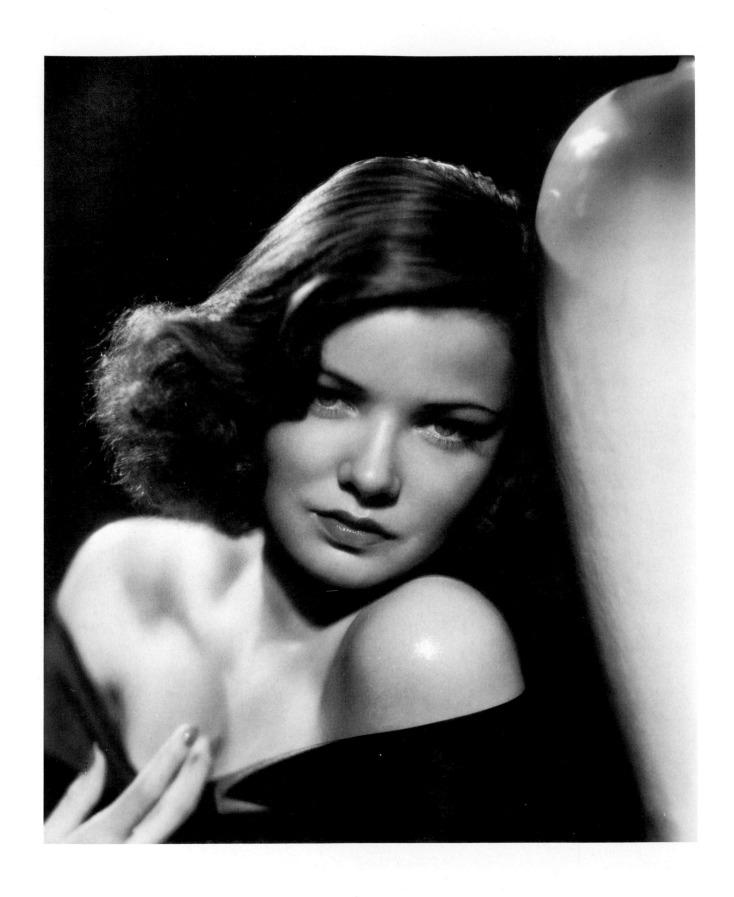

Gene Tierney, 1939. Photo: A. L. ("Whitey") Schafer, for Columbia.

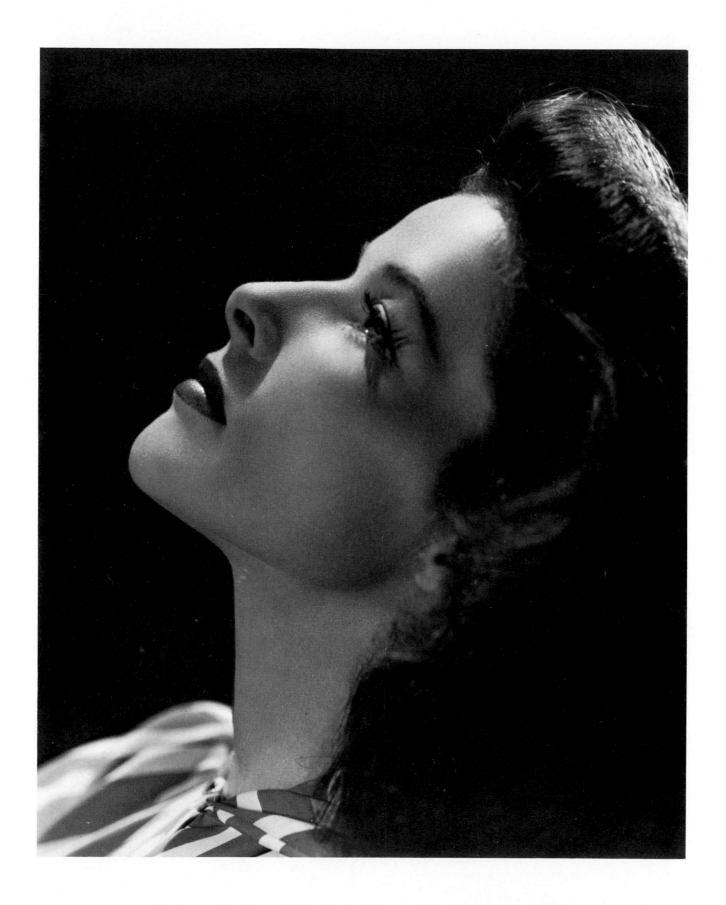

Katharine Hepburn, 1941. Photo: Clarence Sinclair Bull, for MGM.

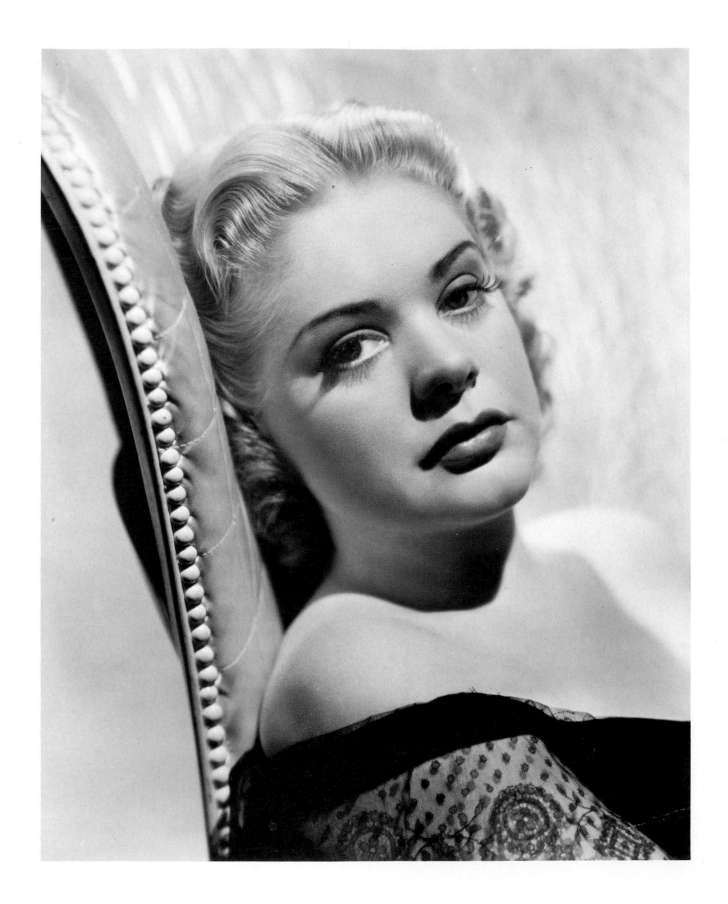

Alice Faye, 1940. Photo: Gene Kornman, for 20th Century-Fox.

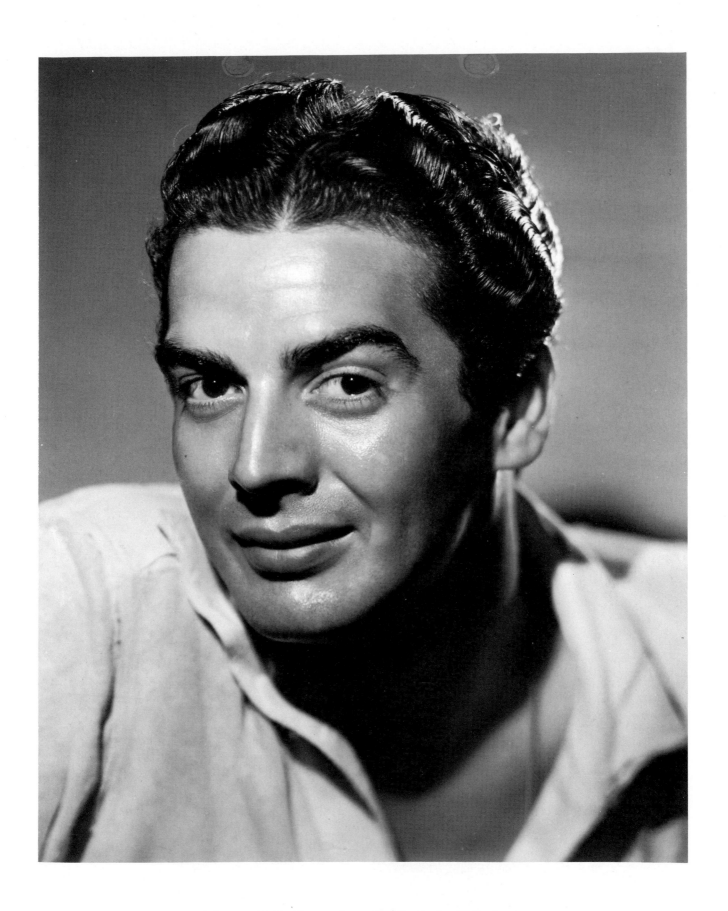

Victor Mature, 1941. Photo: Gene Kornman, for 20th Century-Fox.

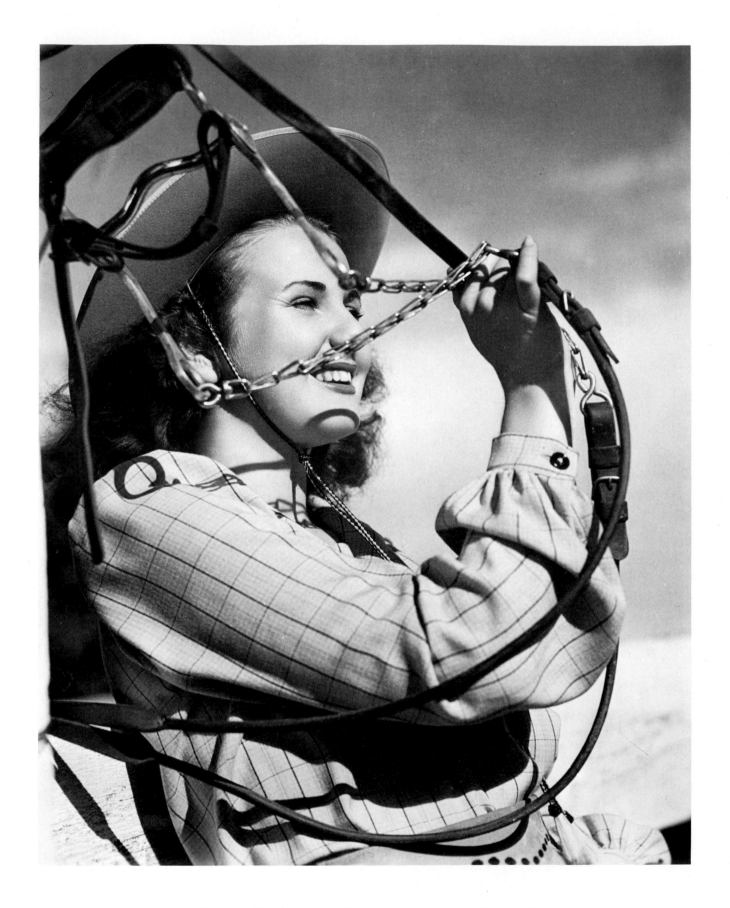

Deanna Durbin, 1941. Photo: Ray Jones, for Universal.

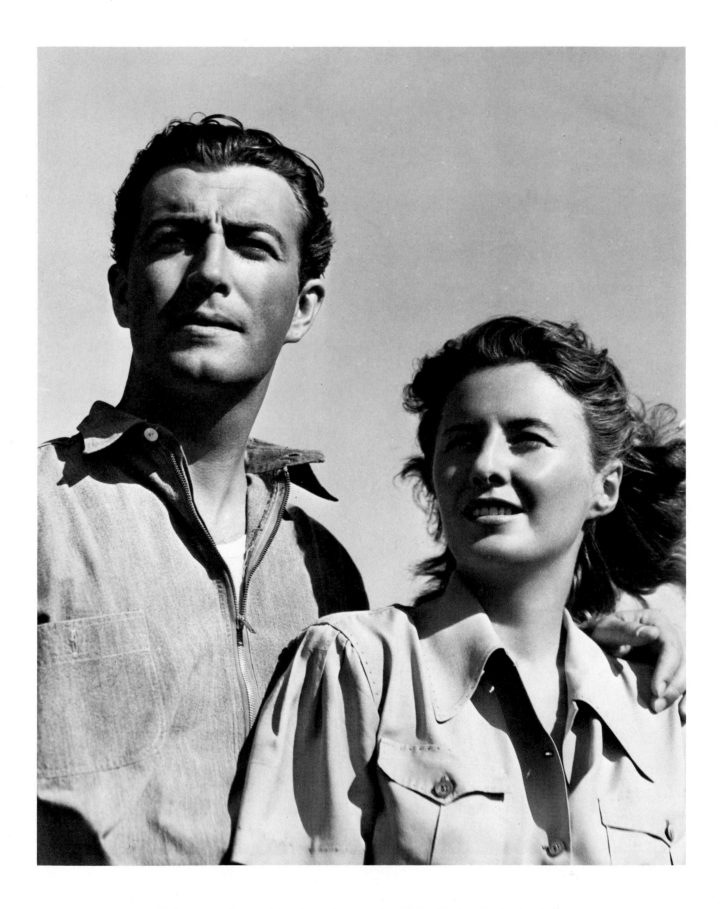

Robert Taylor and Barbara Stanwyck, 1939. Photo: Bud Graybill.

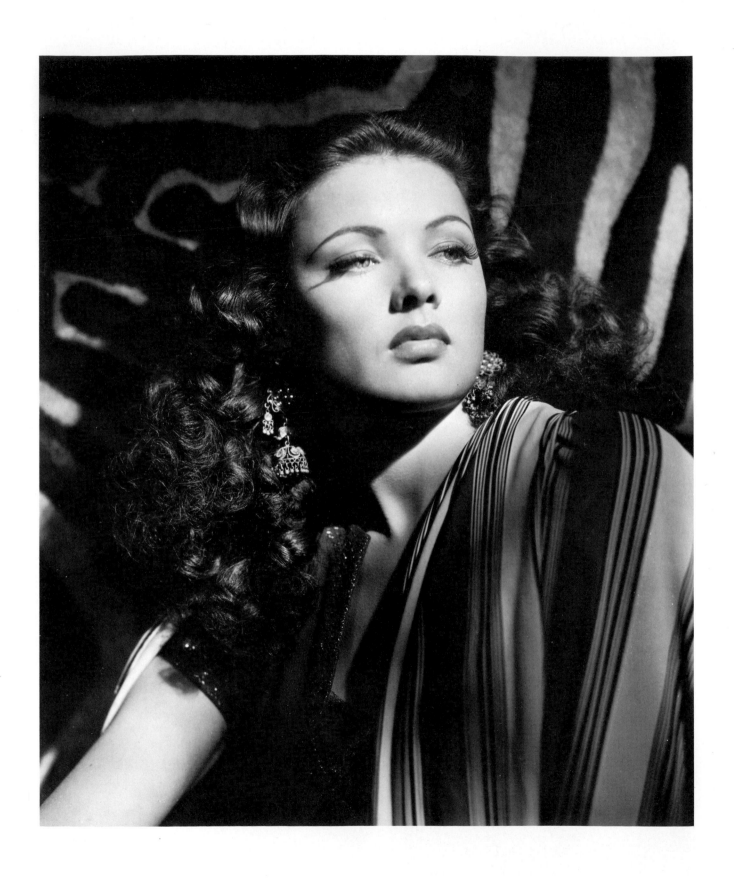

Gene Tierney, 1941. Photo: Robert Coburn, for United Artists (Walter Wanger). Publicity shot for *Sundown*.

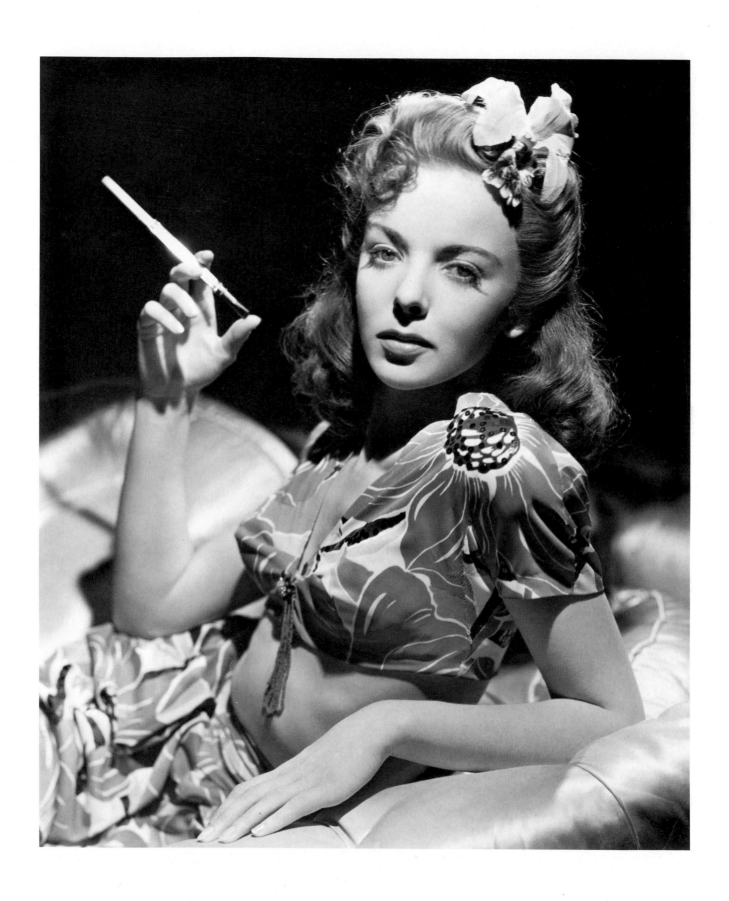

Ida Lupino, 1941. Photo: Scotty Welbourne, for Warner Bros.

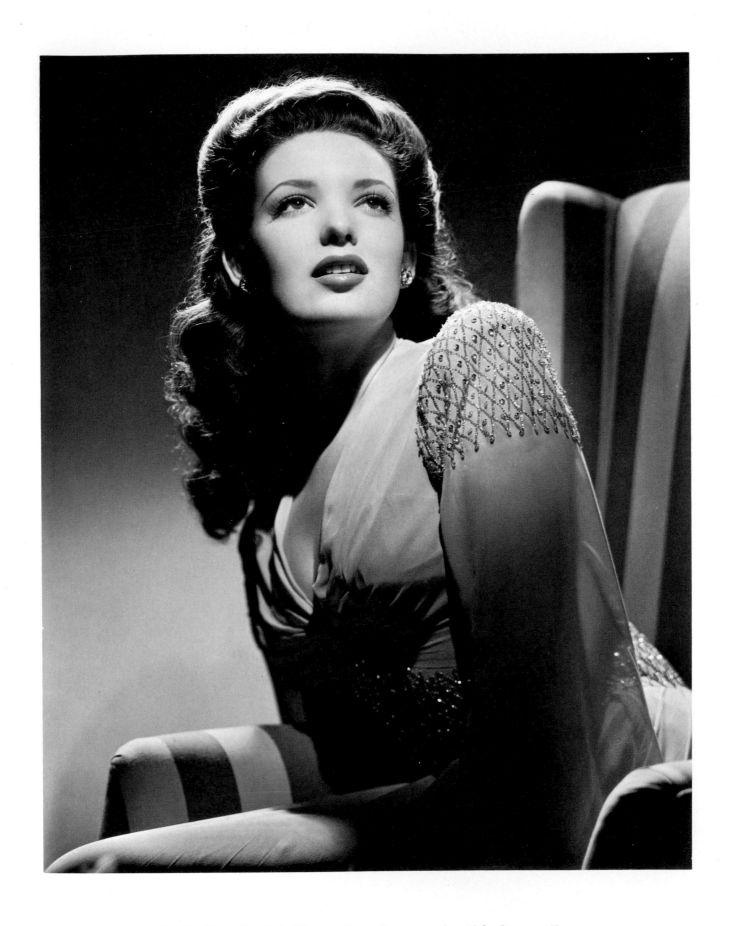

Linda Darnell, 1942. Photo: Gene Kornman, for 20th Century-Fox.

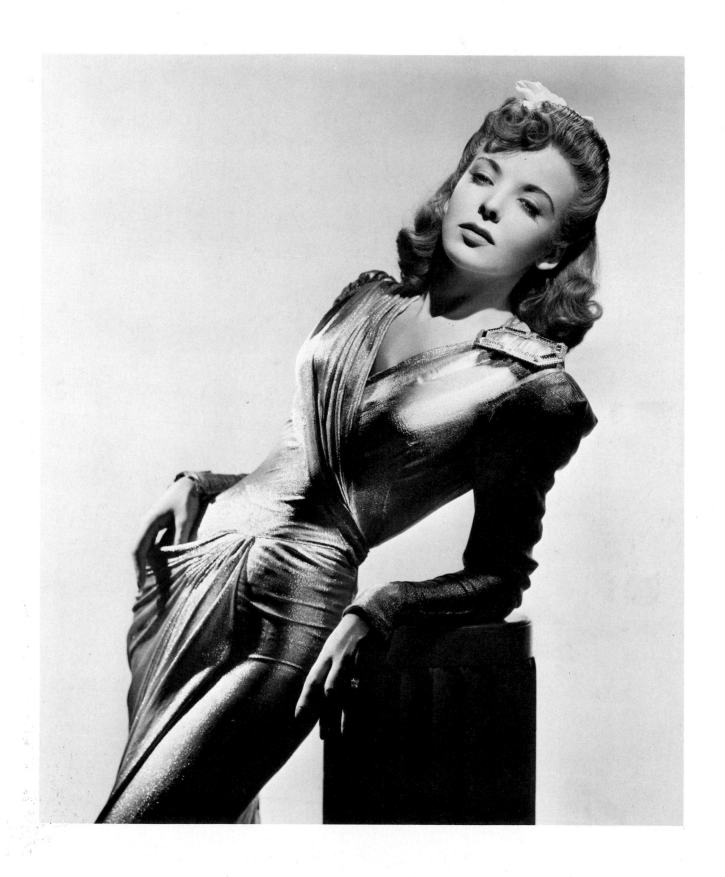

Ida Lupino, 1940. Photo: Scotty Welbourne, for Warner Bros. Costume
by Orry Kelly. Publicity shot for *They Drive by Night*.

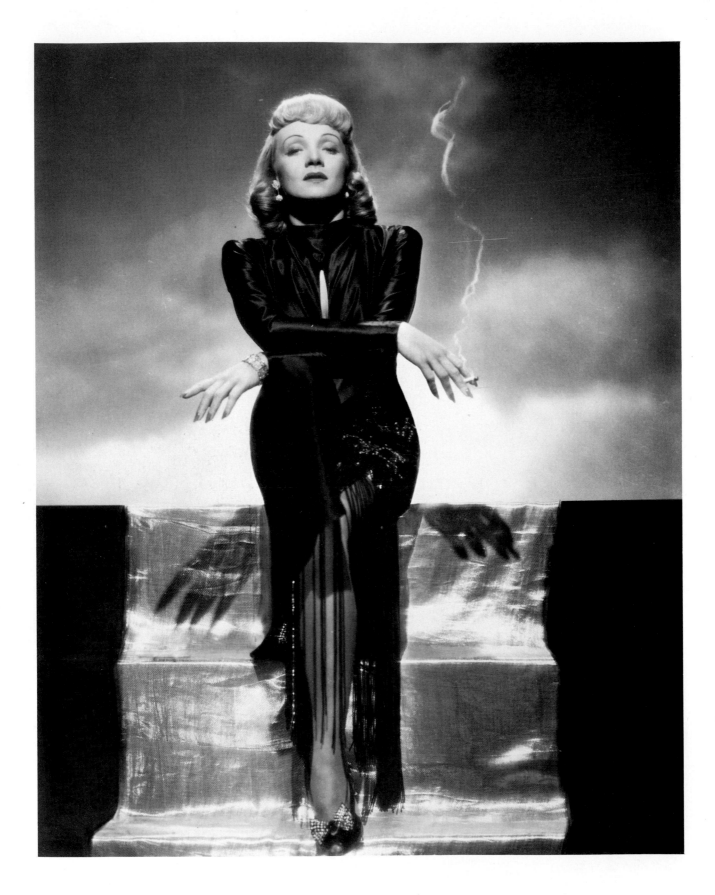

Marlene Dietrich, 1941. Warner Bros. Costume by Orry Kelly. Publicity
shot for *Manpower*.

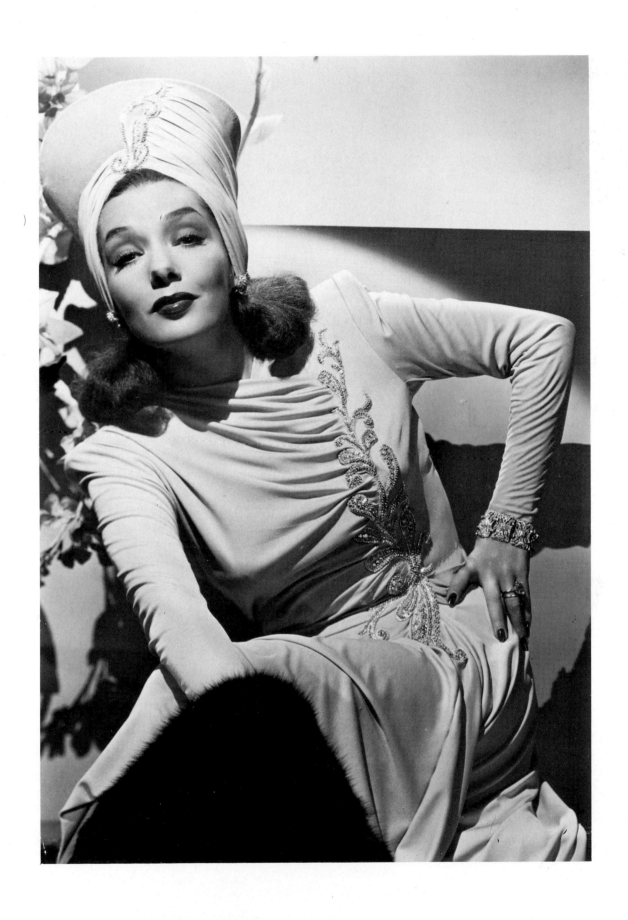

Lupe Velez, 1941. Photo: Ernest A. Bachrach, for RKO Radio.

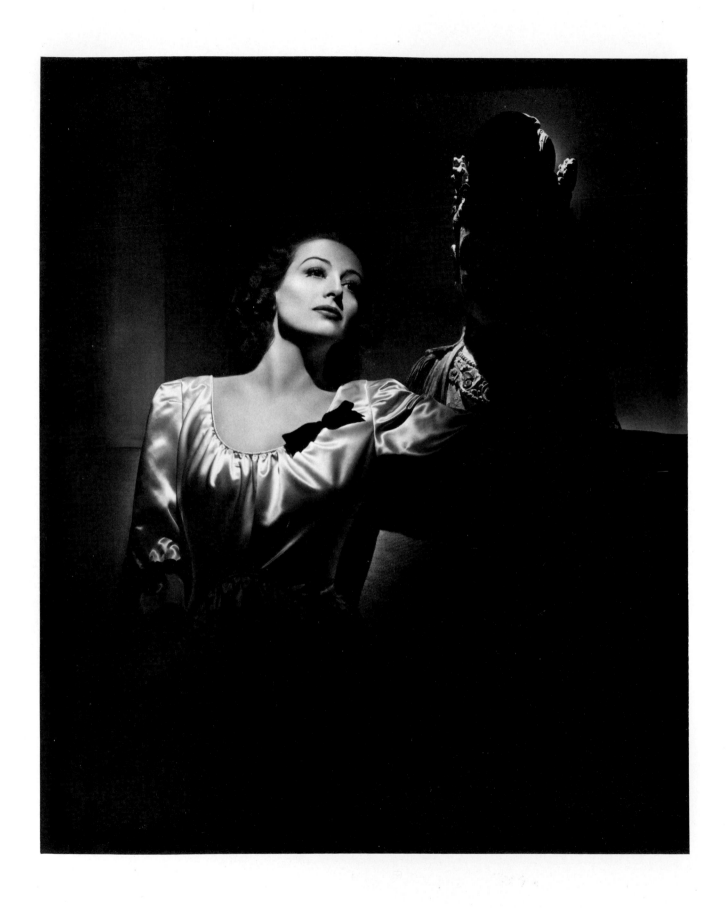

Joan Crawford, 1939. Photo: Laszlo Willinger, for MGM. Costume by Adrian.

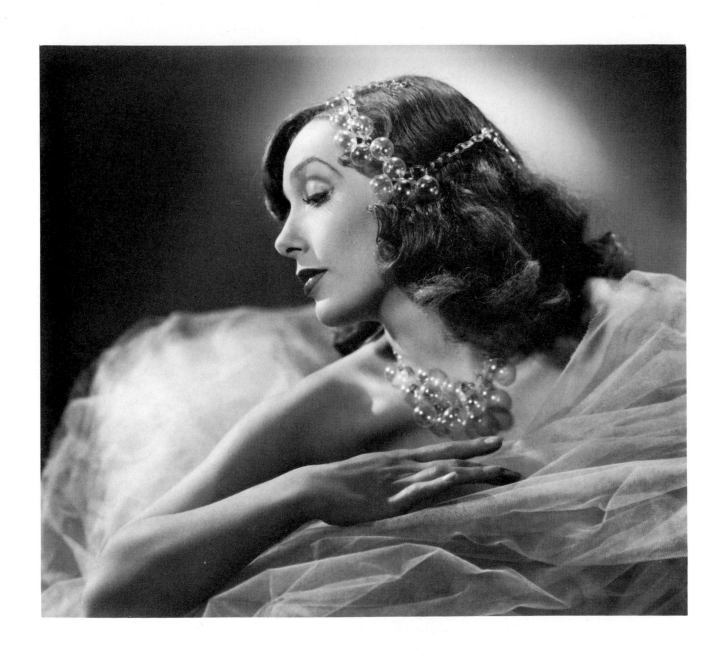

Lupe Velez, 1940. Photo: Ernest A. Bachrach, for RKO Radio.

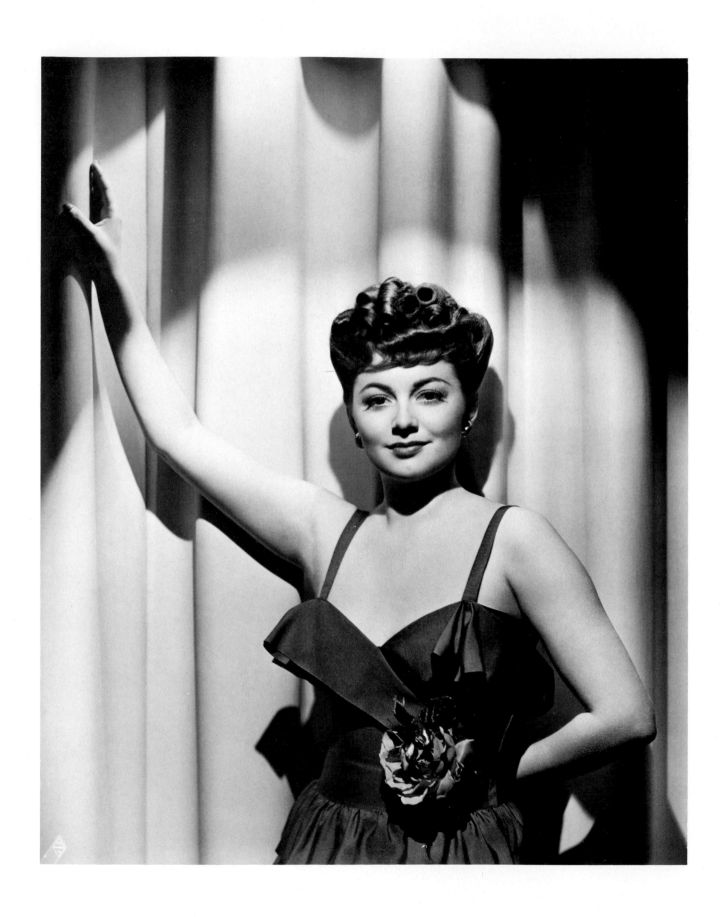

Olivia de Havilland, 1941. Photo: Scotty Welbourne, for Warner Bros.

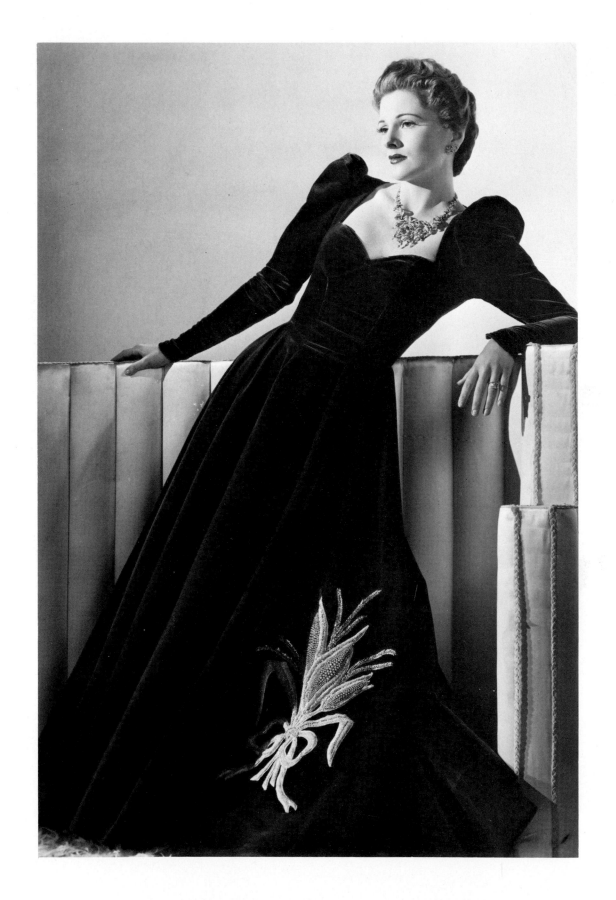

Joan Fontaine, 1941. Photo: Ernest A. Bachrach, for RKO Radio. Publicity shot for *Suspicion*.

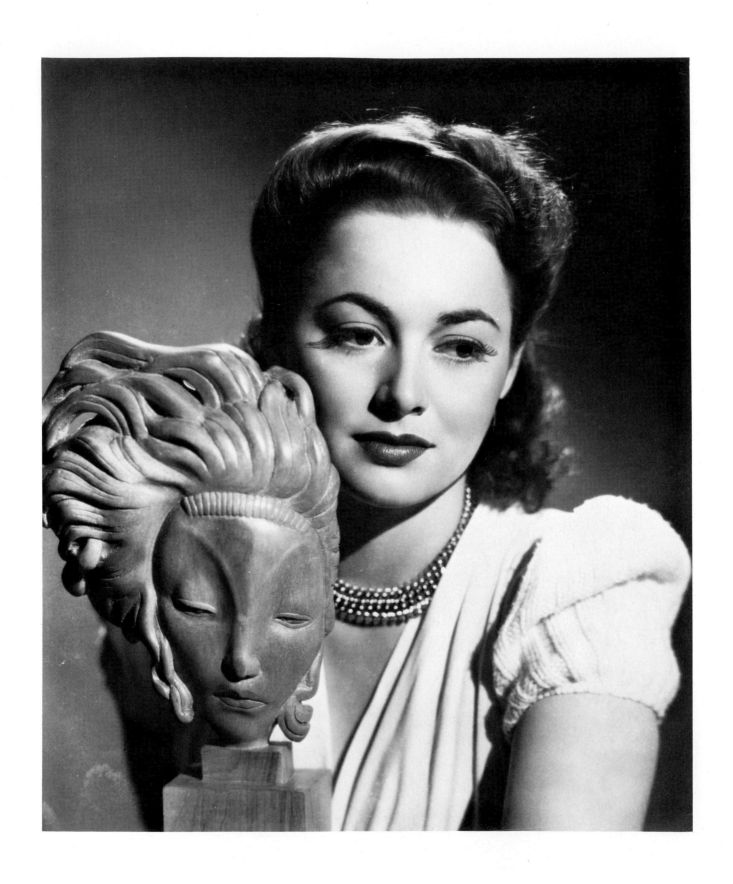

Olivia de Havilland, 1941. Photo: A. L. ("Whitey") Schafer, for Paramount.

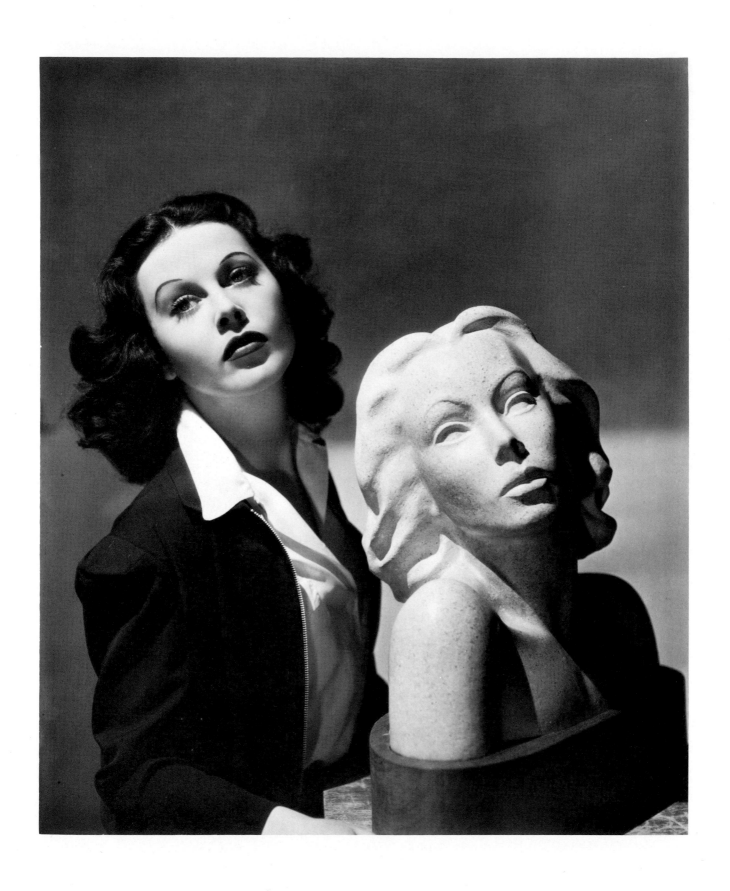

Hedy Lamarr, 1939. Photo: Eric Carpenter, for MGM.

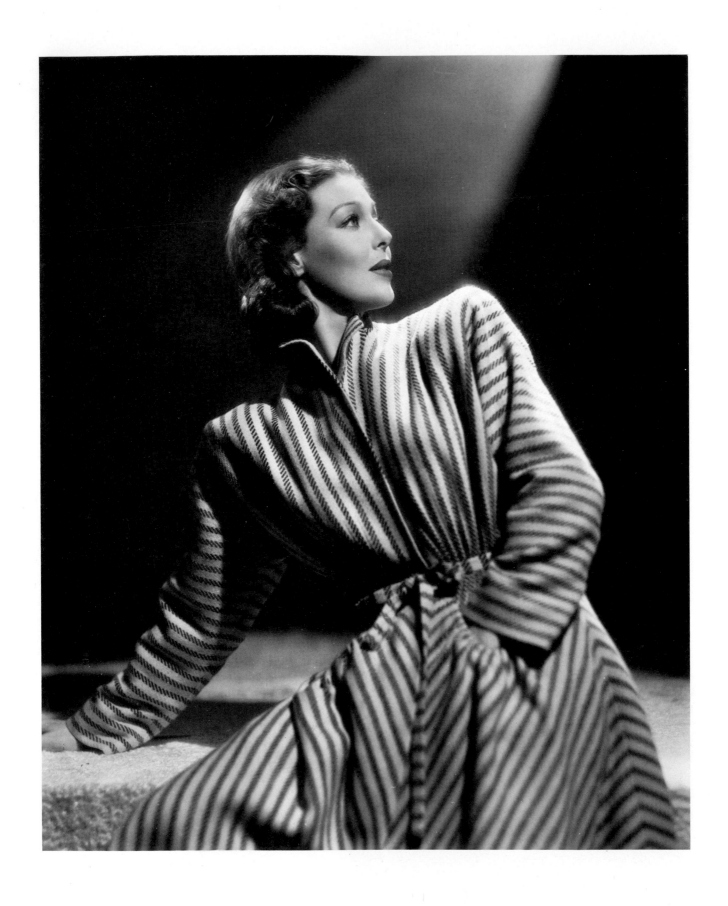

Loretta Young, 1940. Photo: A. L. ("Whitey") Schafer, for Columbia.
Publicity shot for *The Doctor Takes a Wife*.

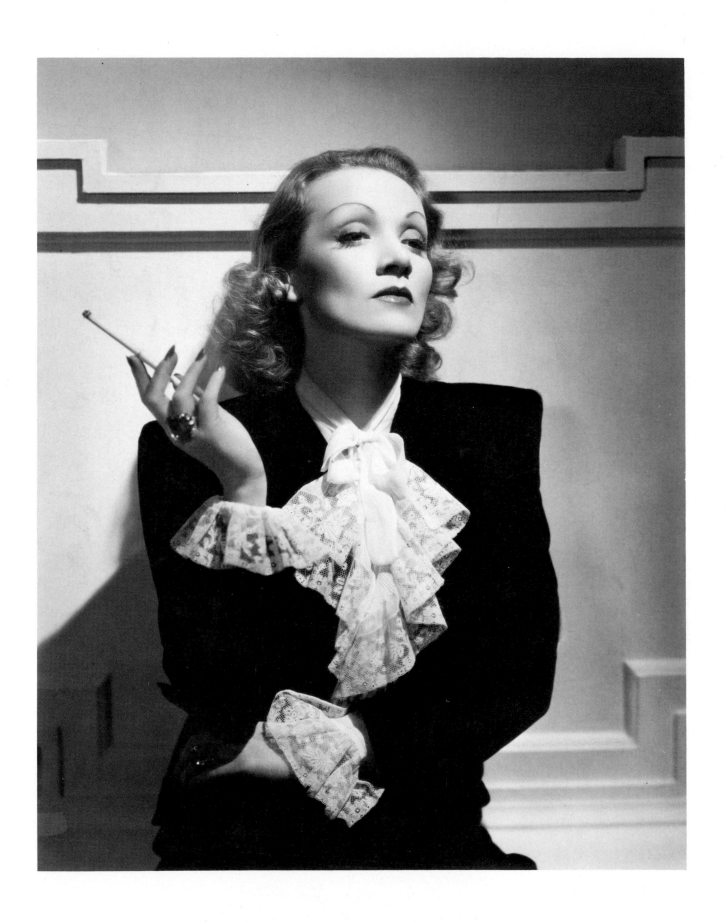

Marlene Dietrich, 1940. Photo: Ray Jones, for Universal.

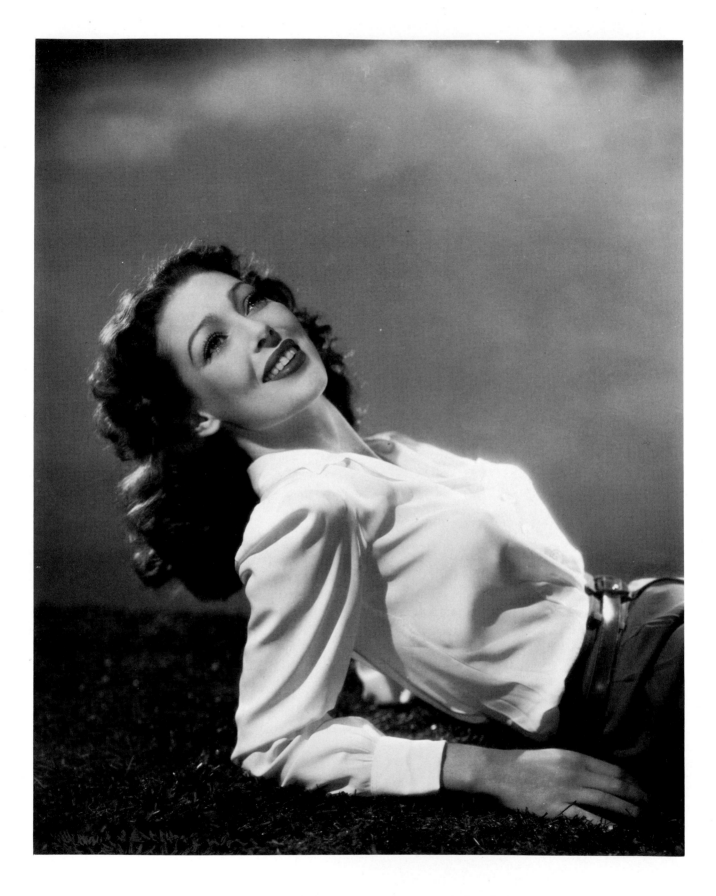

Loretta Young, 1943. Photo: A. L. ("Whitey") Schafer, for Paramount.

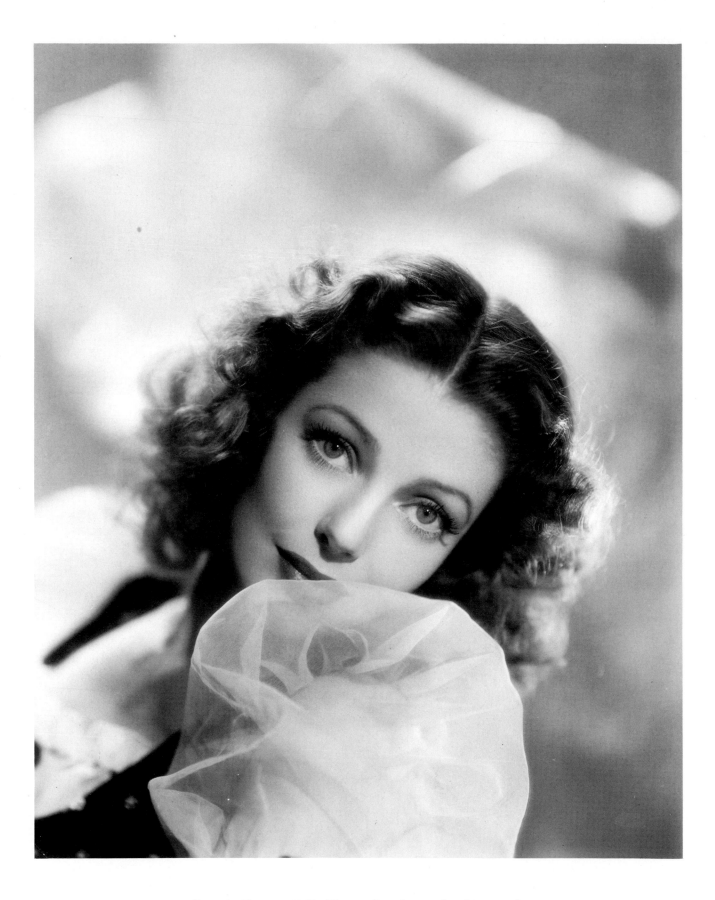

Loretta Young, 1941. Photo: Ray Jones, for Universal.

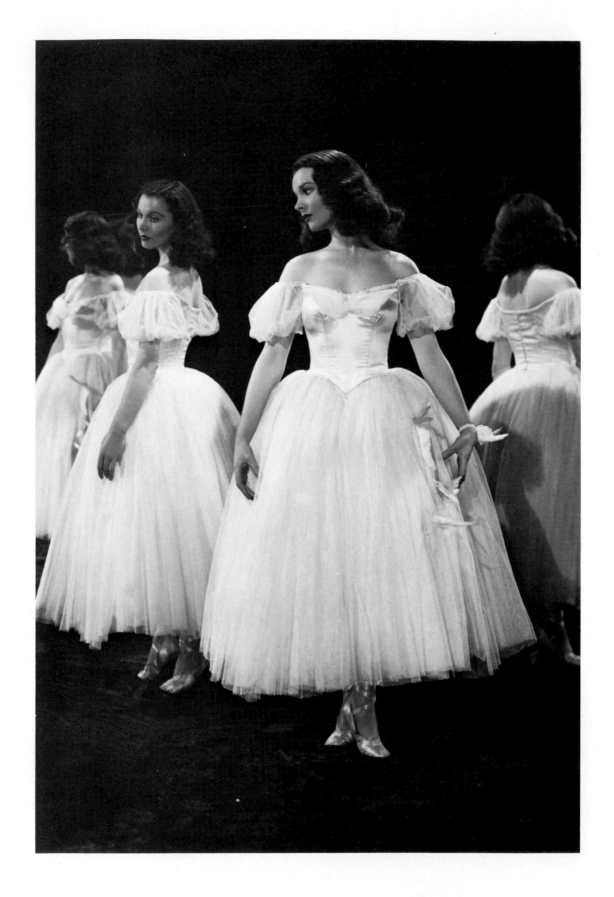

Vivien Leigh, 1940. Photo: Laszlo Willinger, for MGM. Costume by
Adrian. Publicity shot for *Waterloo Bridge*.

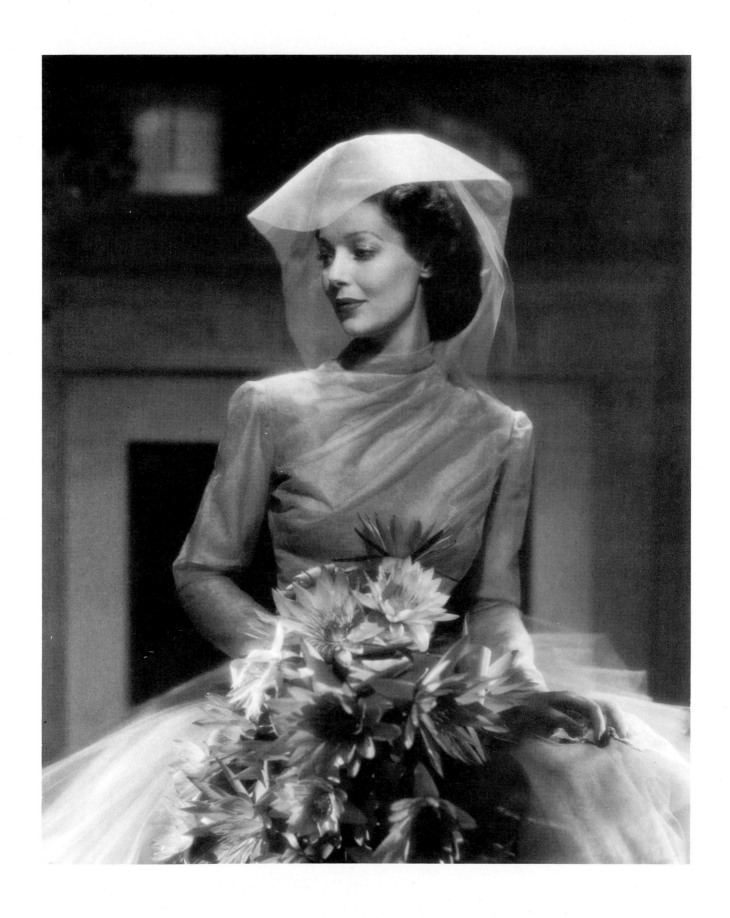

Loretta Young, 1941. Photo: John Engstead.

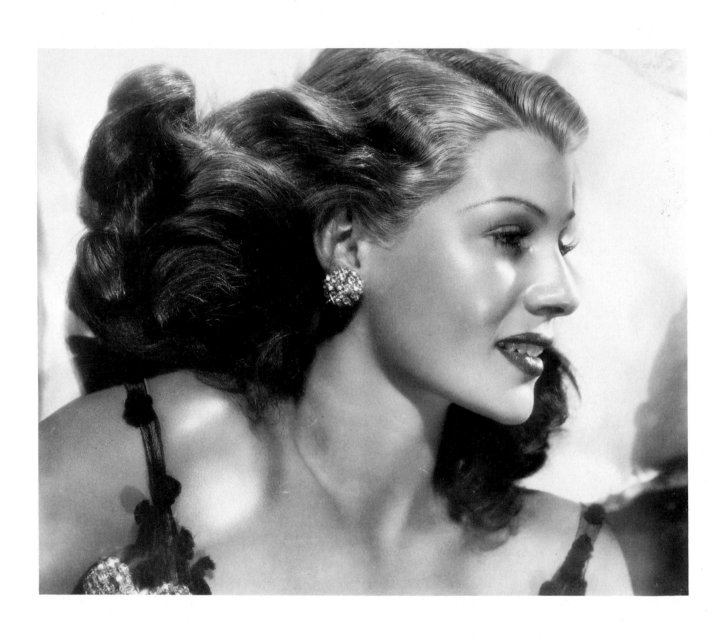

Rita Hayworth, 1941. Photo: A. L. ("Whitey") Schafer, for Columbia.
Publicity shot for *You'll Never Get Rich*.

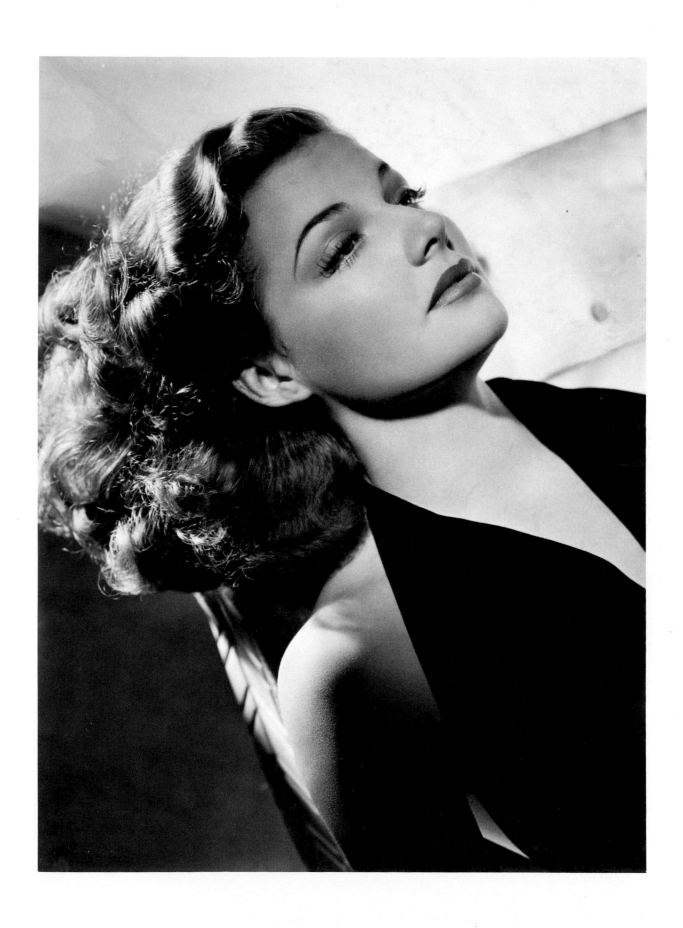

Ann Sheridan, 1941. Photo: George Hurrell, for Warner Bros.

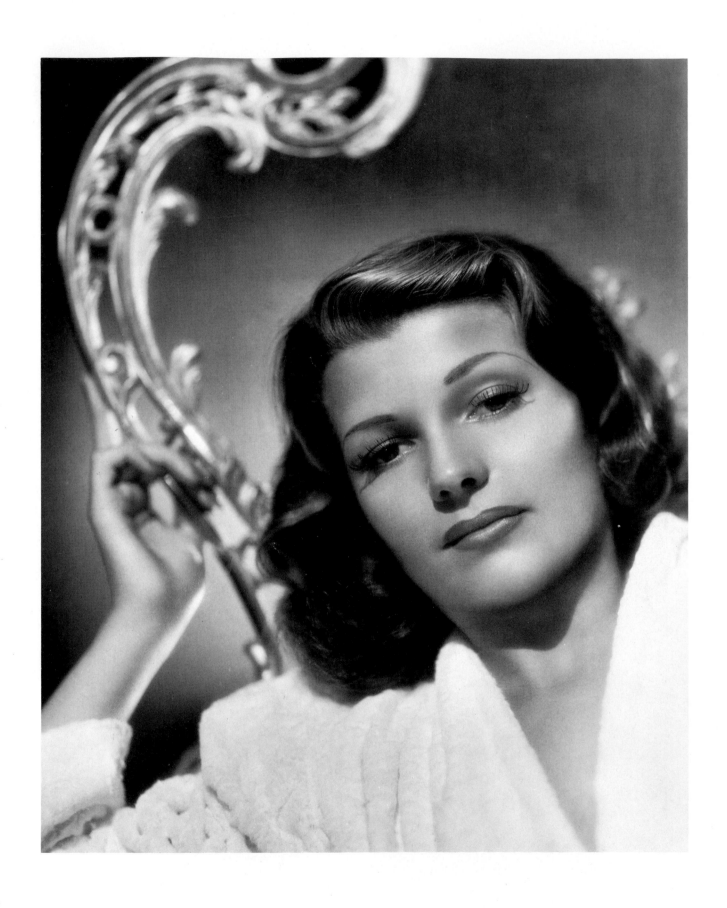

Rita Hayworth, 1940. Photo: Irving Lippman, for Columbia. Publicity shot for *Angels Over Broadway*.

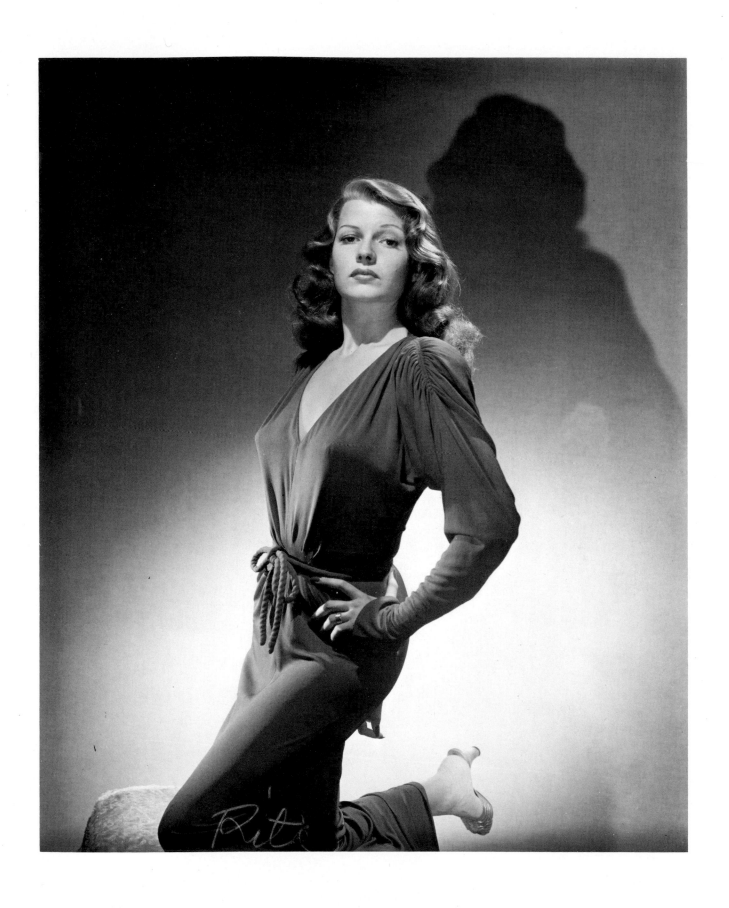

Rita Hayworth, 1941. Photo: George Hurrell, for Warner Bros.

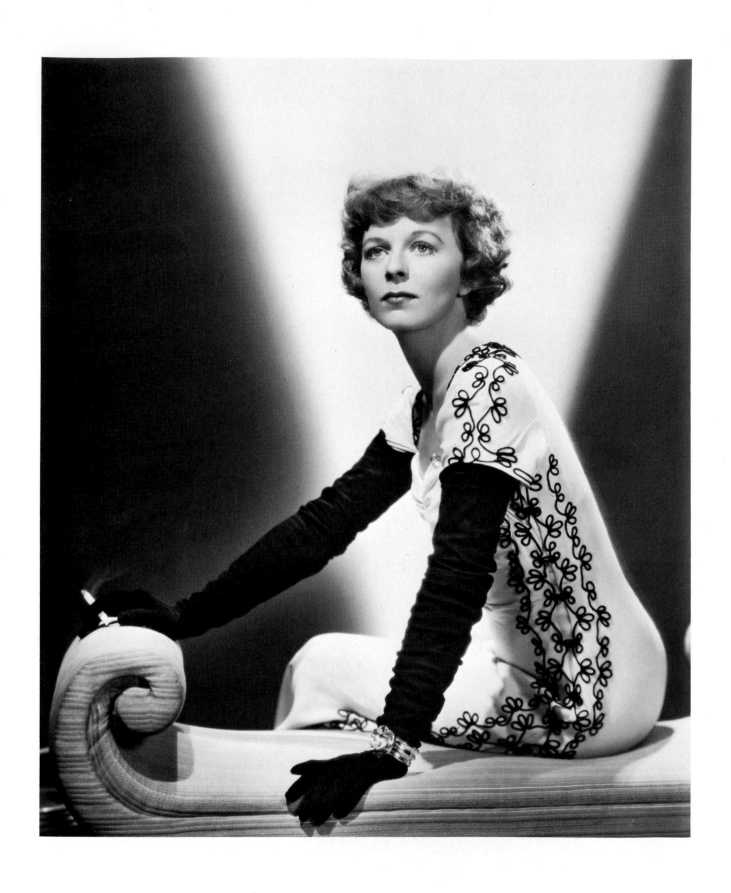

Margaret Sullavan, 1941. Photo: Ray Jones, for Universal. Costume by
Muriel King. Publicity shot for *Appointment for Love*.

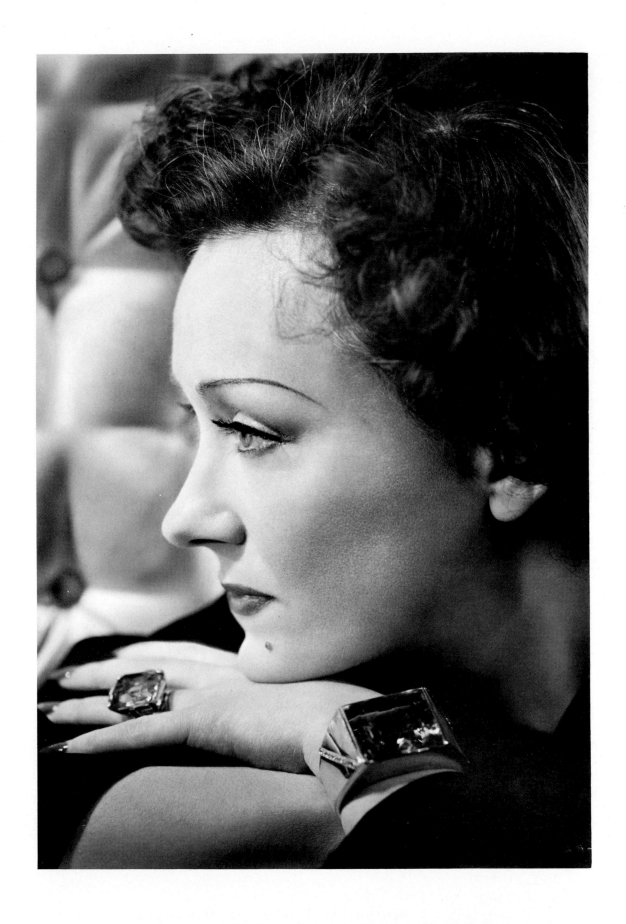

Gloria Swanson, 1941. Photo: Ernest A. Bachrach, for RKO Radio.

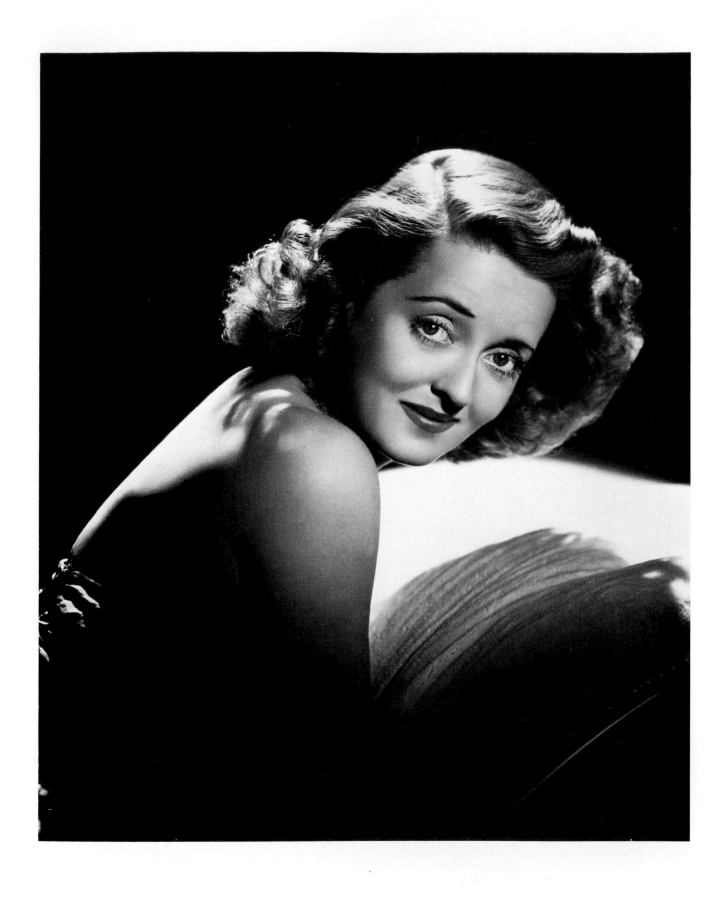

Bette Davis, 1940. Photo: George Hurrell, for Warner Bros.

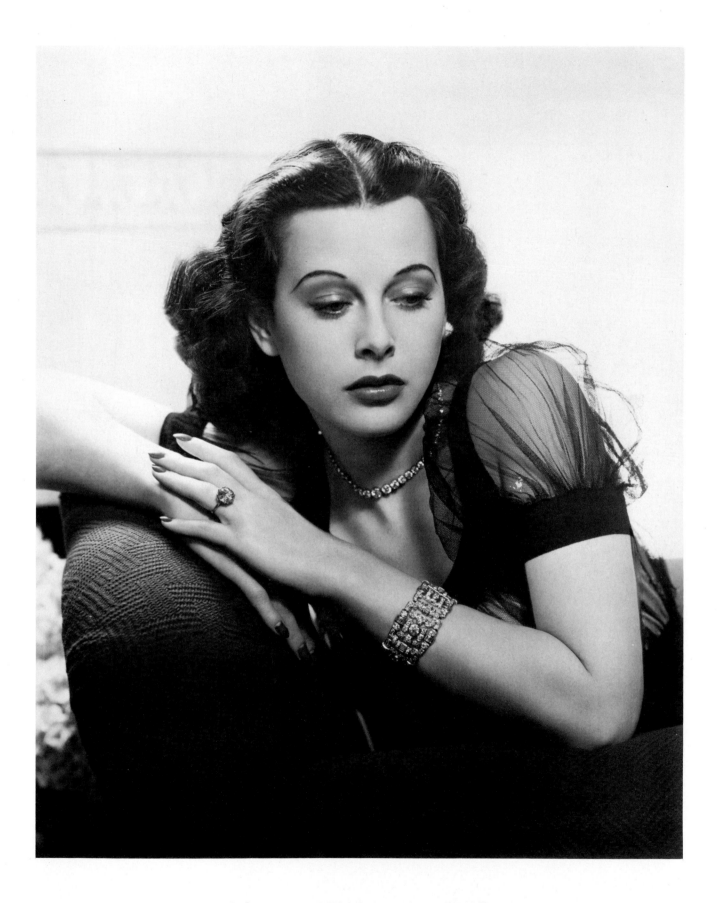

Hedy Lamarr, 1939. Photo: George Hurrell.

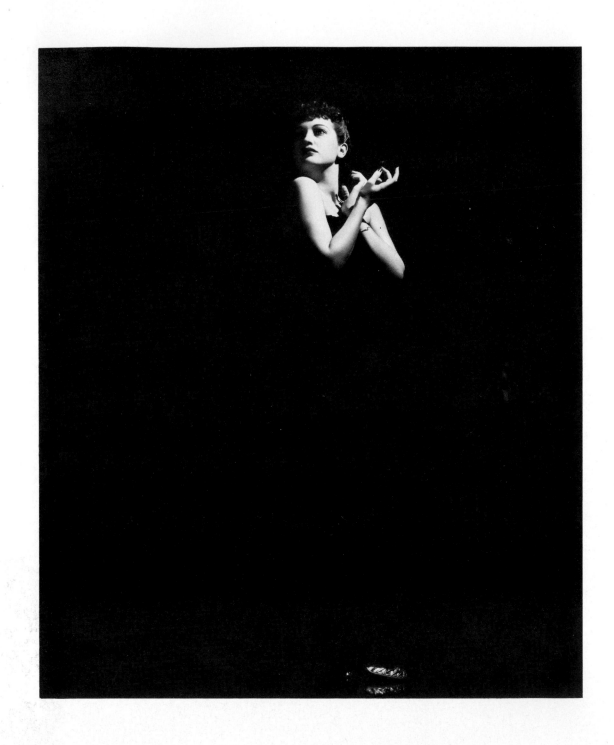

Dorothy Lamour, 1940. Photo: Frank Powolny, for 20th Century-Fox.
Publicity shot for *Johnny Apollo*.

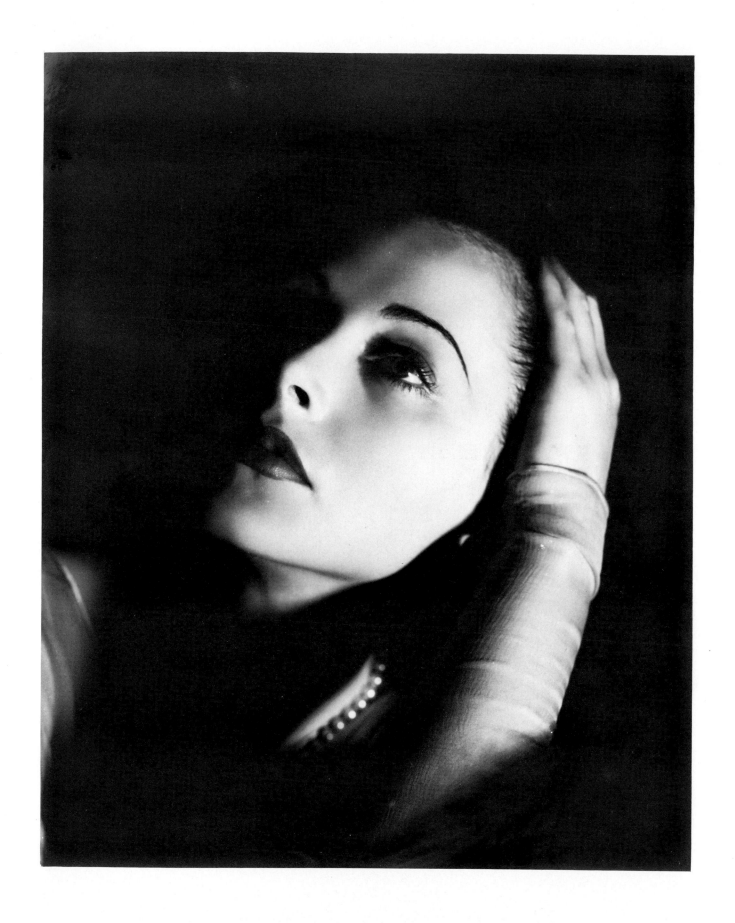

Hedy Lamarr, 1941. Photo: Clarence Sinclair Bull, for MGM.

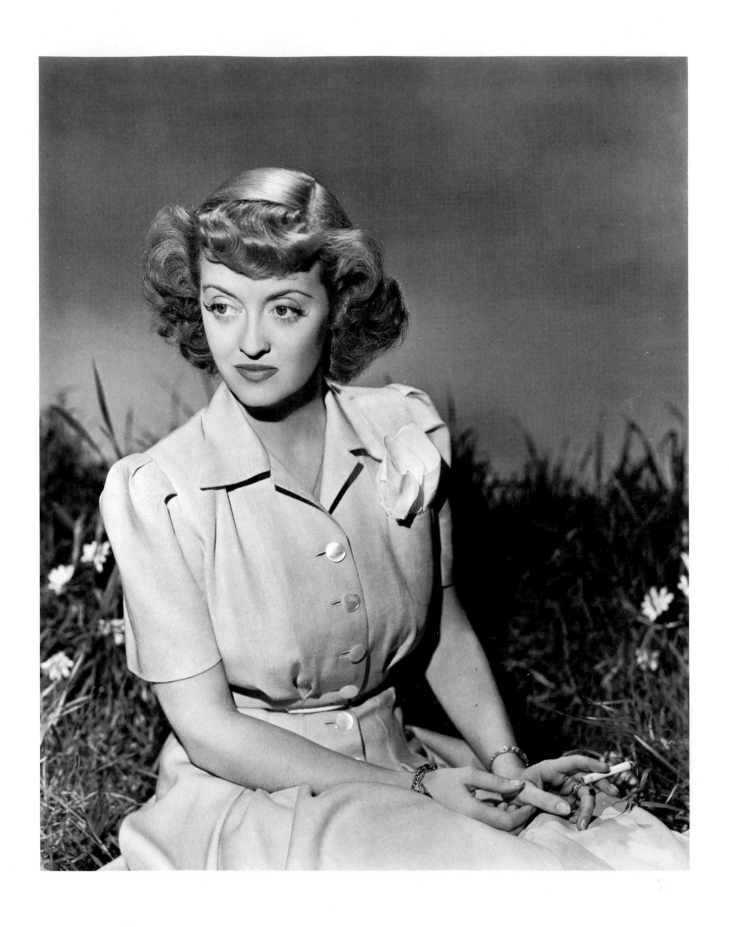

Bette Davis, 1942. Photo: Scotty Welbourne, for Warner Bros.

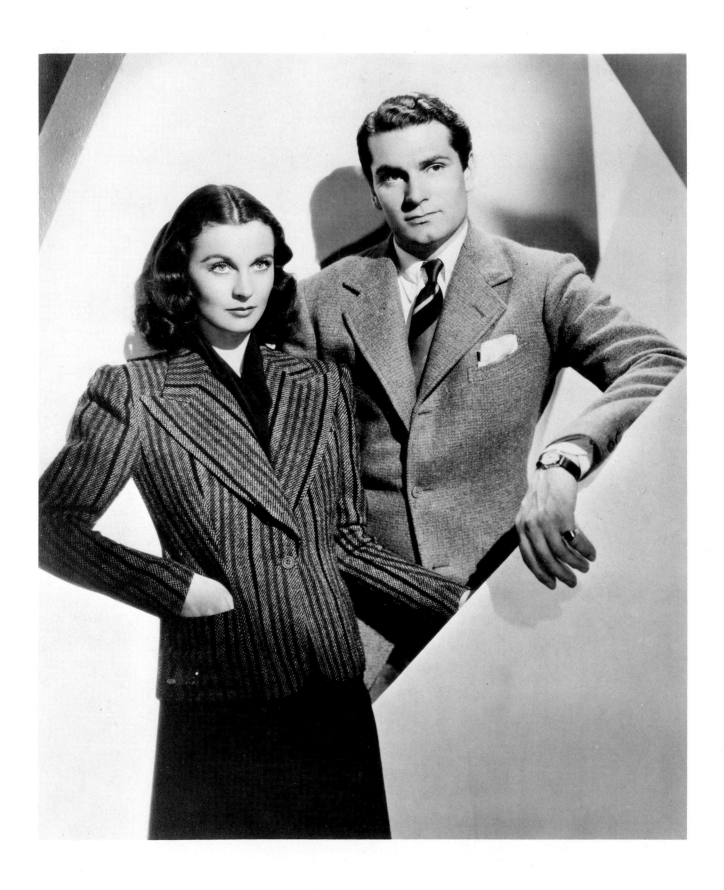

Vivien Leigh and Laurence Olivier, 1941. Photo: Laszlo Willinger, for United Artists (Alexander Korda). Publicity shot for *That Hamilton Woman.*

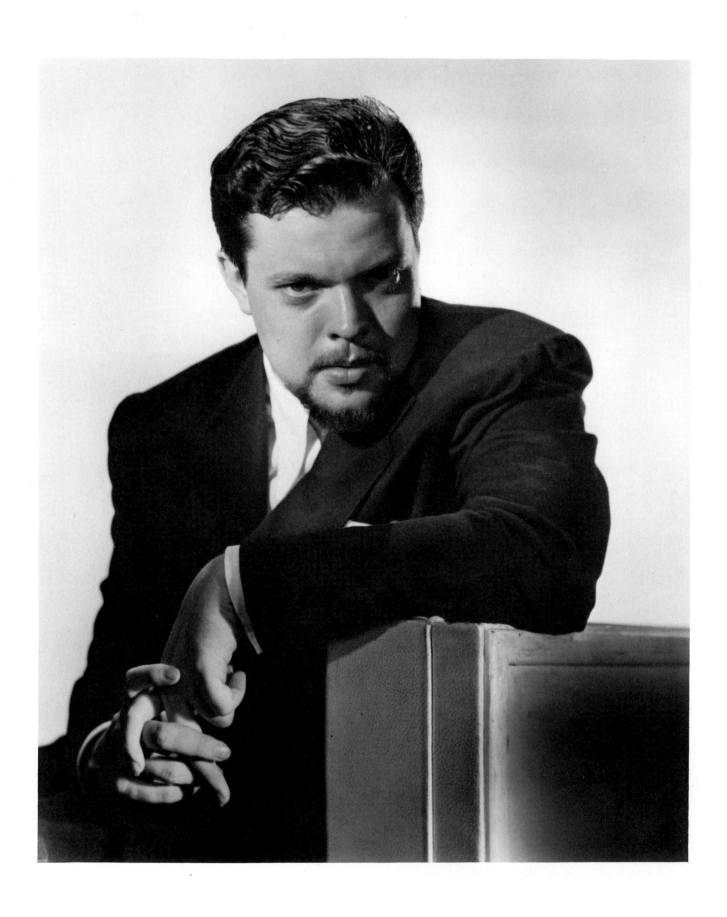

Orson Welles, 1940. Photo: Ernest A. Bachrach.

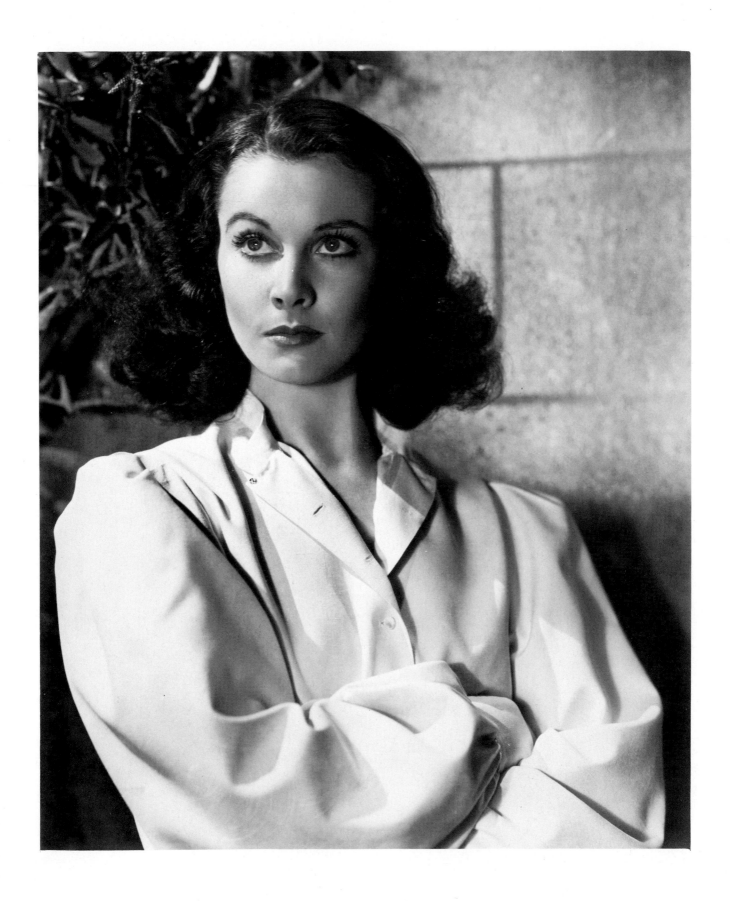

Vivien Leigh, 1940. Photo: Laszlo Willinger, for MGM.

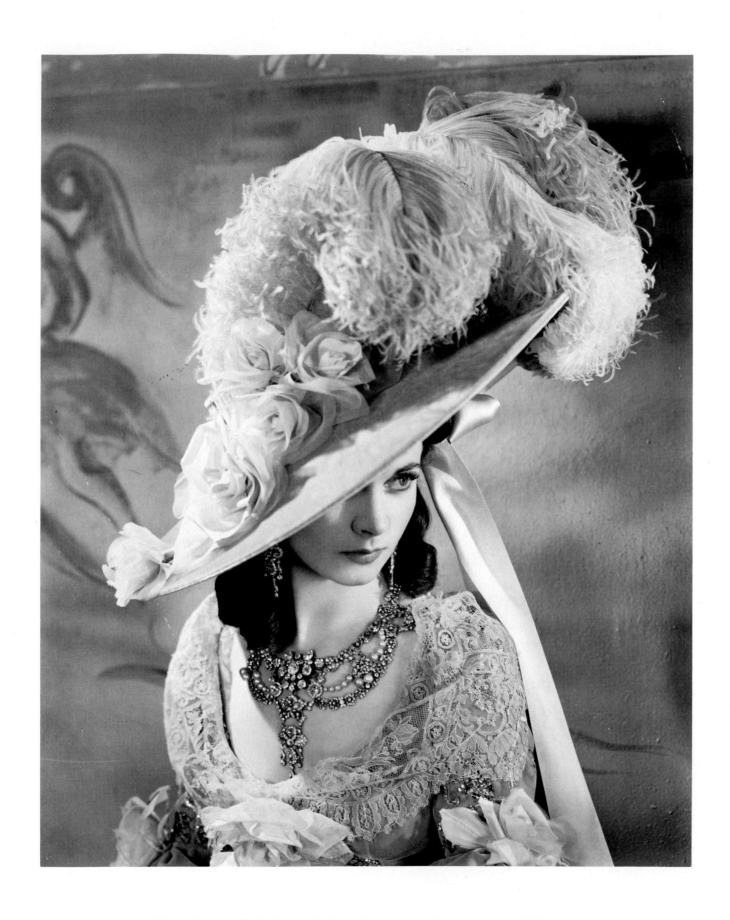

Vivien Leigh, 1940. Photo: Robert Coburn, for United Artists (Alexander Korda). Publicity shot for *That Hamilton Woman.*

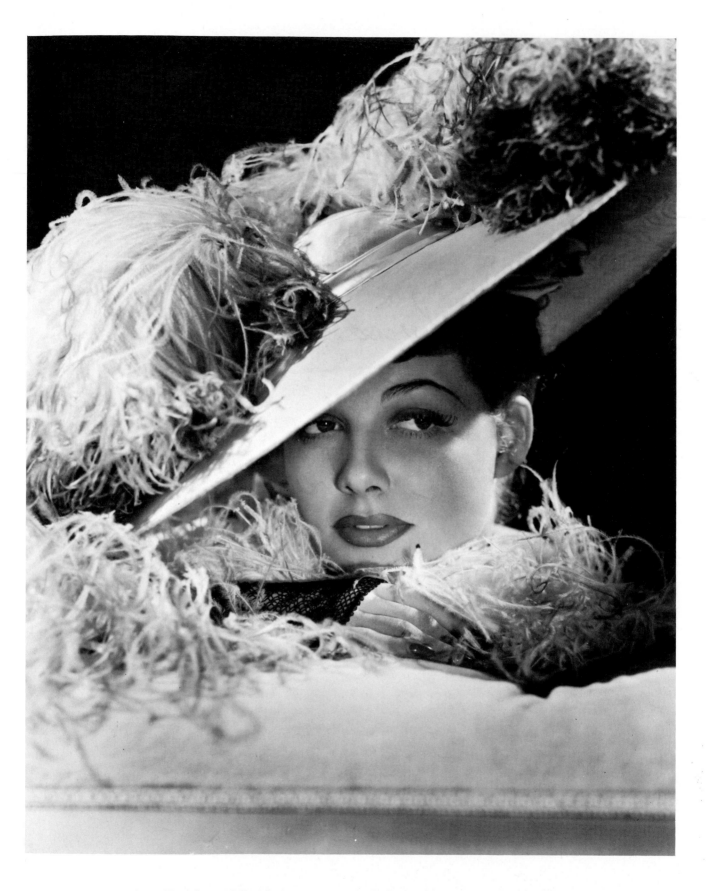

Ann Sheridan, 1940. Photo: George Hurrell, for Warner Bros. Publicity
shot for *It All Came True*.

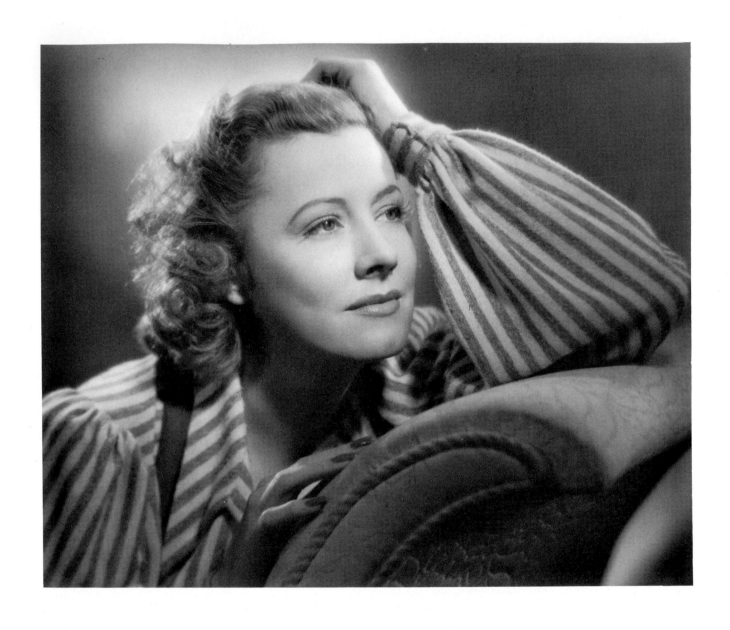

Irene Dunne, 1940. Photo: Ernest A. Bachrach, for RKO Radio. Publicity shot for *My Favorite Wife*.

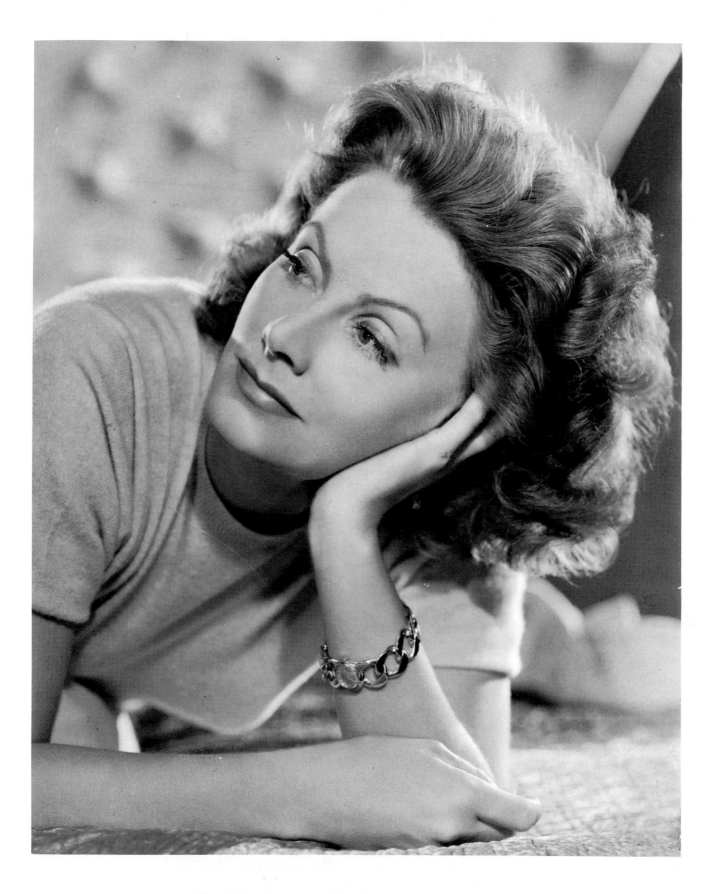

Greta Garbo, 1941. Photo: Clarence Sinclair Bull, for MGM. Publicity
shot for *Two Faced Woman.*

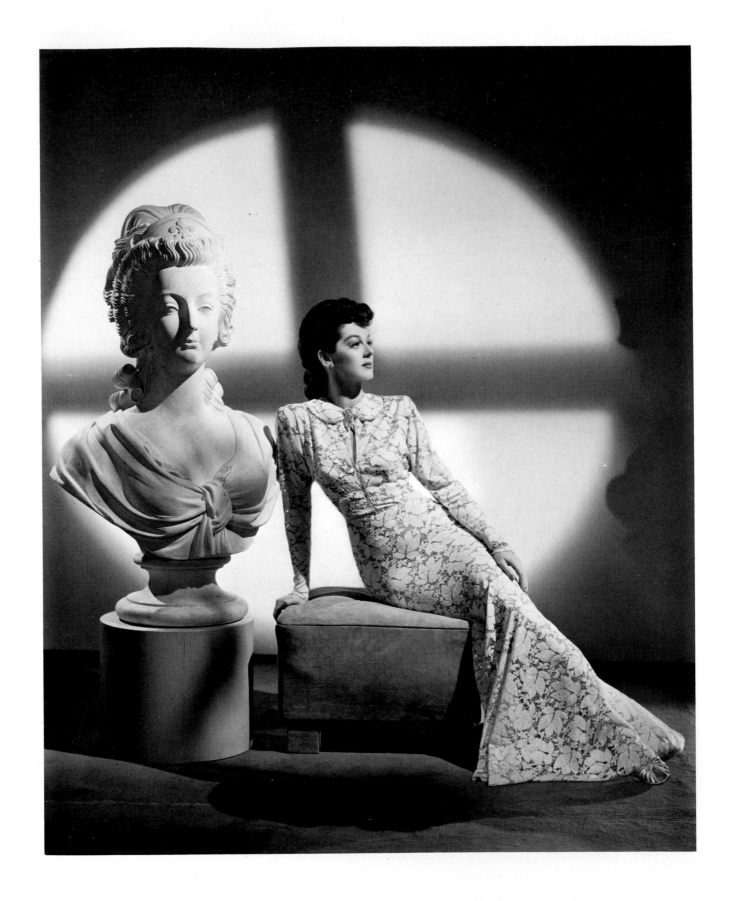

Rosalind Russell, 1941. Photo: Frank Tanner, for MGM. Costume by Kalloch. Publicity shot for *Design for Scandal*.

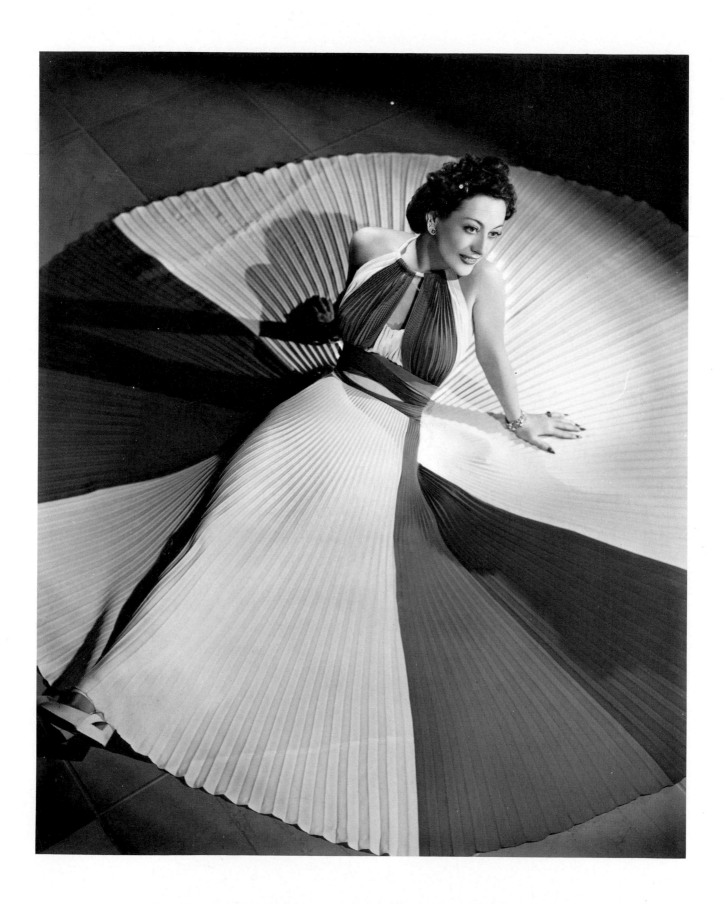

Joan Crawford, 1940. Photo: Laszlo Willinger, for MGM. Costume by Adrian. Publicity shot for *Susan and God*.

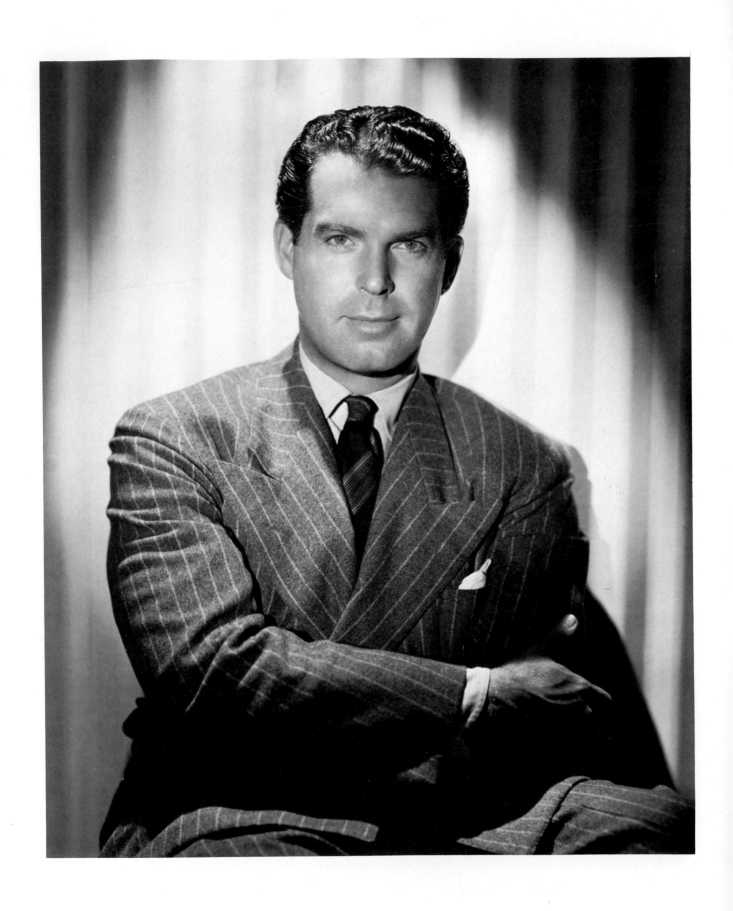

Fred MacMurray, 1940. Photo: William Walling, for Paramount.

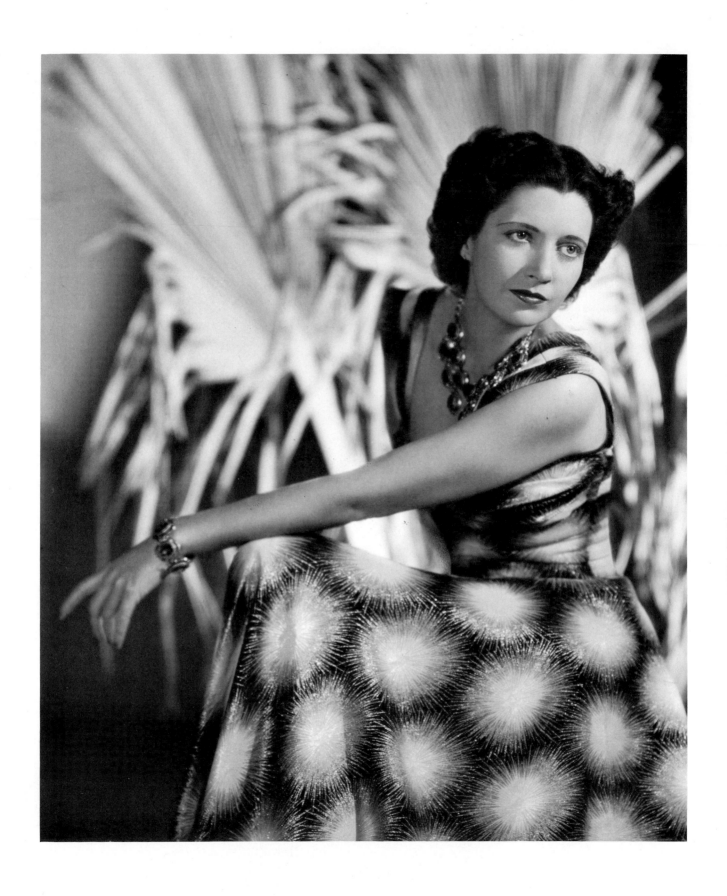

Kay Francis, 1940. Photo: Ray Jones, for Universal.

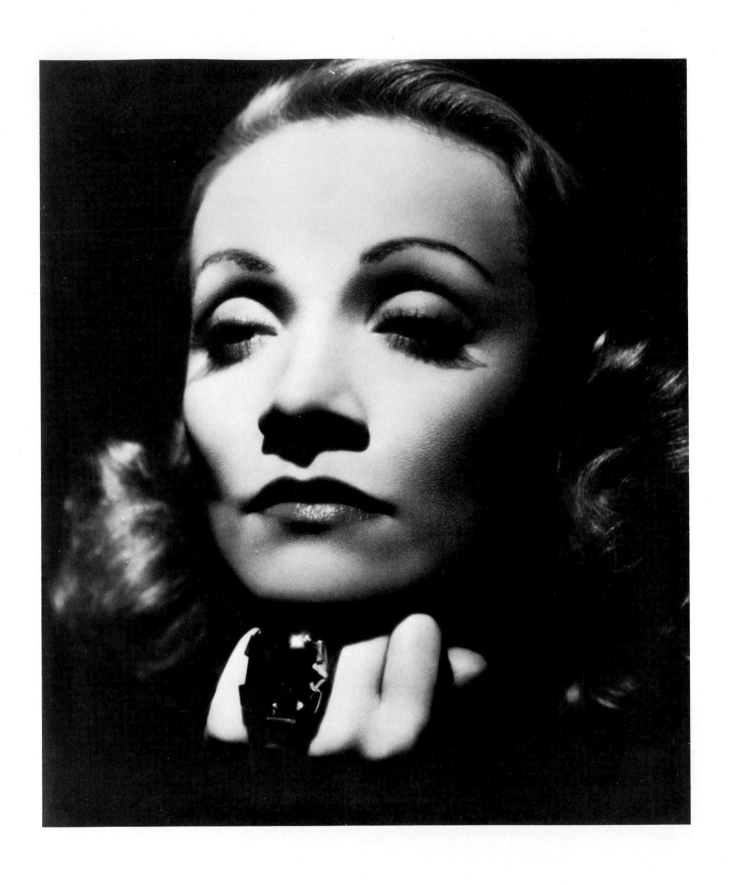

Marlene Dietrich, 1941. Photo: A. L. ("Whitey") Schafer, for Columbia.

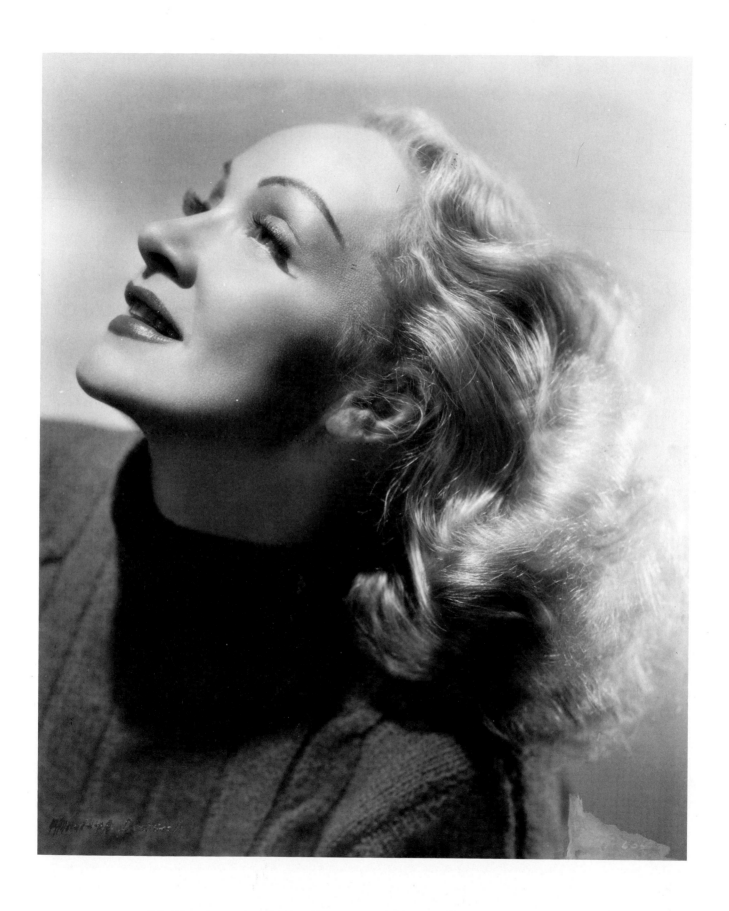

Marlene Dietrich, 1947. Photo: A. L. ("Whitey") Schafer, for Paramount.

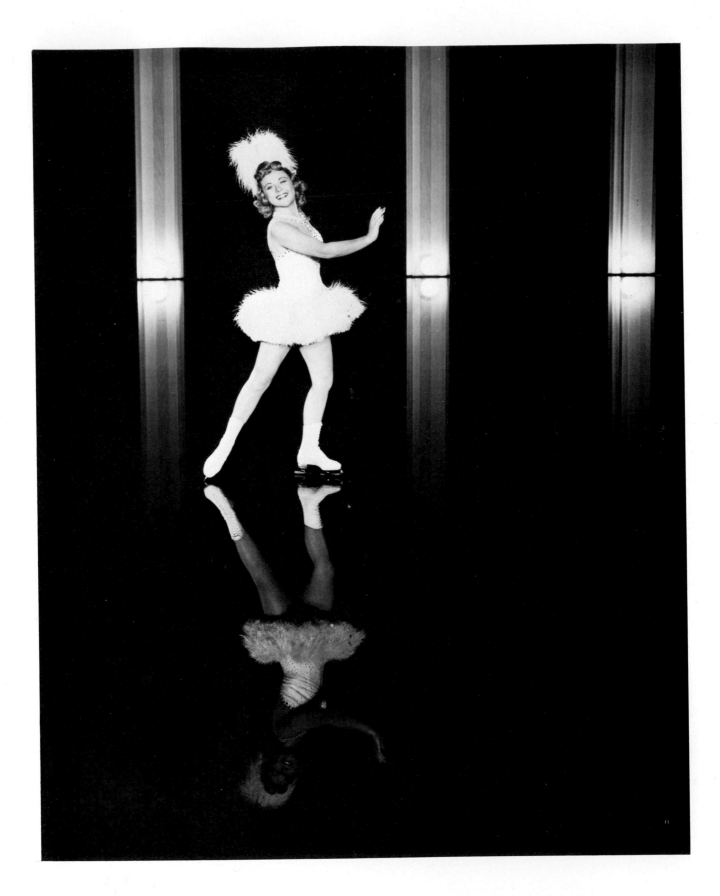

Sonja Henie, 1943. Photo: Frank Powolny, for 20th Century-Fox. Publicity shot for *Wintertime*.

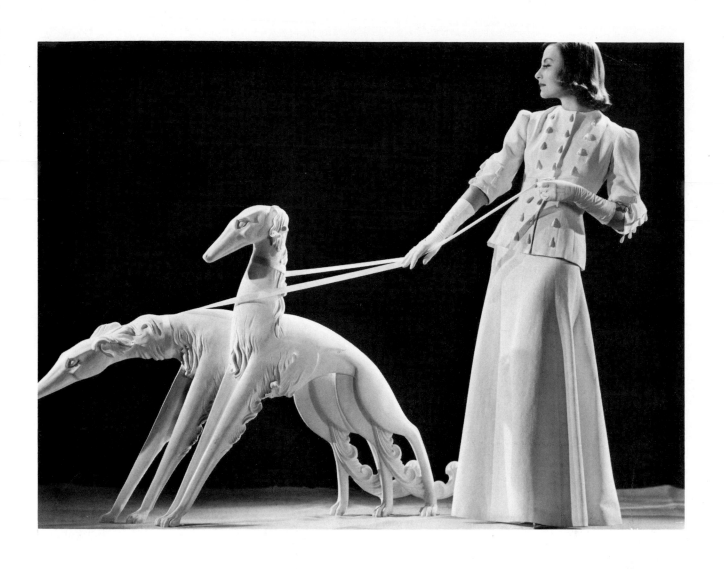

Michele Morgan, 1940. Photo: Ernest A. Bachrach, for RKO Radio.

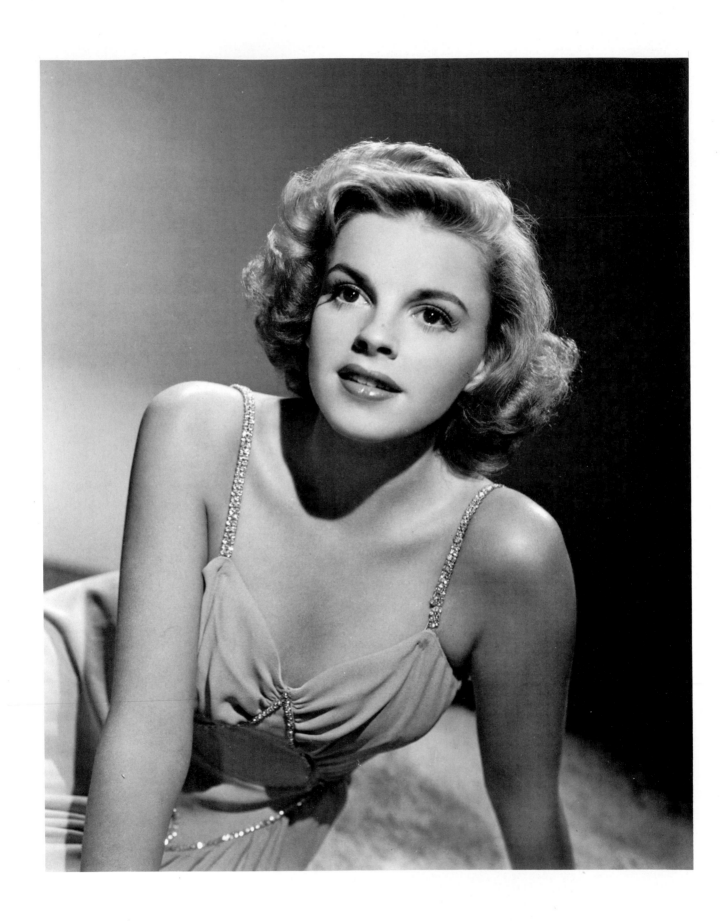

Judy Garland, 1940. Photo: Eric Carpenter, for MGM.

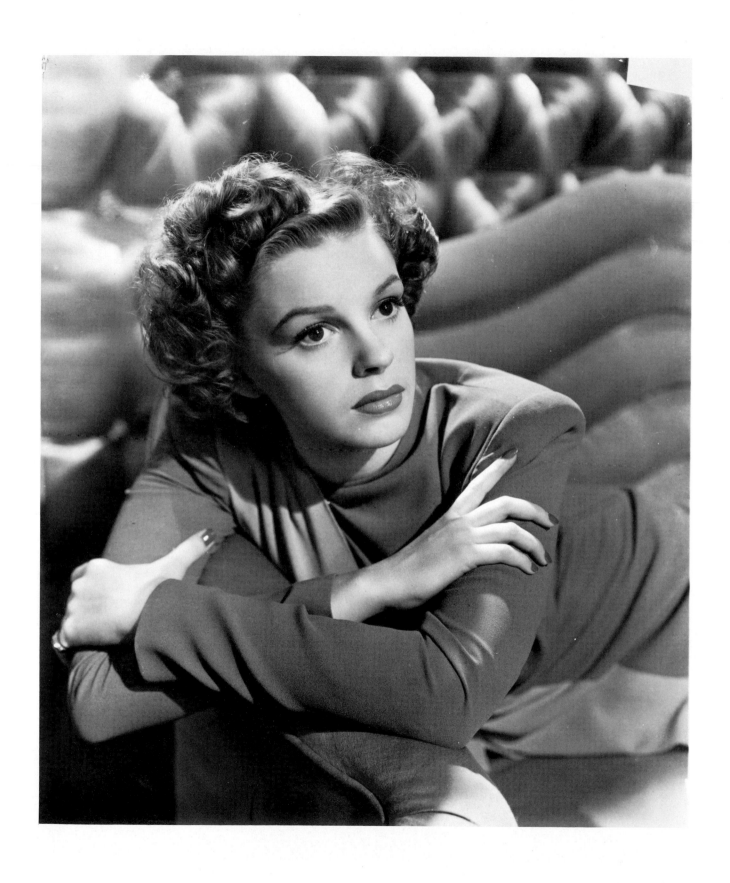

Judy Garland, 1943. Photo: Eric Carpenter, for MGM. Publicity shot
for *Presenting Lily Mars.*

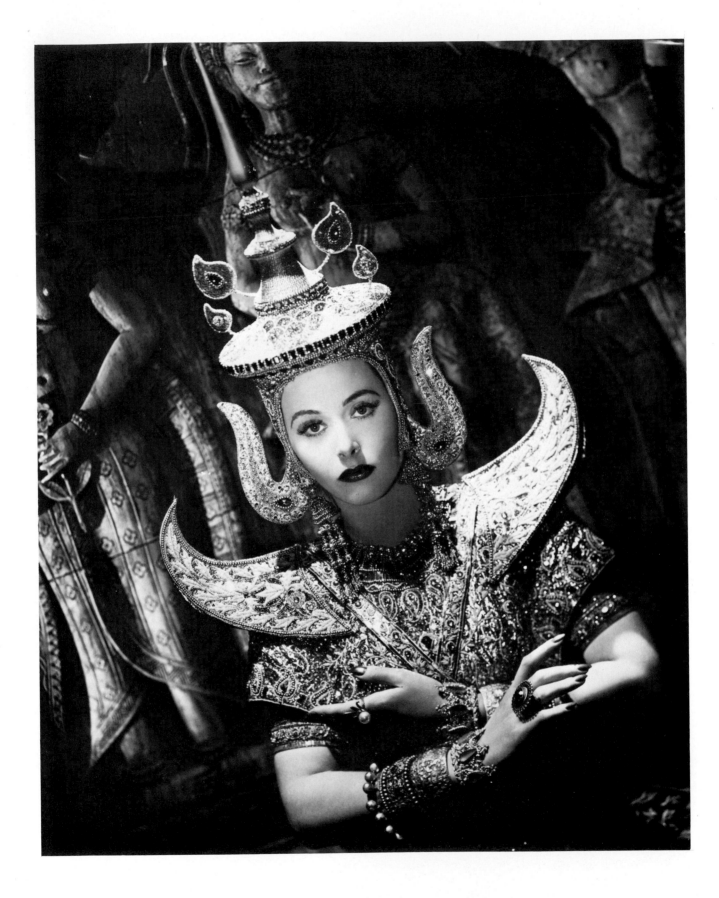

Hedy Lamarr, 1939. Photo: Laszlo Willinger, for MGM. Costume by Adrian. Publicity shot for *Lady of the Tropics*.

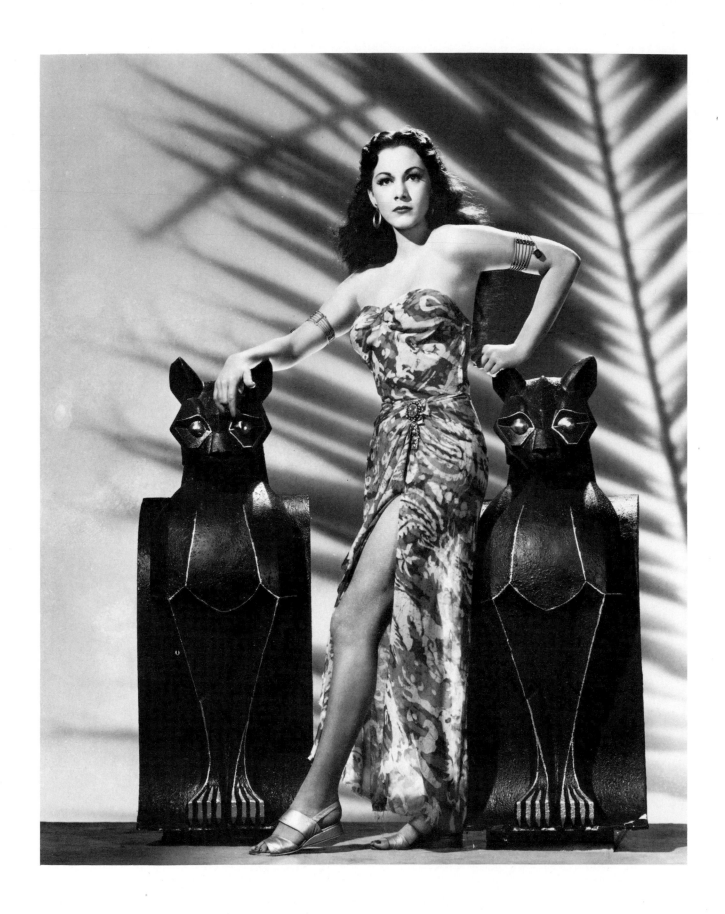

Maria Montez, 1943. Photo: Ray Jones, for Universal. Publicity shot for
White Savage.

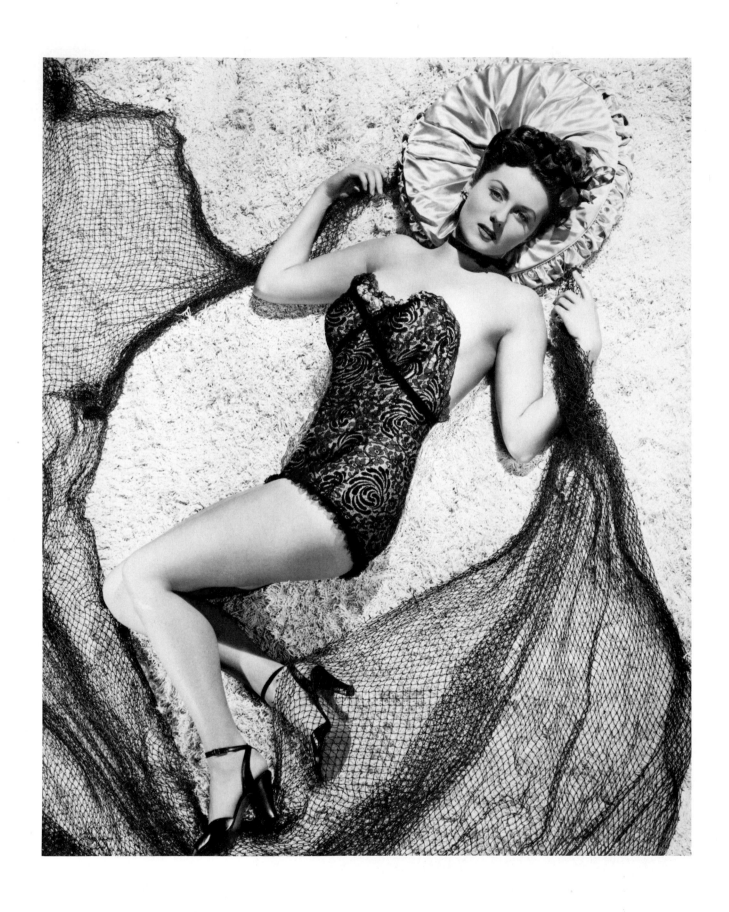

Rhonda Fleming, 1946. Photo: Madison Lacy, for United Artists (Selznick).

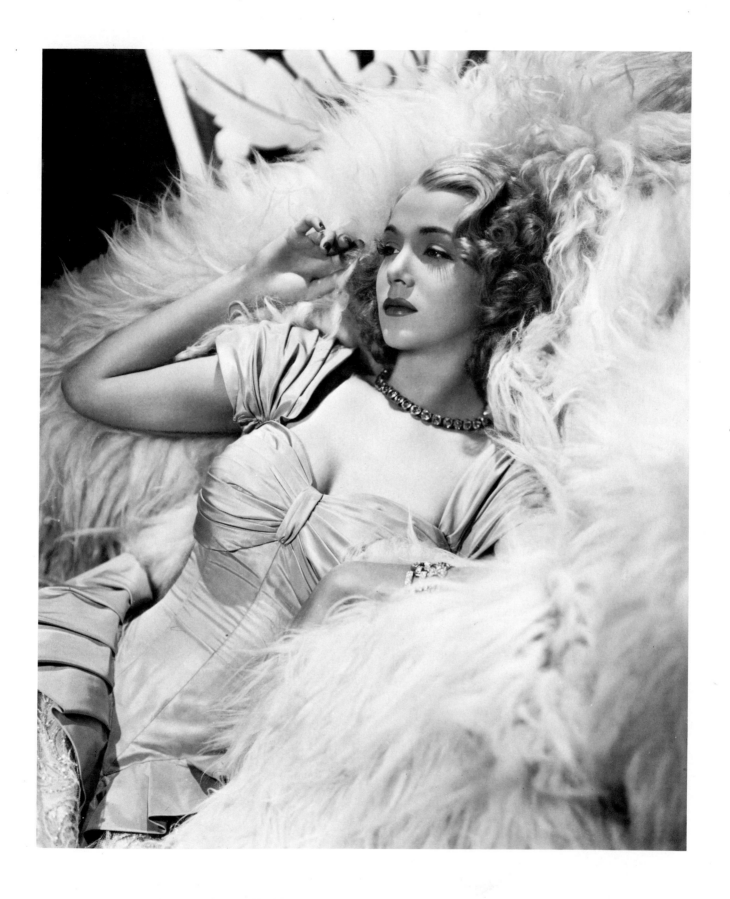

Carole Landis, 1940. Photo: Tom Evans, for United Artists. Publicity
shot for *Turnabout*.

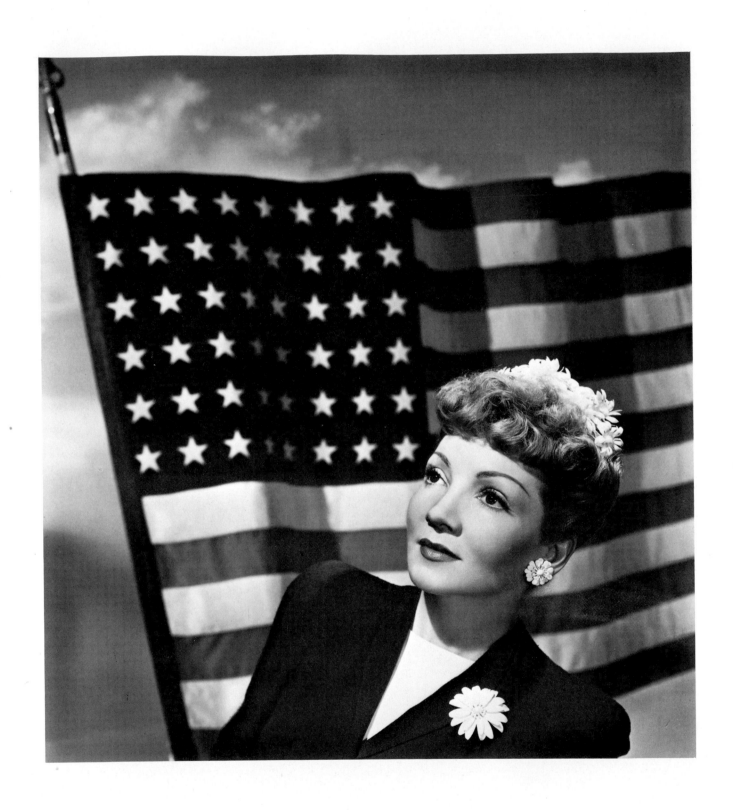

Claudette Colbert, 1943. Photo: A. L. ("Whitey") Schafer, for Paramount. Publicity shot for *So Proudly We Hail*.

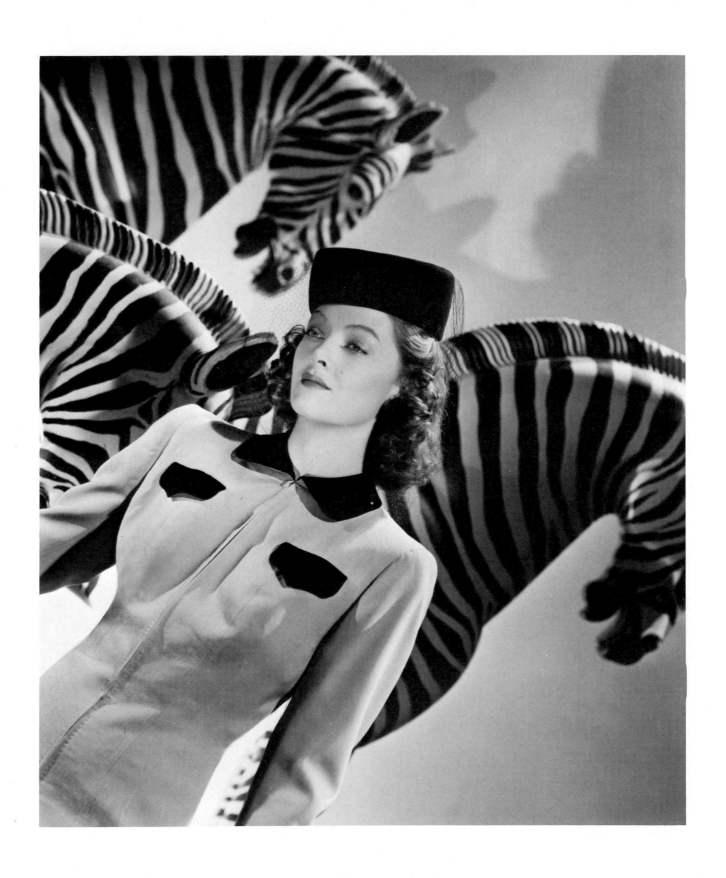

Myrna Loy, 1941. Photo: Laszlo Willinger, for MGM.

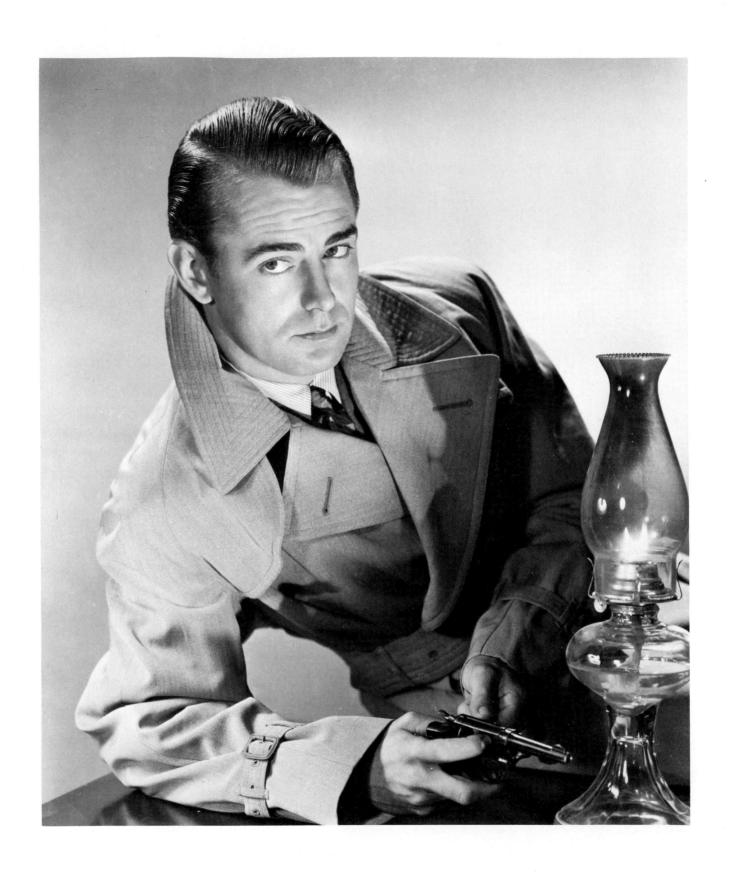

Alan Ladd, 1942. Photo: A. L. ("Whitey") Schafer, for Paramount. Publicity shot for *This Gun for Hire*.

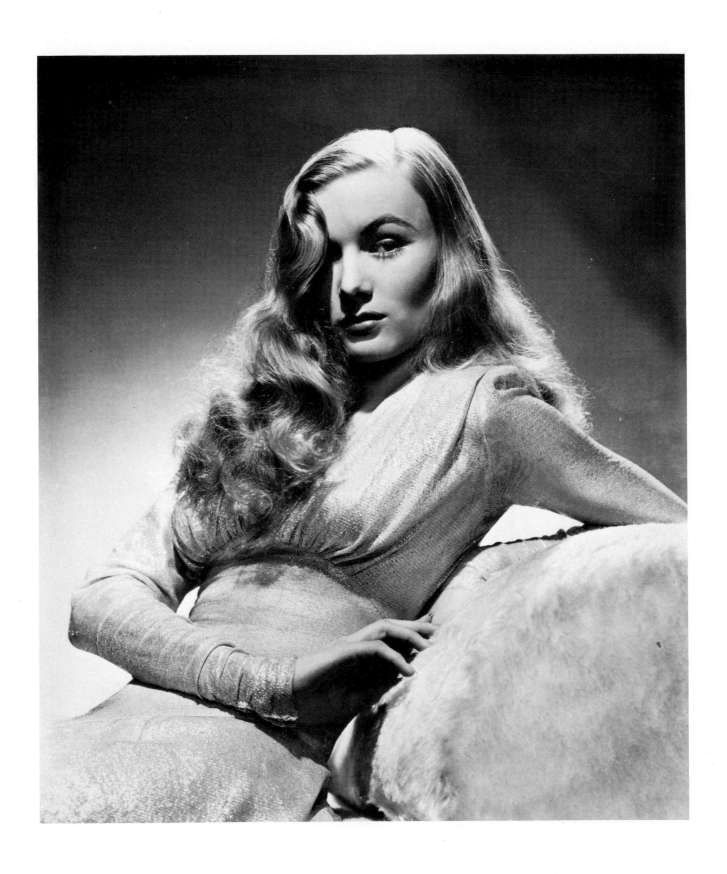

Veronica Lake, 1942. Photo: George Hurrell, for Paramount. Publicity shot for *This Gun for Hire*.

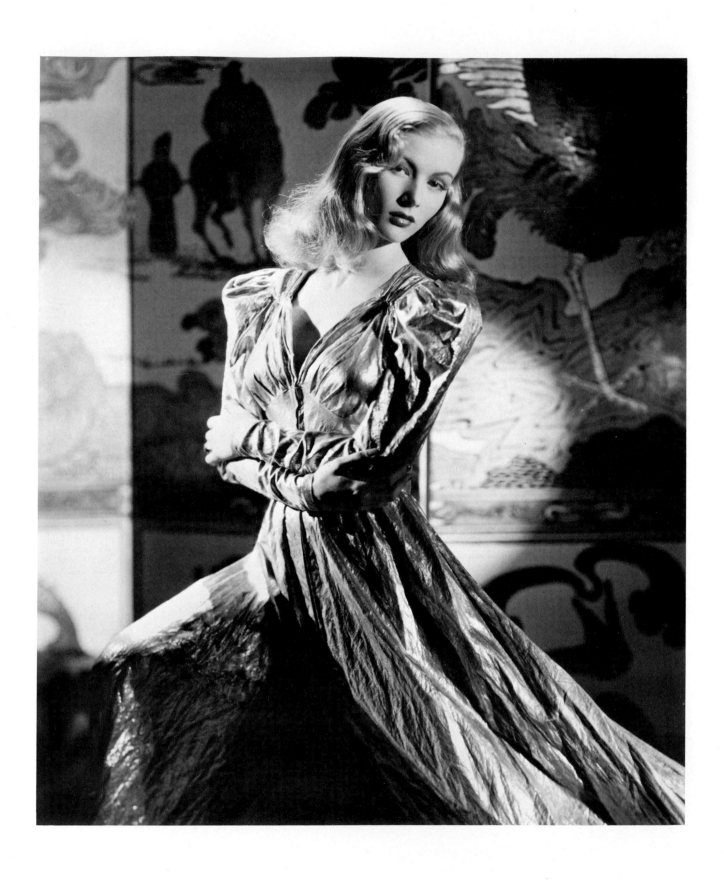

Veronica Lake, 1941. Photo: Eugene Robert Richee (?), for Paramount.

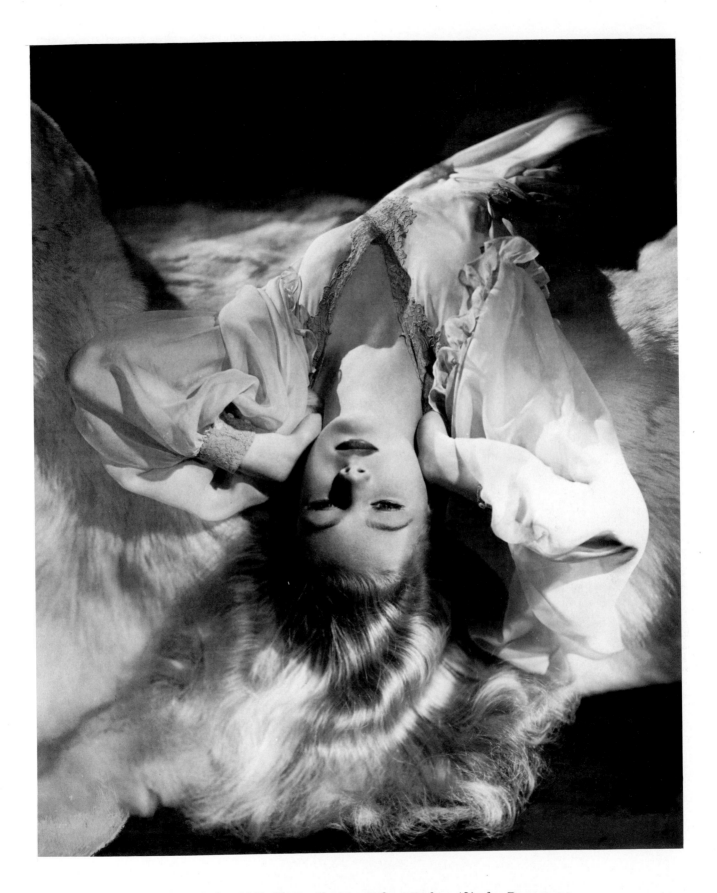

Veronica Lake, 1941. Photo: Eugene Robert Richee (?), for Paramount.

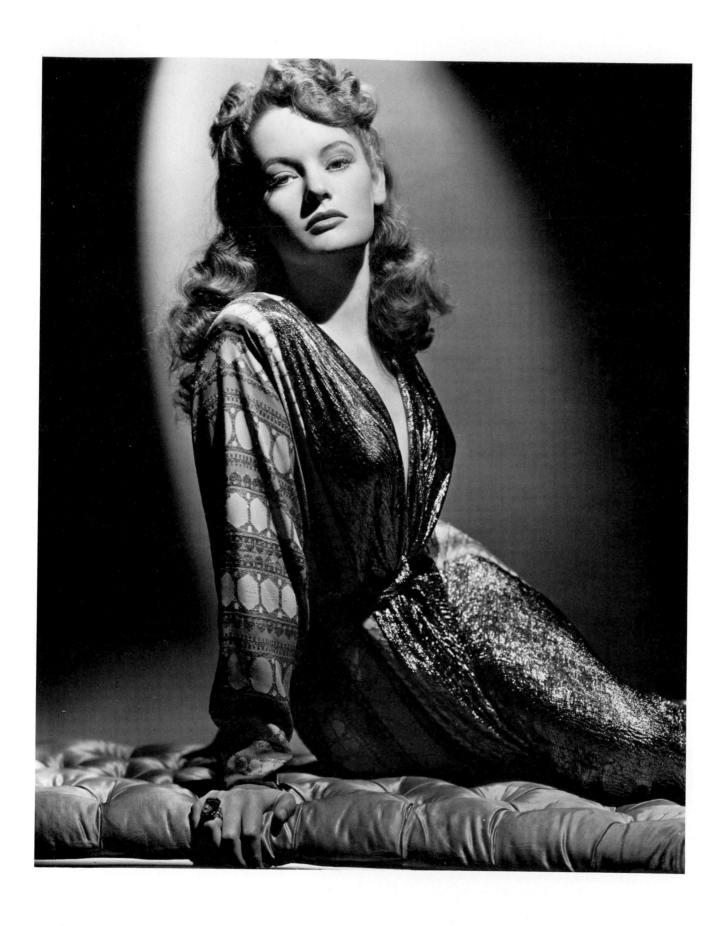

Alexis Smith, 1942. Photo: George Hurrell, for Warner Bros.

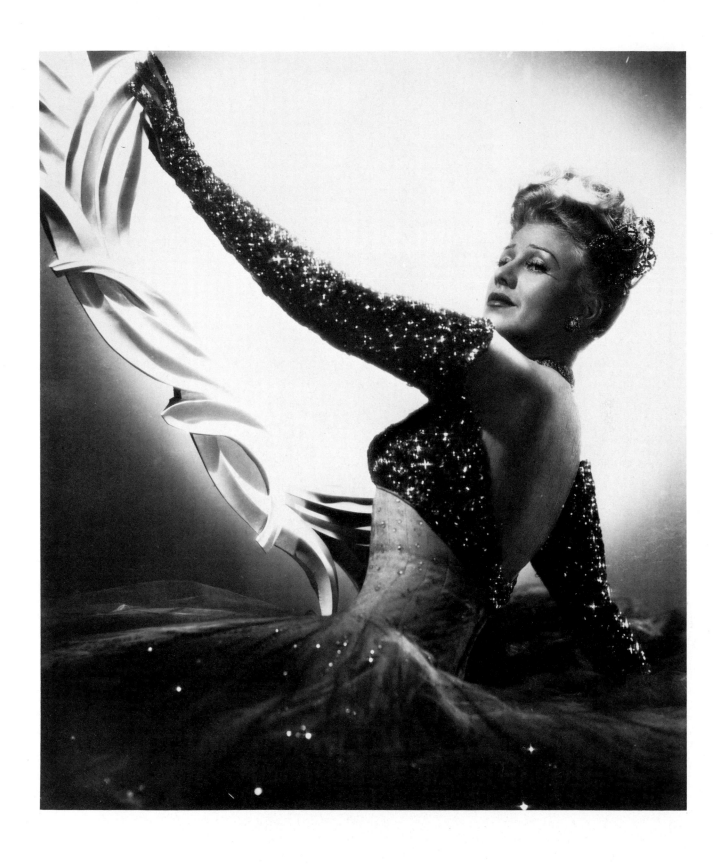

Ginger Rogers, 1943. Photo: A. L. ("Whitey") Schafer, for Paramount.
Costume by Edith Head. Publicity shot for *Lady in the Dark*.

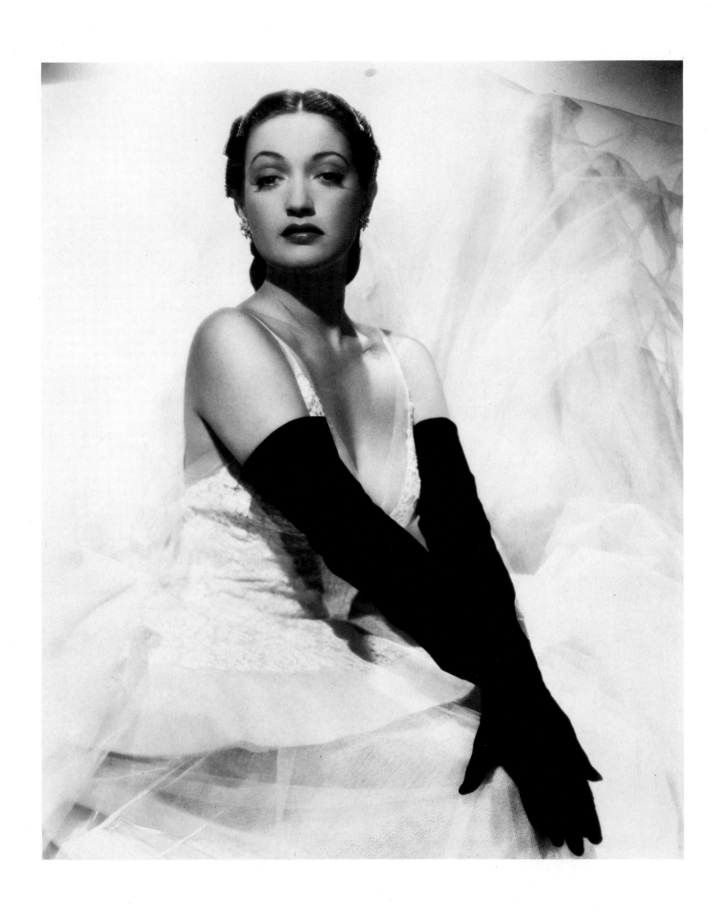

Dorothy Lamour, 1945. Photo: A. L. ("Whitey") Schafer, for Paramount.
Costume by Edith Head. Publicity shot for *Masquerade in Mexico*.

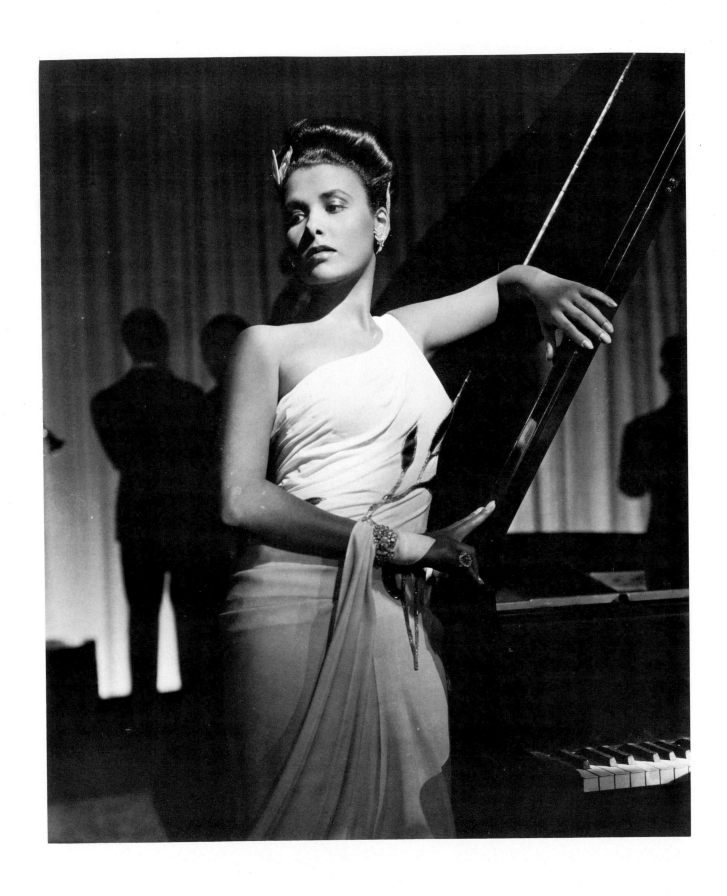

Lena Horne, 1943. Photo: Edward Cronenweth, for MGM. Costume by Irene Sharaff. Still from *Swing Fever*.

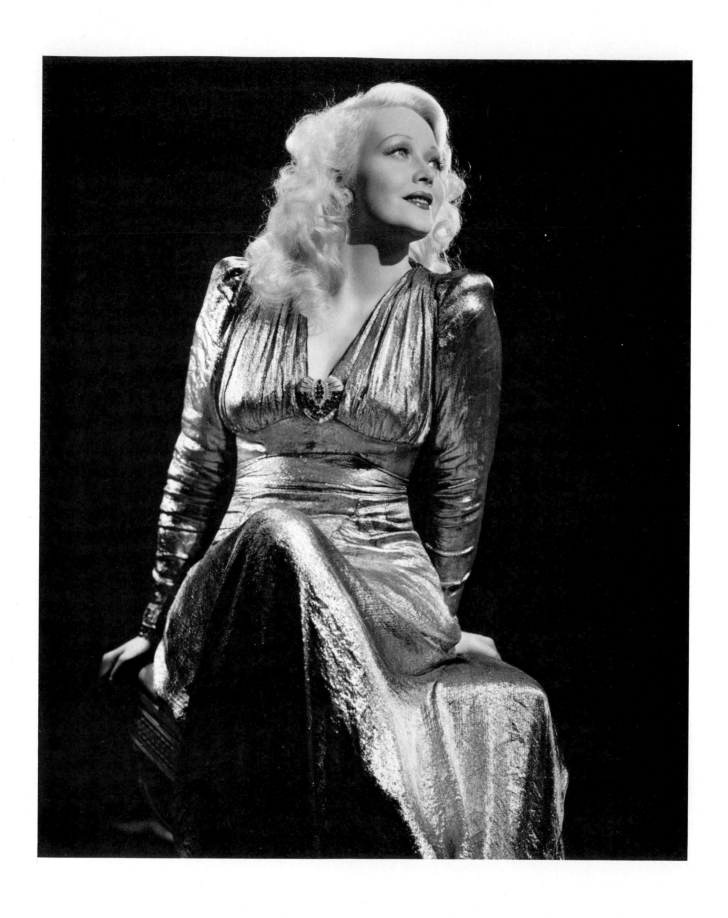

Marion Martin, 1942. Photo: Ernest A. Bachrach, for RKO Radio.

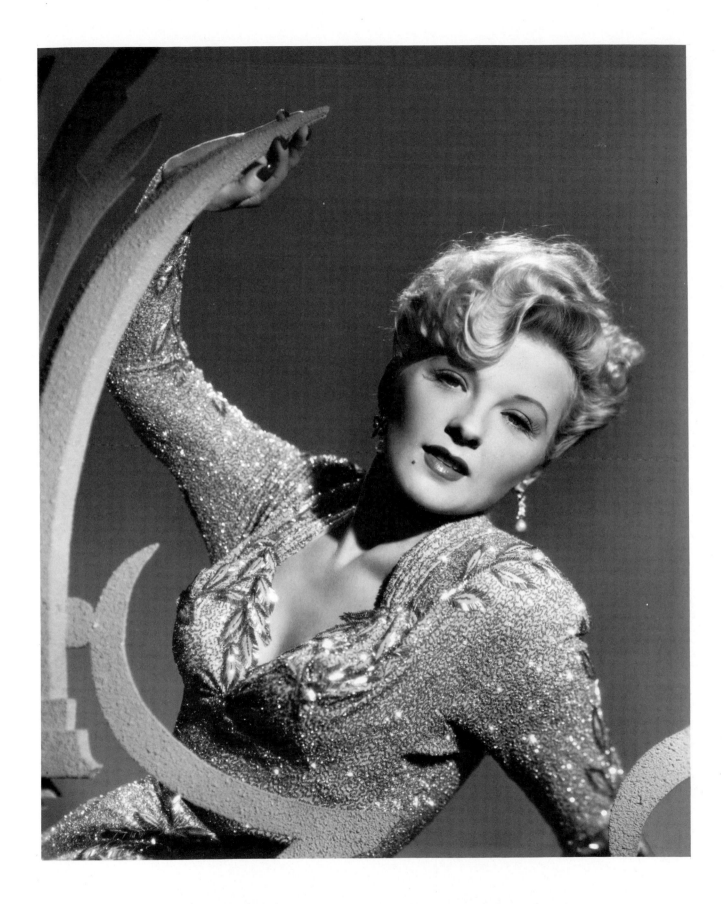

Ilona Massey, 1942. Photo: Ray Jones, for Universal. Publicity shot for
Invisible Agent.

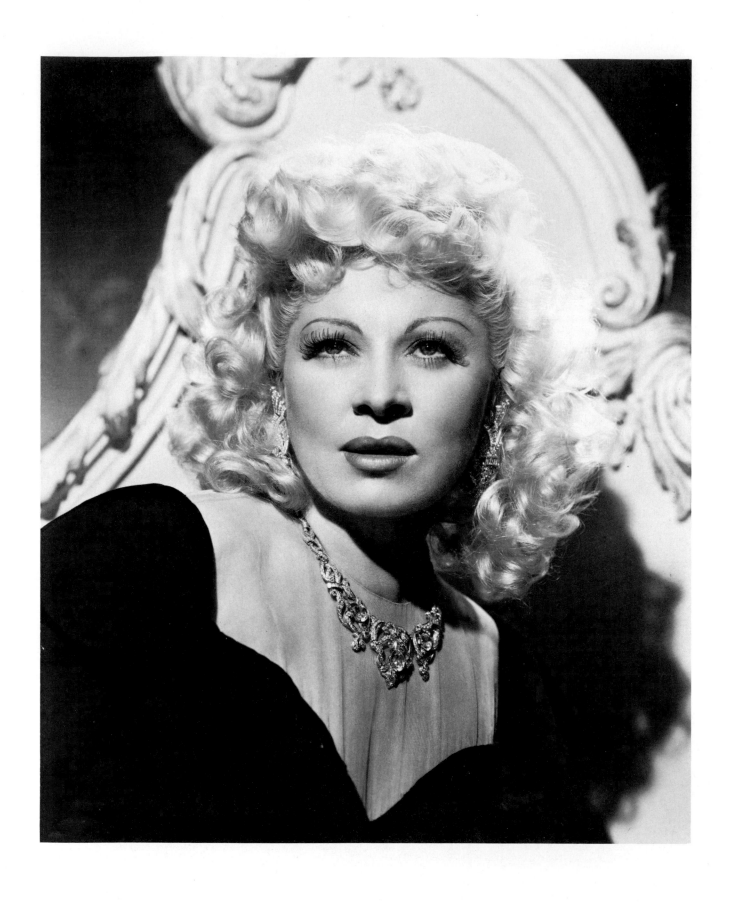

Mae West, 1943. Photo: George Hurrell, for Columbia. Costume by
Walter Plunkett. Publicity shot for *The Heat's On*.

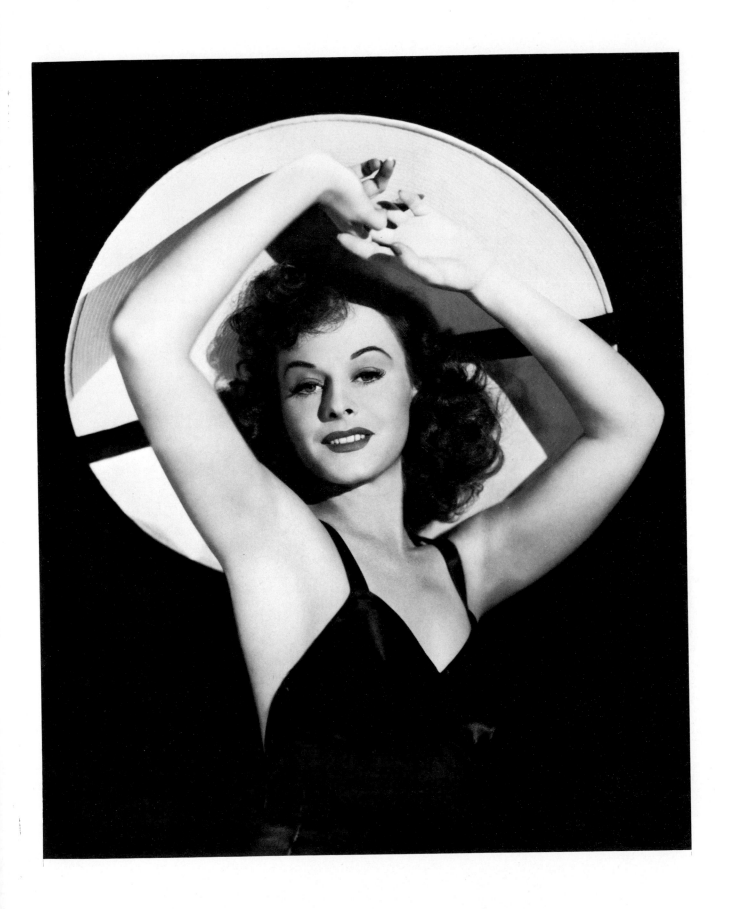

Paulette Goddard, 1940. Photo: William Walling, for Paramount.

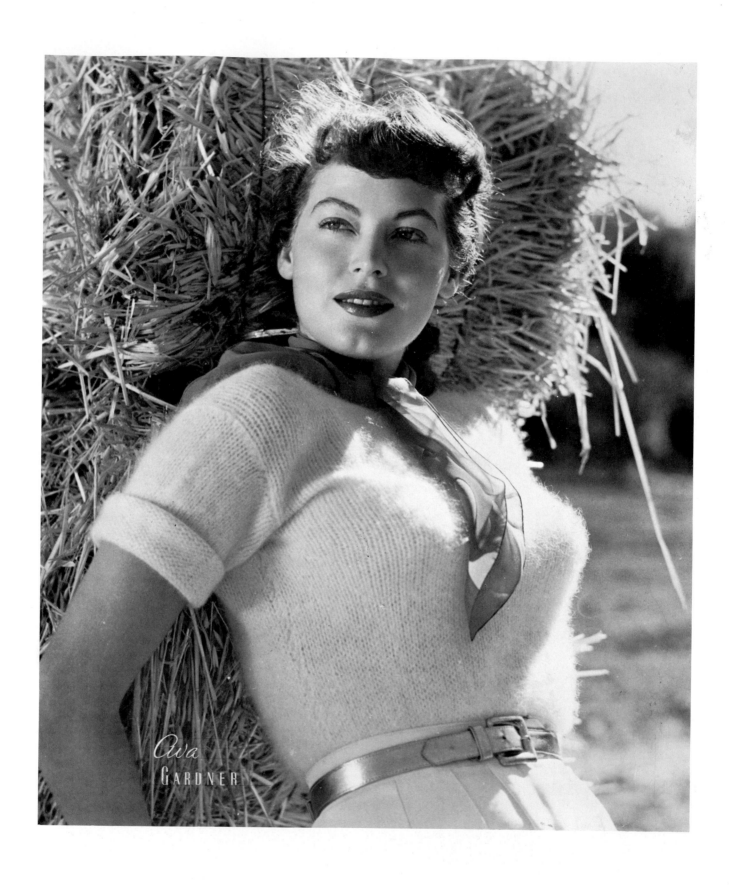

Ava Gardner, 1947. Photo: Eric Carpenter, for MGM.

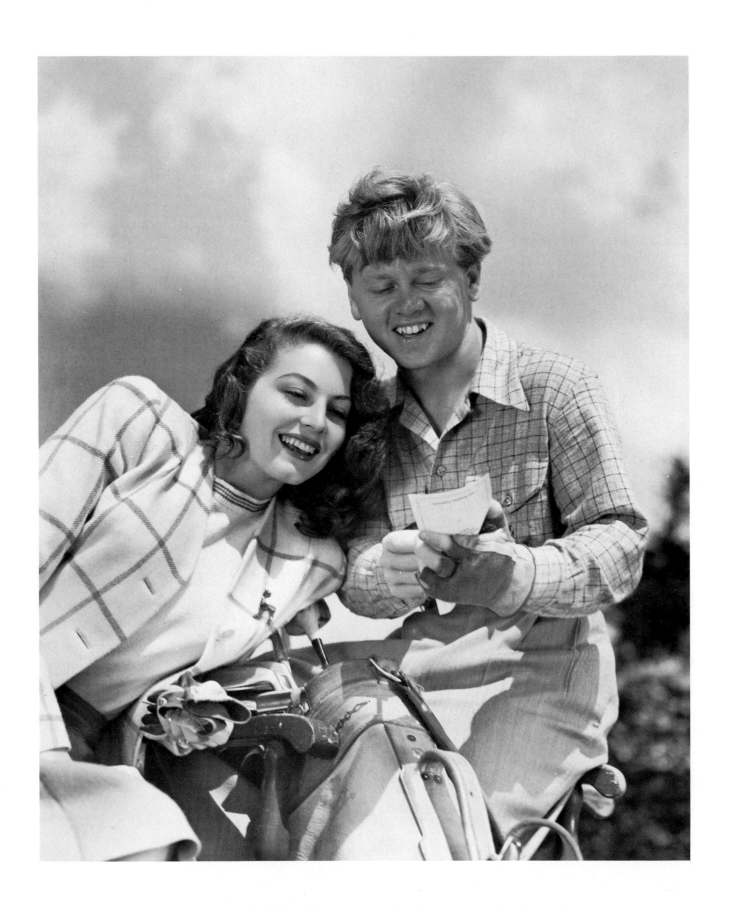

Ava Gardner and Mickey Rooney, 1942. Photo: Eric Carpenter, for MGM.

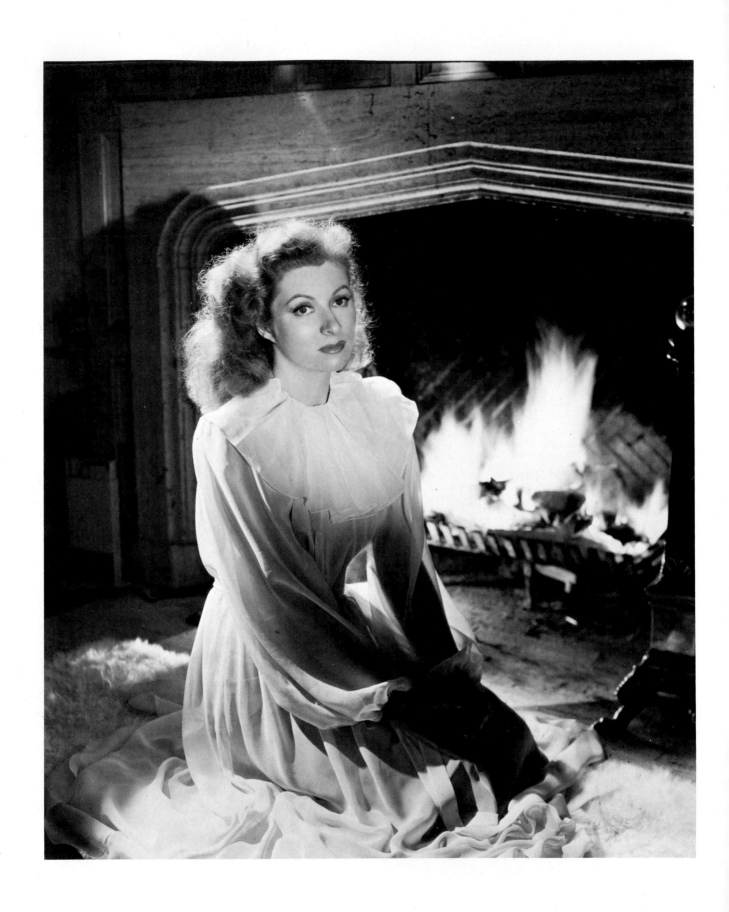

Greer Garson, 1943. Photo: Laszlo Willinger, for MGM.

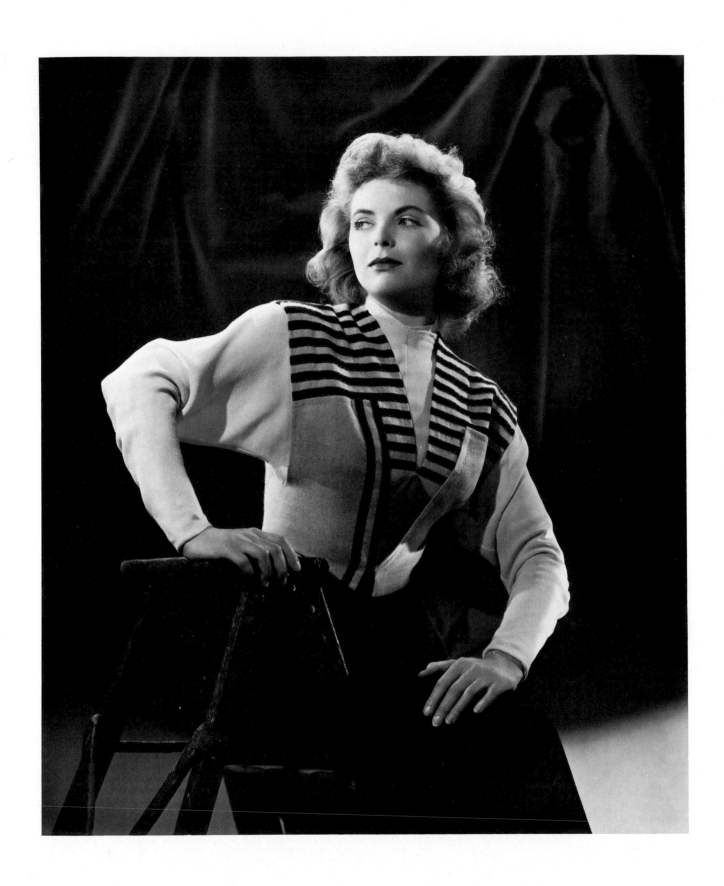

Dorothy McGuire, 1945. Photo: Ernest A. Bachrach, for RKO Radio.

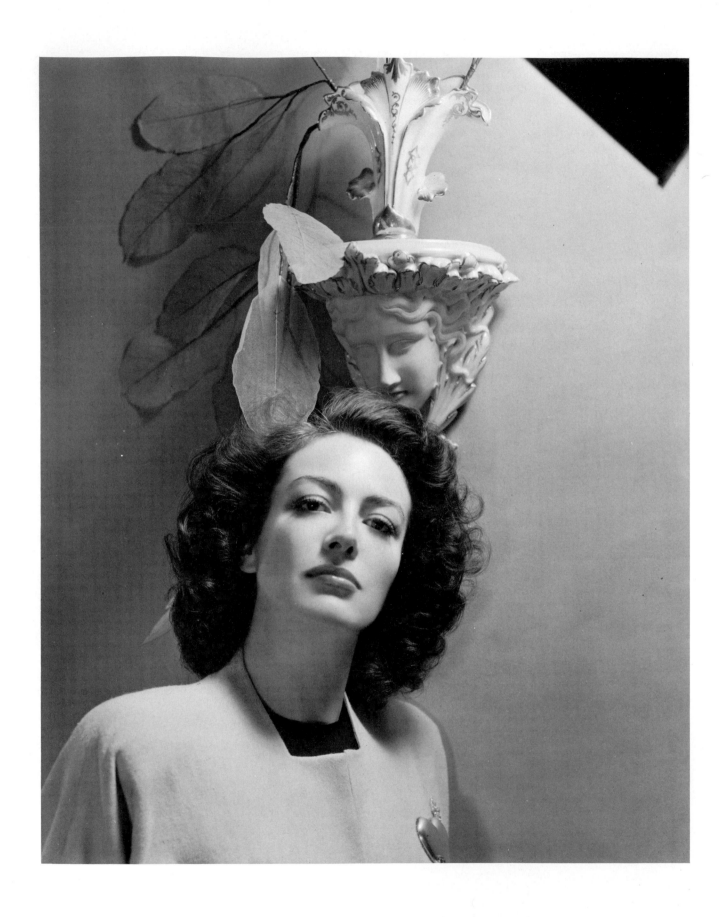

Joan Crawford, 1942. Photo: Laszlo Willinger, for MGM.

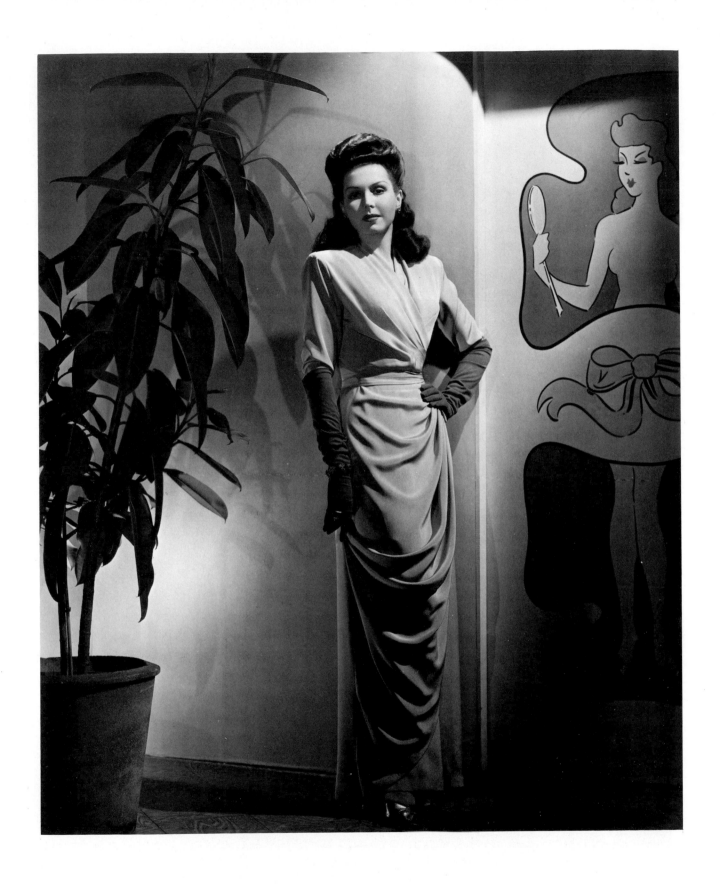

Ann Miller, 1944. Photo: George Hurrell, for Columbia. Costume by
Nancy's Hollywood.

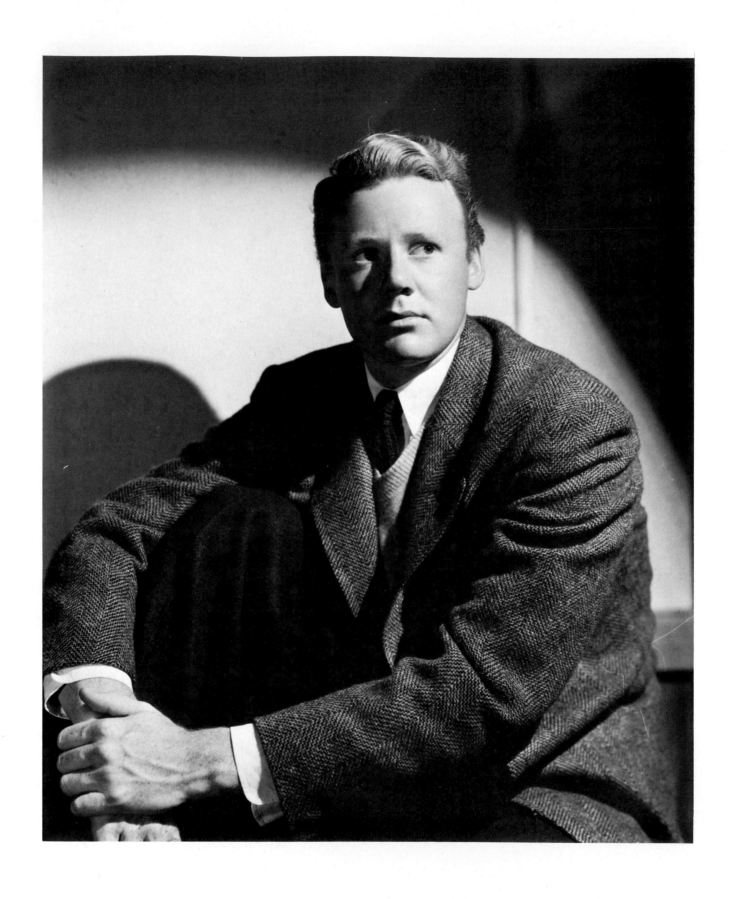

Van Johnson, 1942. Photo: Eric Carpenter, for MGM.

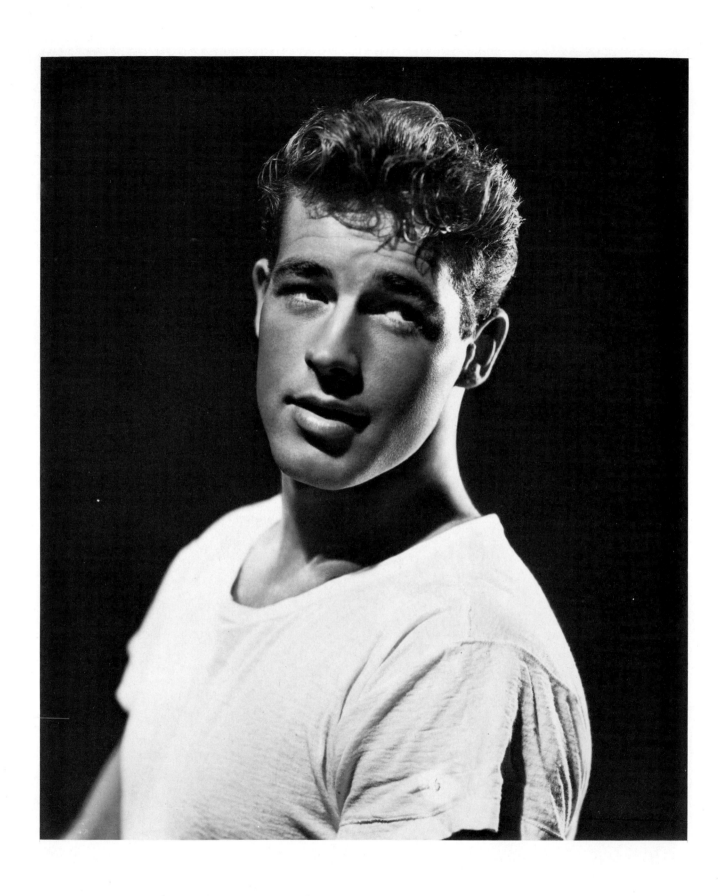

Guy Madison, 1945. Photo: John Miehle, for United Artists (Selznick).

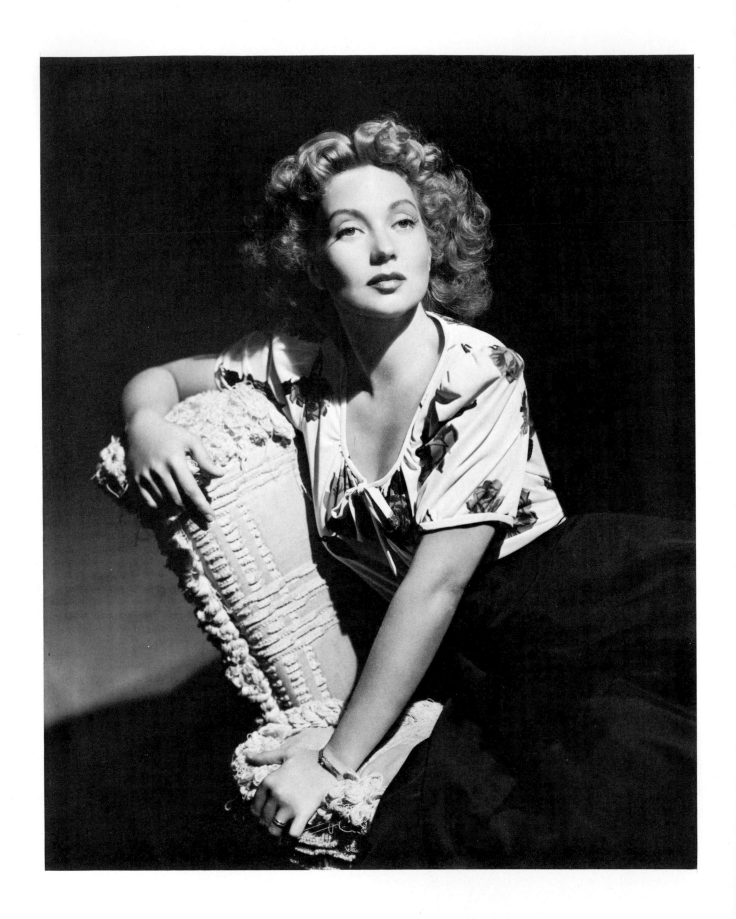

Ann Sothern, 1942. Photo: Laszlo Willinger, for MGM.

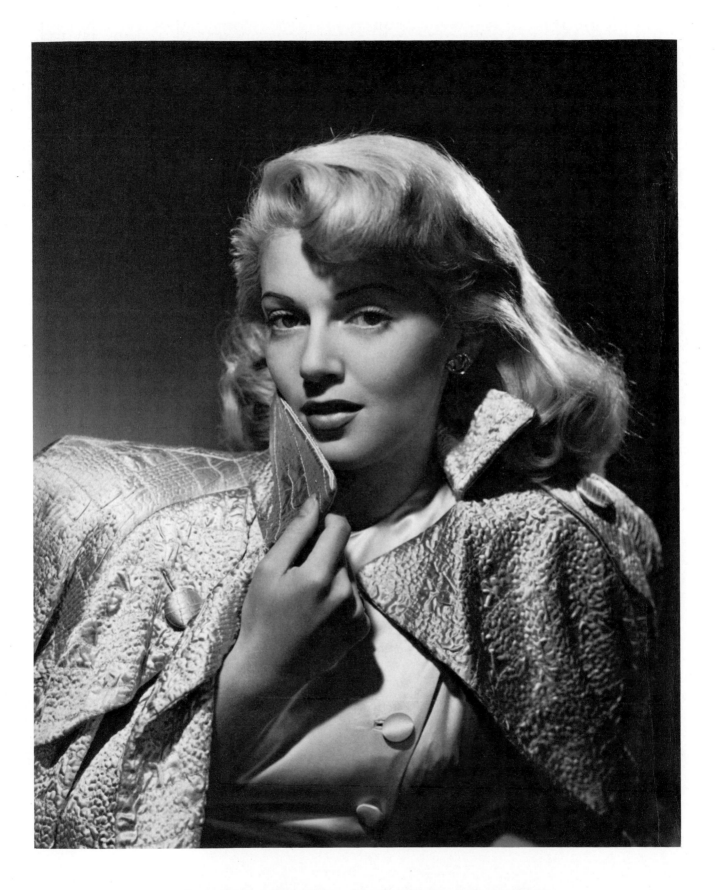

Lana Turner, 1944. Photo: Clarence Sinclair Bull, for MGM.

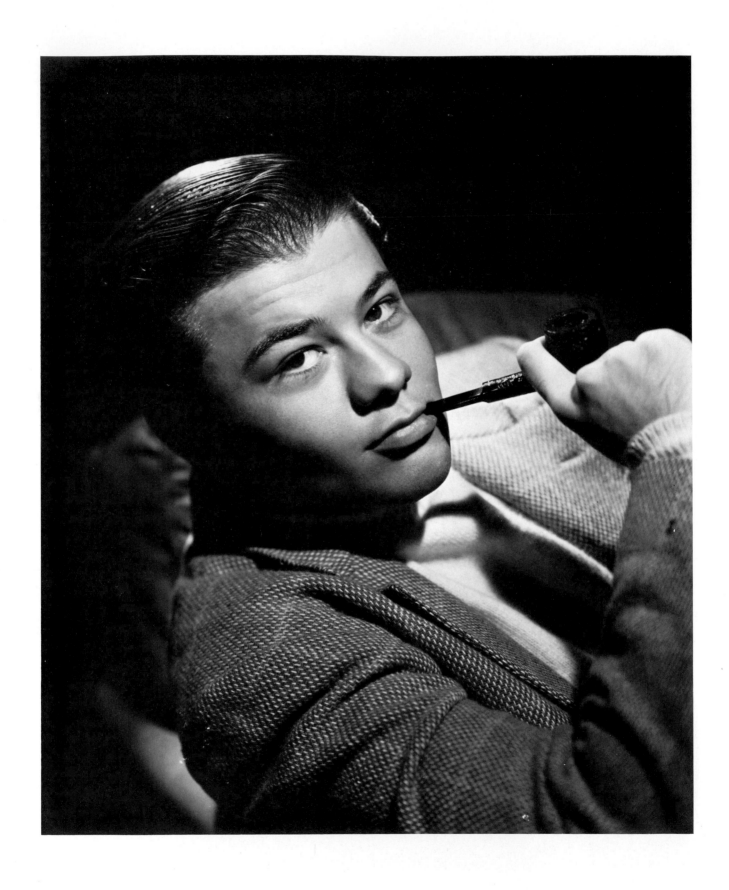

Turhan Bey, 1943. Photo: Eric Carpenter, for MGM.

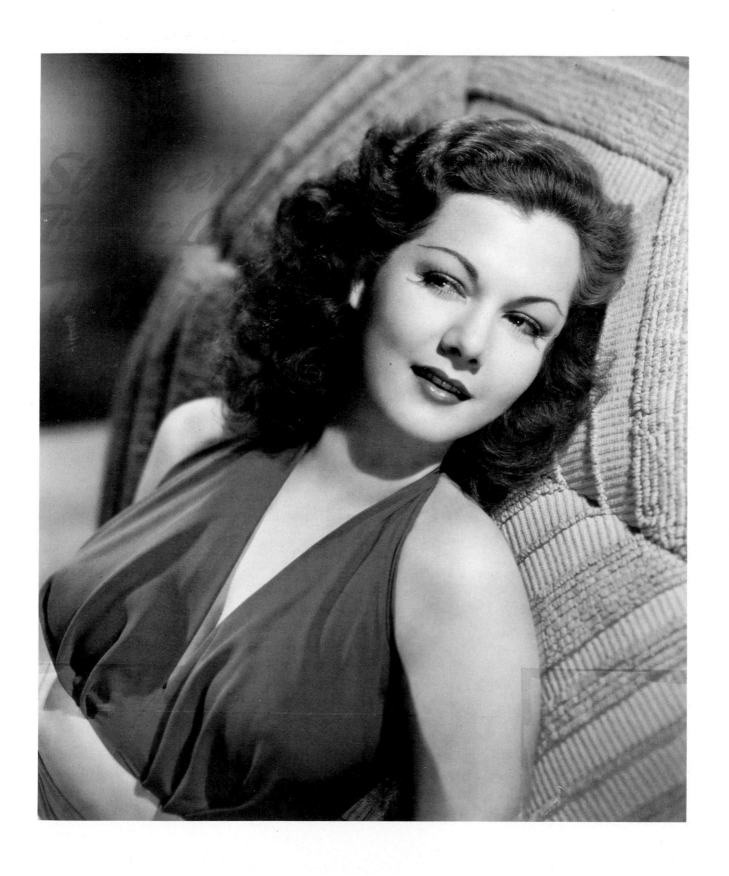

Maria Montez, 1942. Photo: Ray Jones, for Universal.

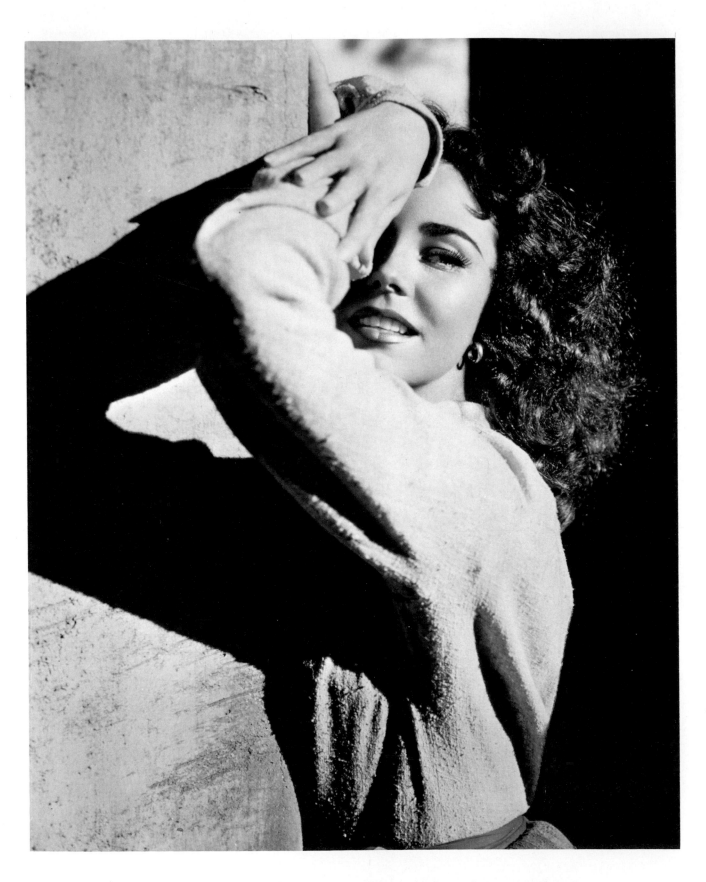

Jennifer Jones, 1946. Photo: Al St. Hilaire, for United Artists (Selznick).
Costume by Walter Plunkett. Publicity shot for *Duel in the Sun*.

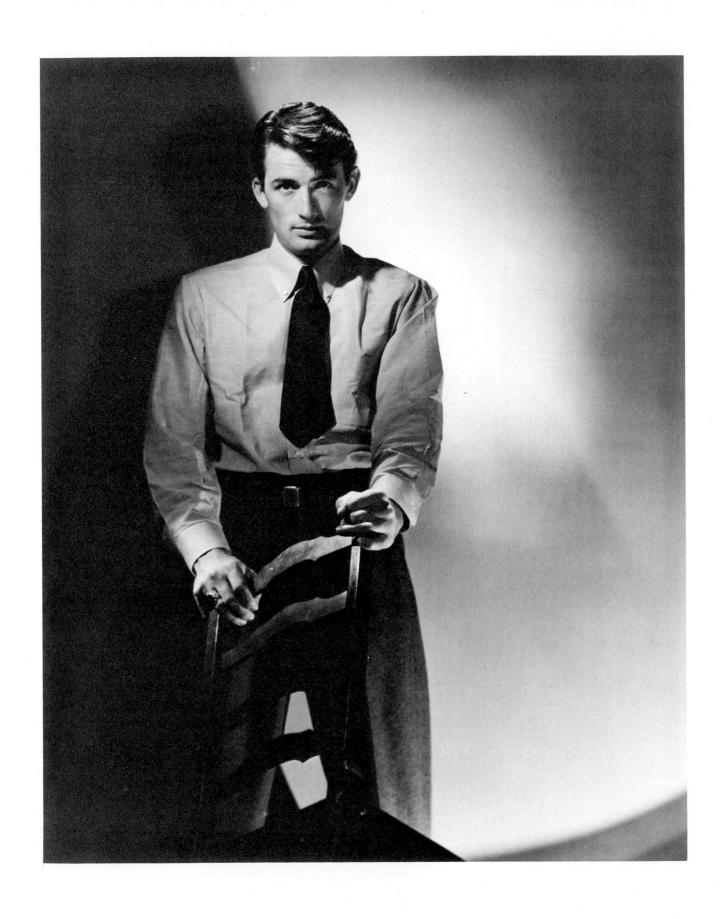

Gregory Peck, 1943. Photo: Ernest A. Bachrach.

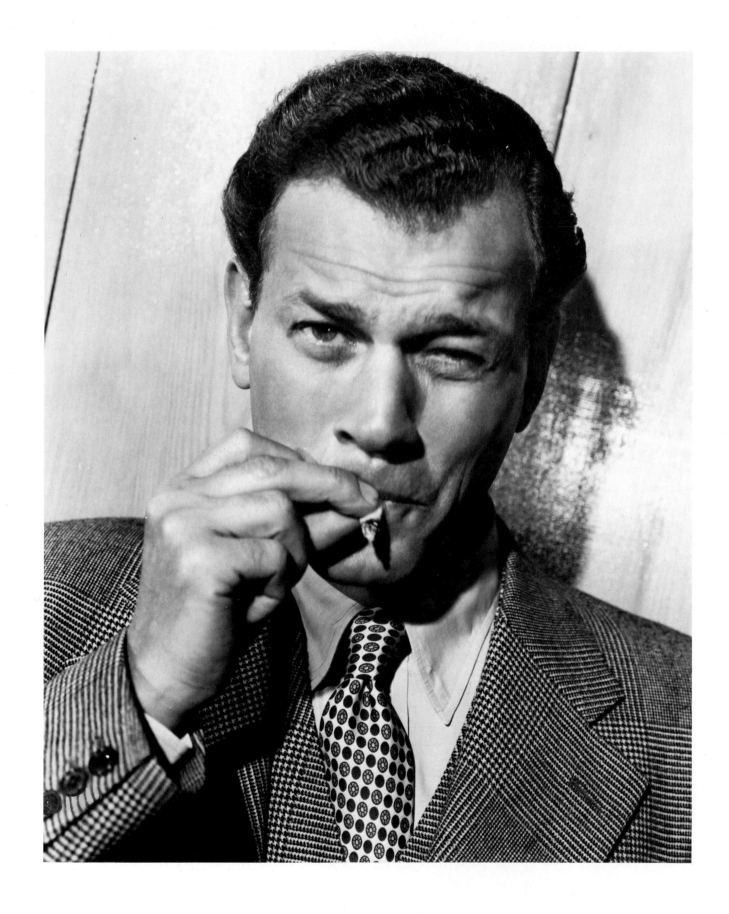

Joseph Cotten, 1944. Photo: Al St. Hilaire, for United Artists.

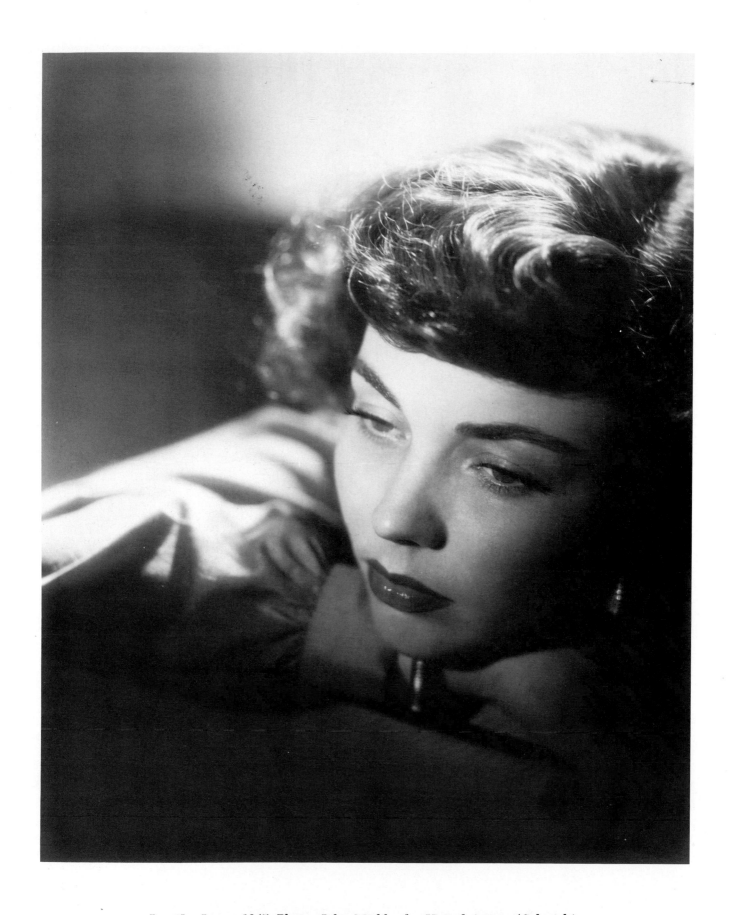

Jennifer Jones, 1945. Photo: John Miehle, for United Artists (Selznick).

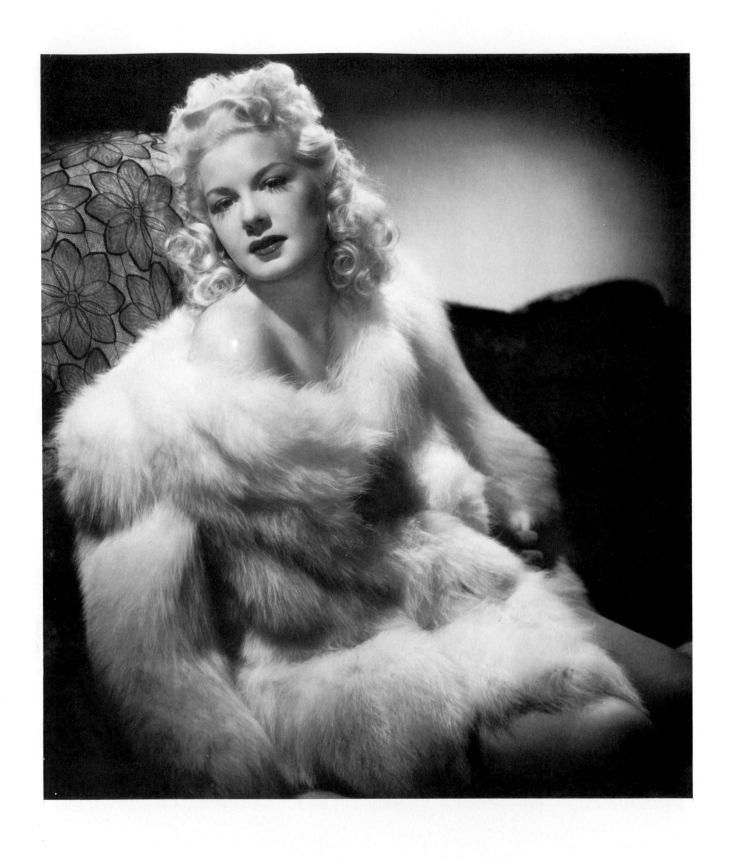

Betty Hutton, 1942. Photo: A. L. ("Whitey") Schafer, for Paramount.

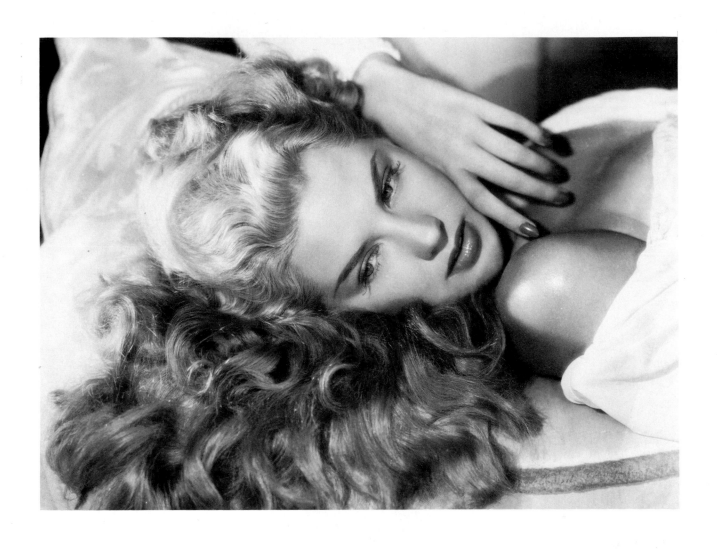

Marie McDonald, 1943. Photo: A. L. ("Whitey") Schafer, for Paramount.

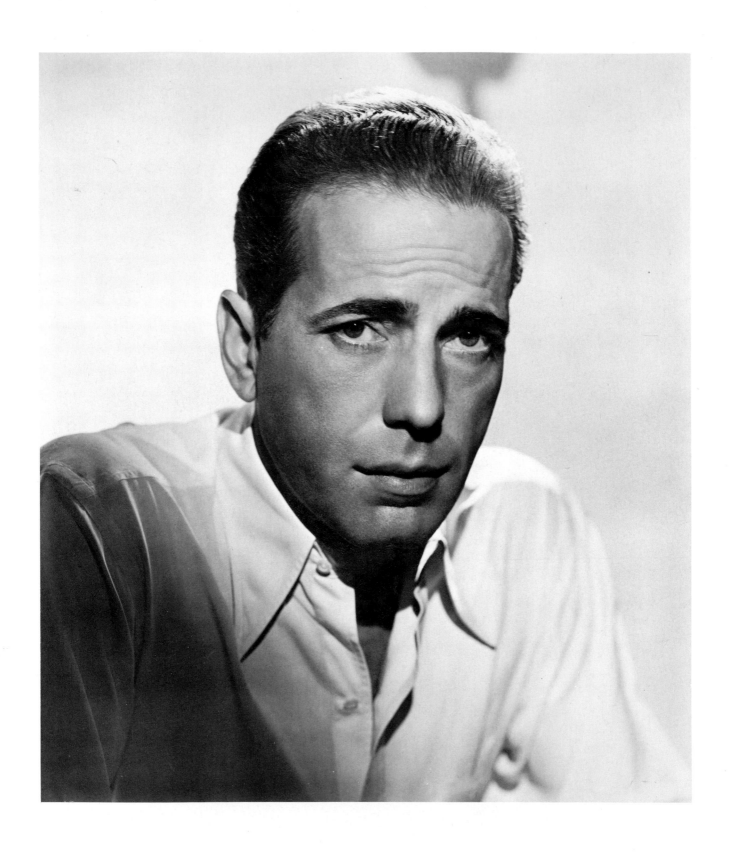

Humphrey Bogart, 1941. Photo: Scotty Welbourne, for Warner Bros.

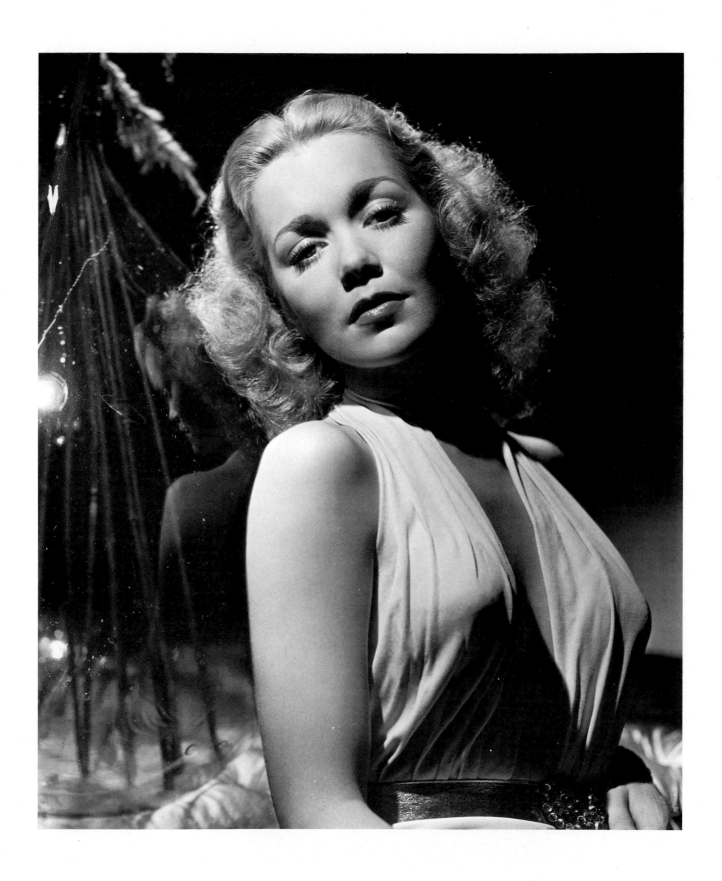

Jane Wyman, 1942. Photo: Scotty Welbourne, for Warner Bros.

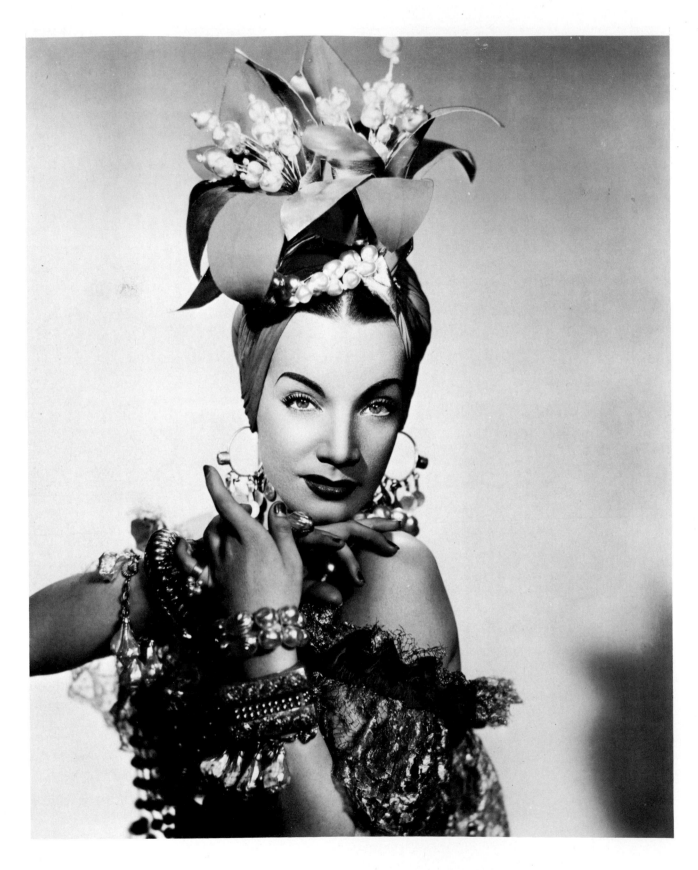

Carmen Miranda, 1940. Photo: Frank Powolny, for 20th Century-Fox.
Costume by Travis Banton.

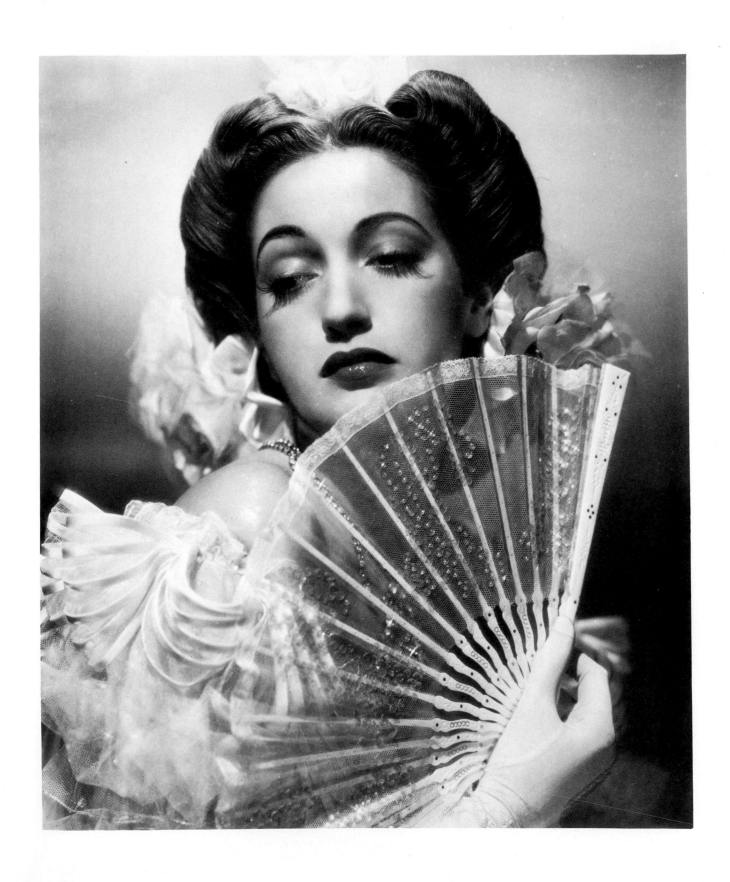

Dorothy Lamour, 1943. Photo: A. L. ("Whitey") Schafer, for Paramount.
Costume by Edith Head. Publicity shot for *Dixie*.

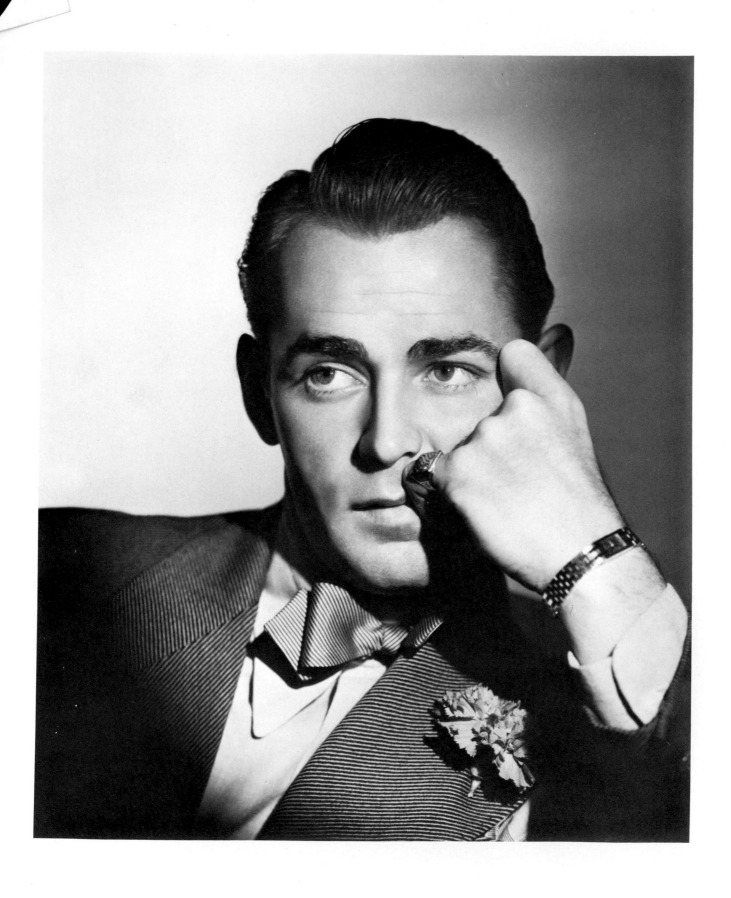

Alan Ladd, 1942. Photo: Eugene Robert Richee or George Hurrell, for Paramount.

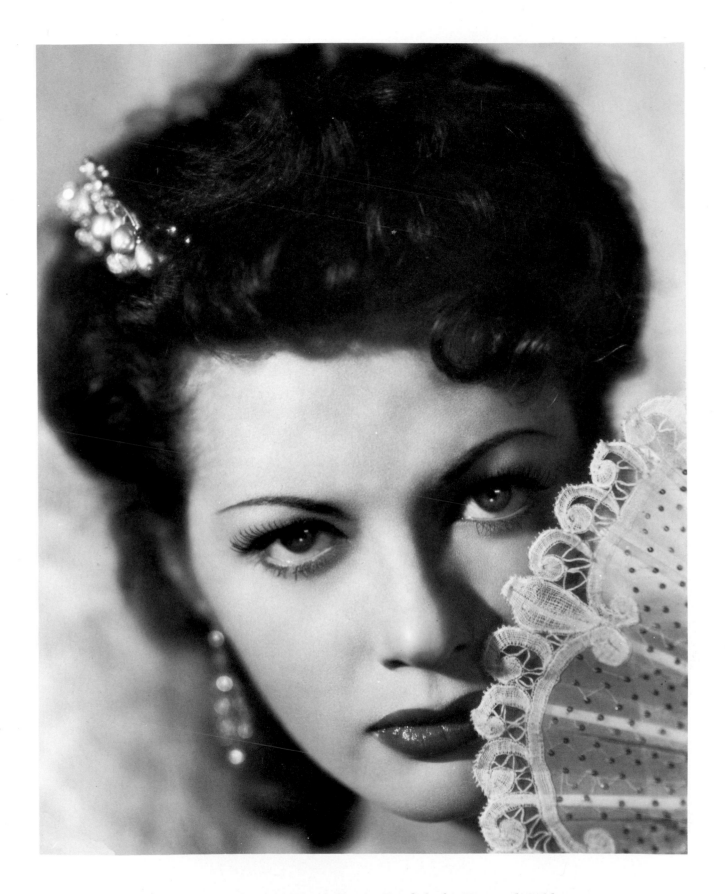

Yvonne De Carlo, 1944. Photo: Roman Freulich, for Universal. Publicity
shot for *Salome, Where She Danced.*

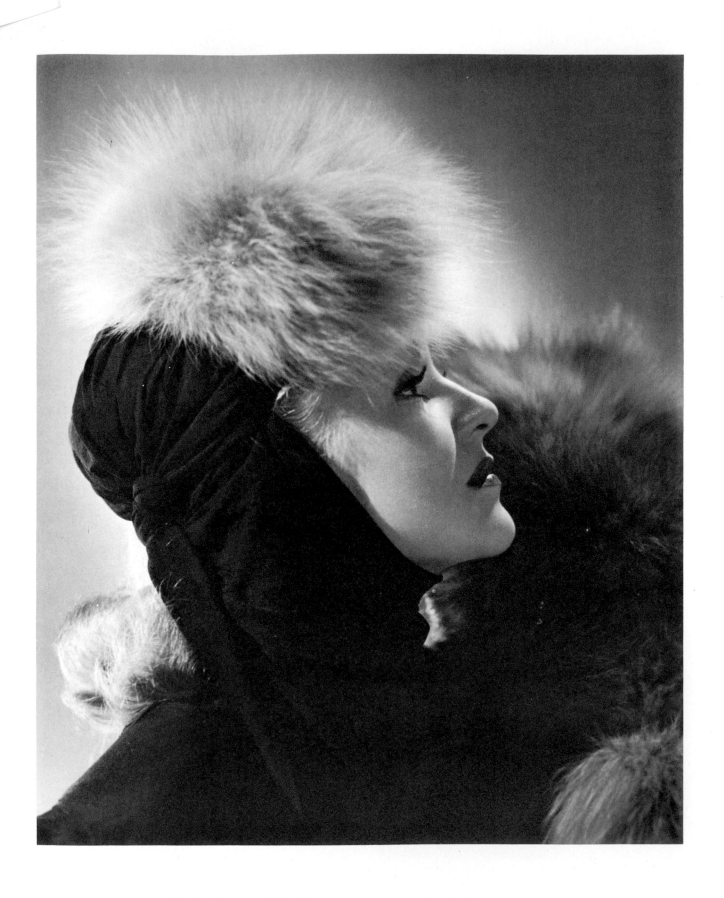

Claire Trevor, 1944. Photo: Ernest A. Bachrach, for RKO Radio.

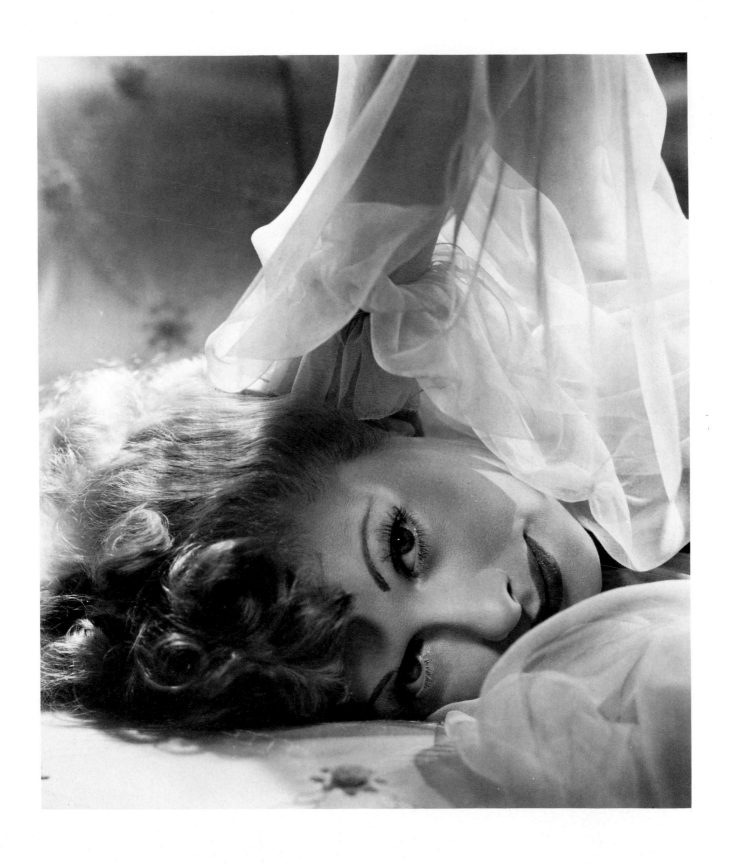

Lucille Ball, 1940. Photo: Ernest A. Bachrach, for RKO Radio.

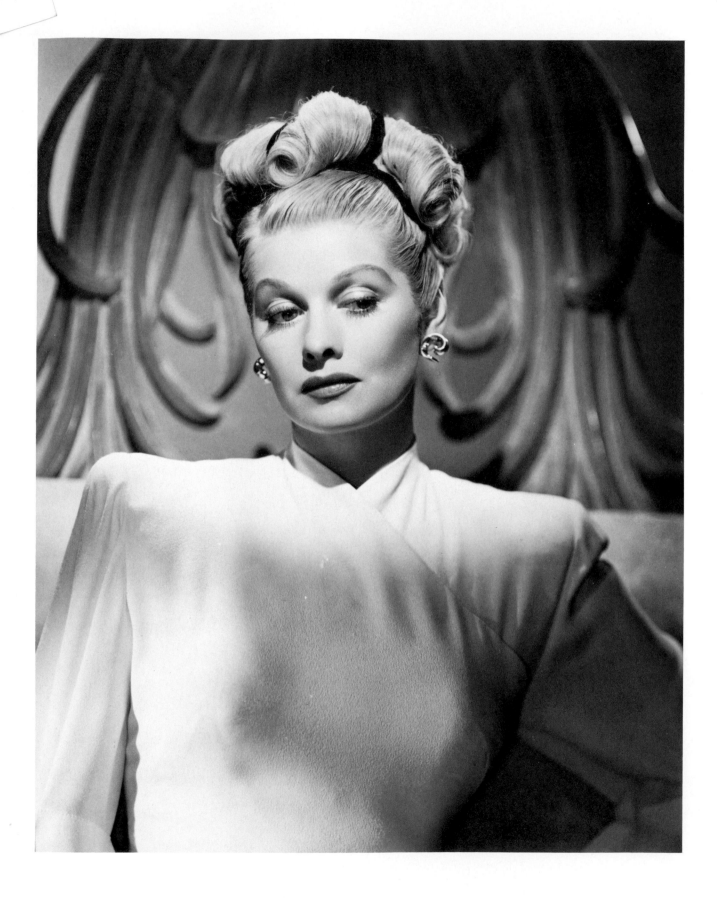

Lucille Ball, 1945. Photo: Clarence Sinclair Bull, for MGM. Costume by
Irene. Hair styling by Sidney Guilaroff.

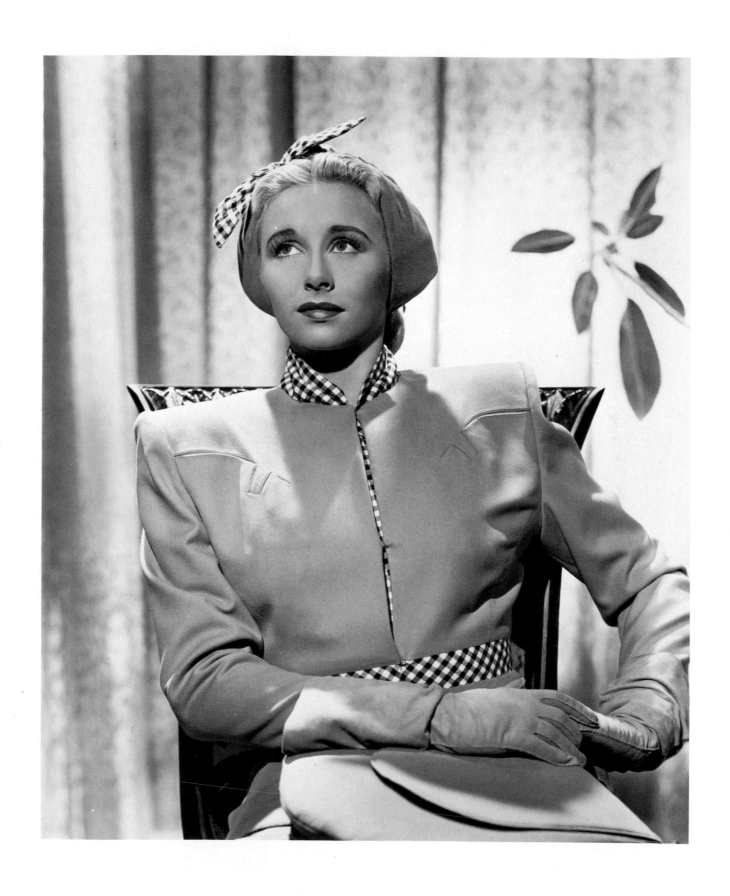

Vera Hruba Ralston, 1945: George Hommel, for Republic.

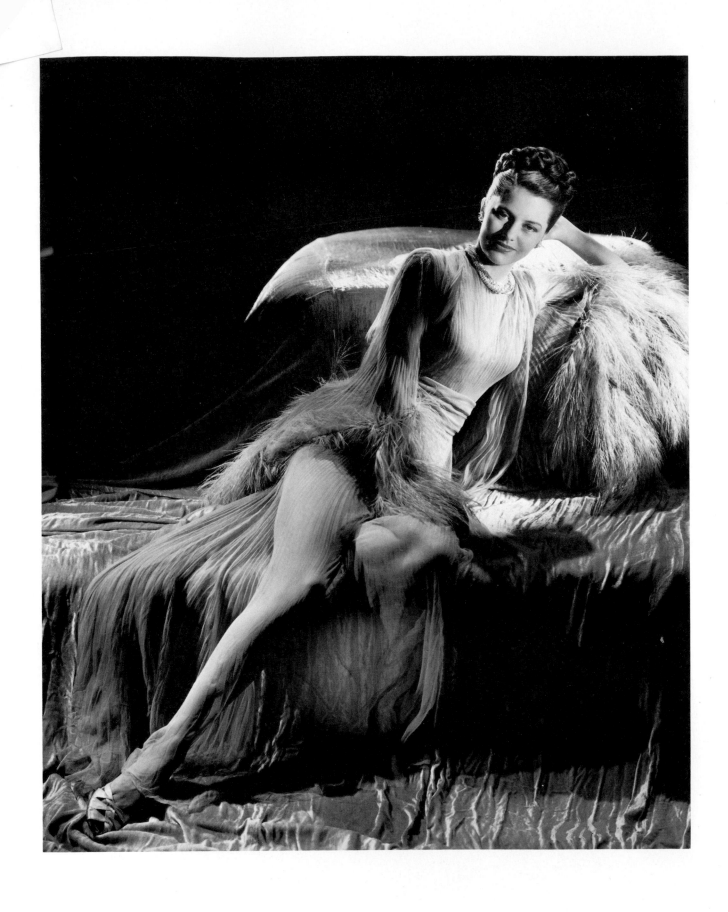

Cyd Charisse, 1947. Photo: Eric Carpenter, for MGM.

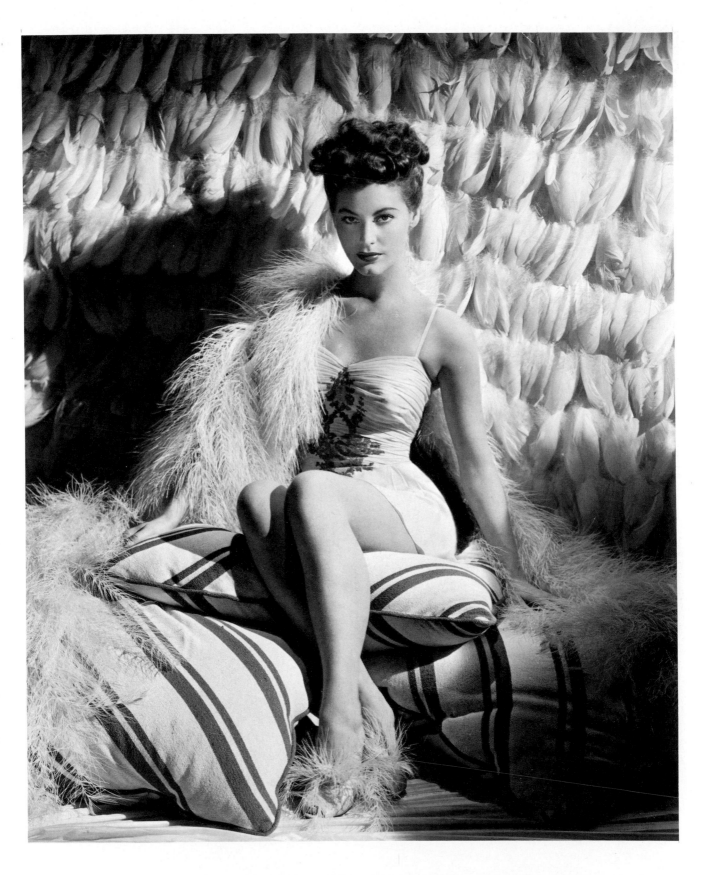

Ava Gardner, 1944. Photo: Eric Carpenter, for MGM. Costume by Irene.
Publicity shot for *Two Girls and a Sailor*.

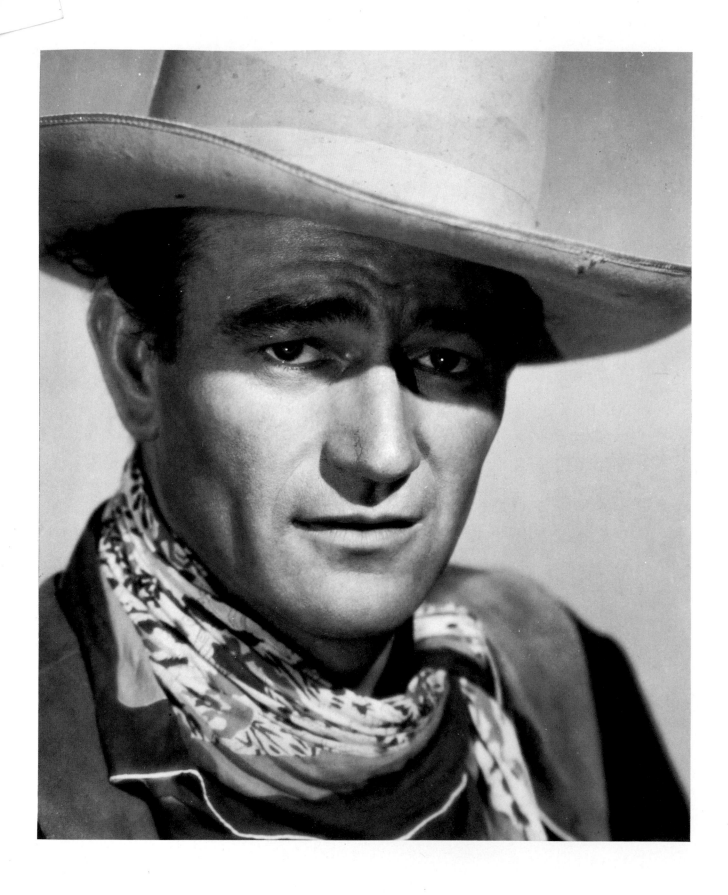

John Wayne, 1943. Photo: George Hommel, for Republic. Publicity shot for *In Old Oklahoma*.

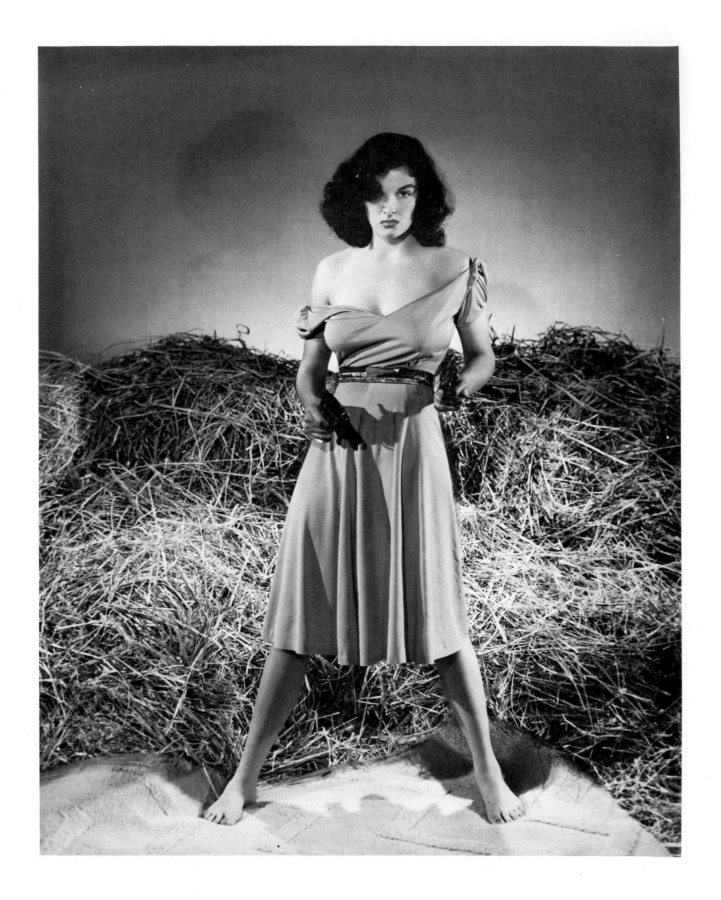

Jane Russell, 1943. Photo: George Hurrell, for United Artists. Publicity
shot for *The Outlaw*.

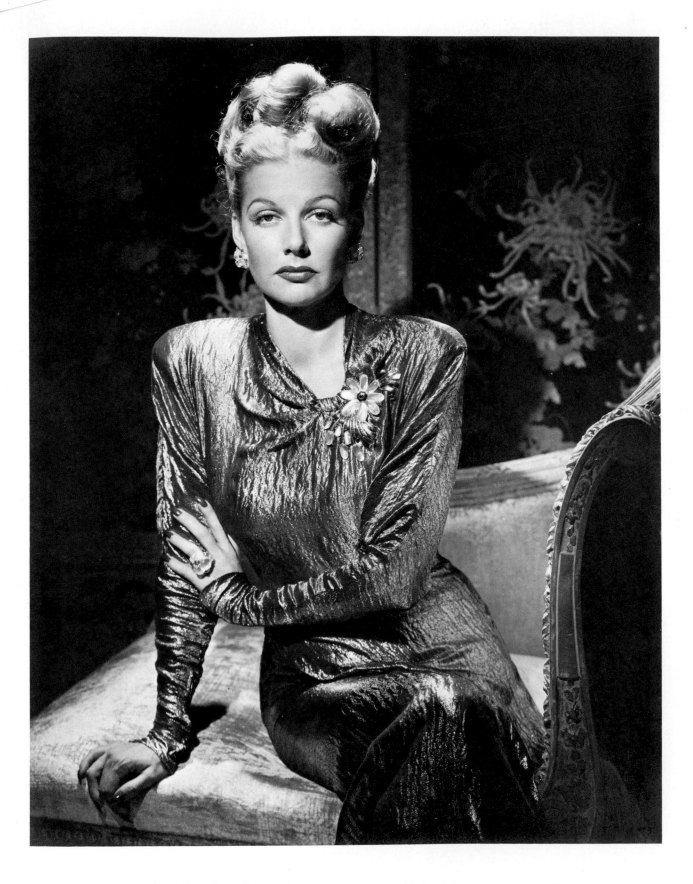

Ann Sheridan, 1947. Photo: George Hurrell, for Warner Bros. Publicity shot for *Nora Prentiss*.

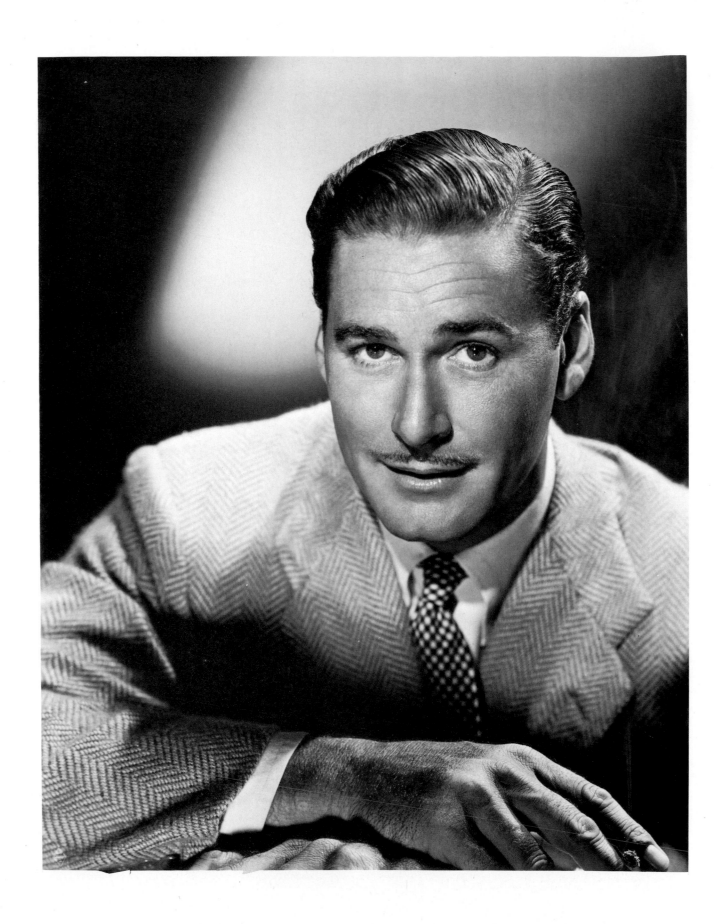

Errol Flynn, 1946. Warner Bros.

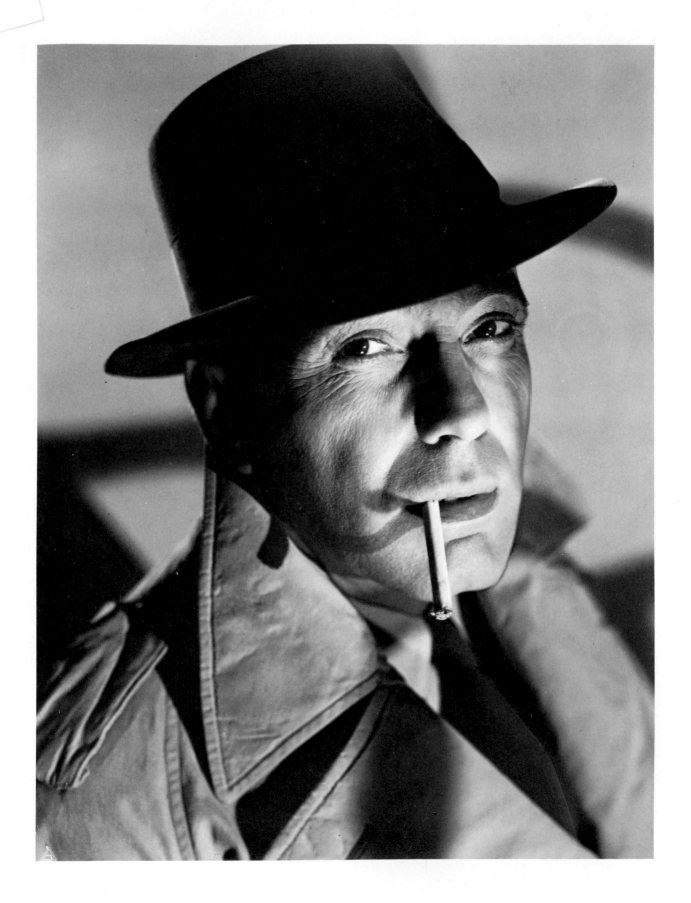

Humphrey Bogart, 1941. Photo: Scotty Welbourne, for Warner Bros.

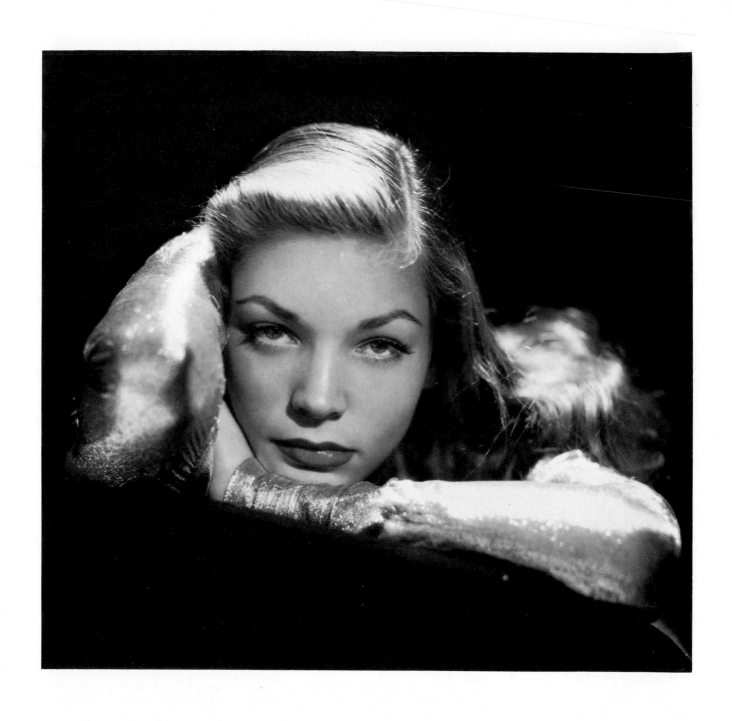

Lauren Bacall, 1945. Photo: John Engstead, for Warner Bros.

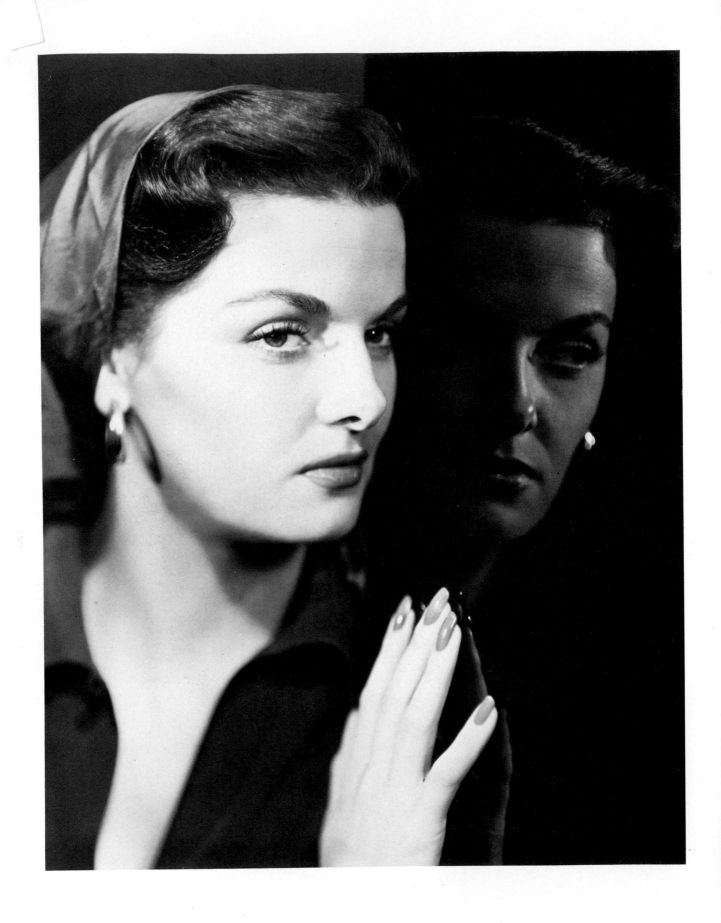

Jane Russell, 1947. Photo: Ernest A. Bachrach, for RKO Radio.

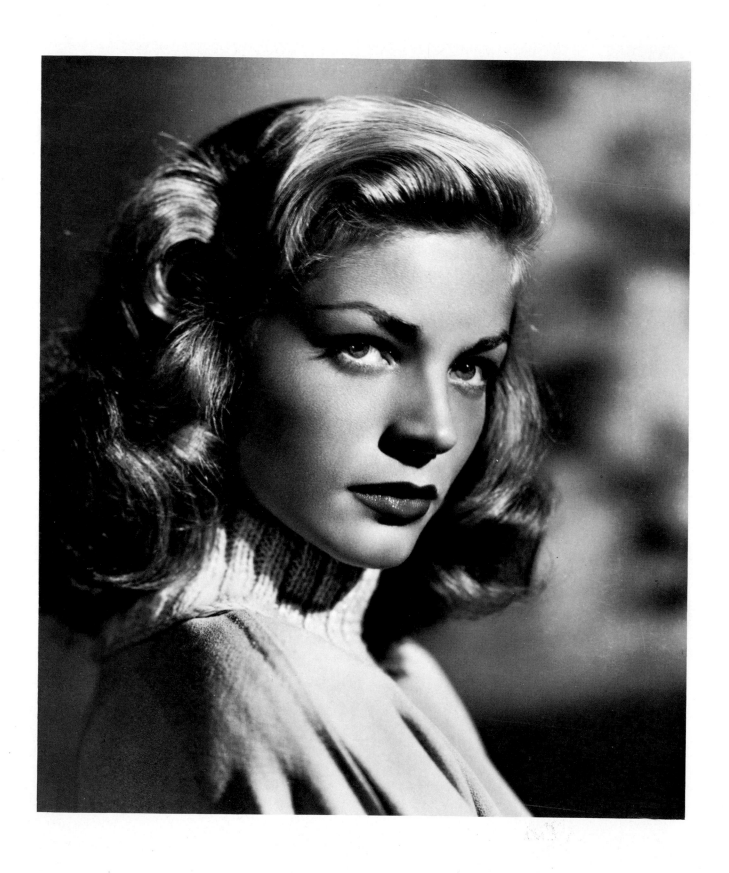

Lauren Bacall, 1946. Photo: Scotty Welbourne, for Warner Bros.

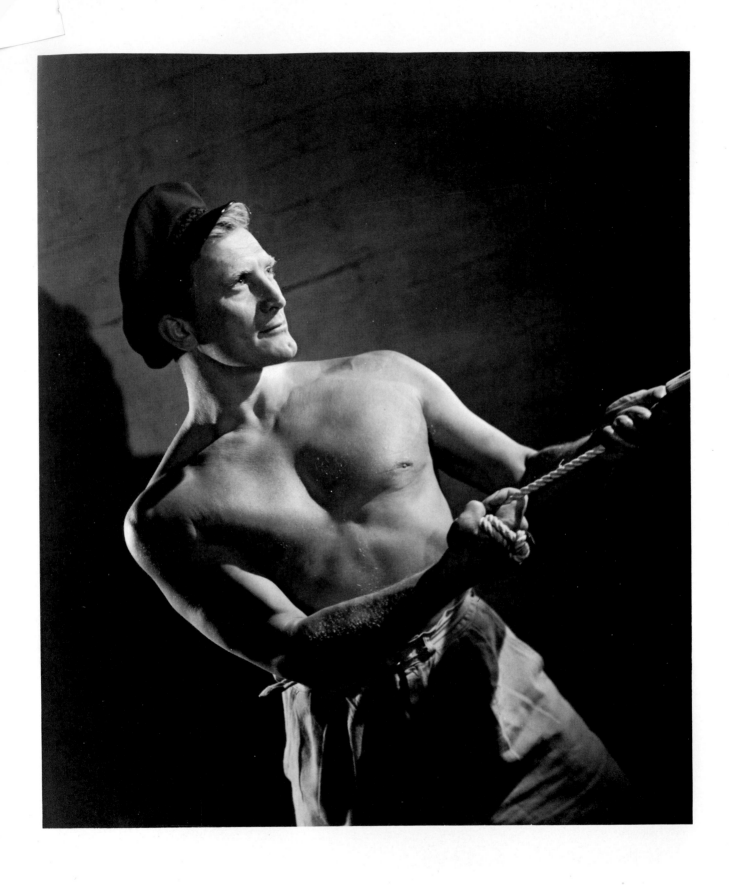

Kirk Douglas, 1949. Warner Bros.

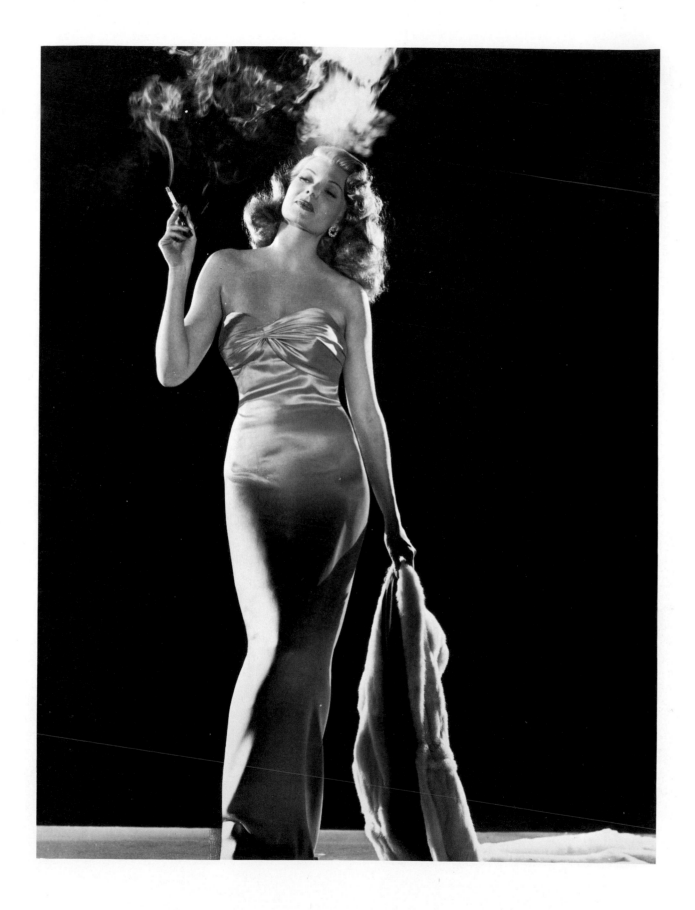

Rita Hayworth, 1946. Photo: Robert Coburn, for Columbia. Costume by Jean Louis. Publicity shot for *Gilda*.

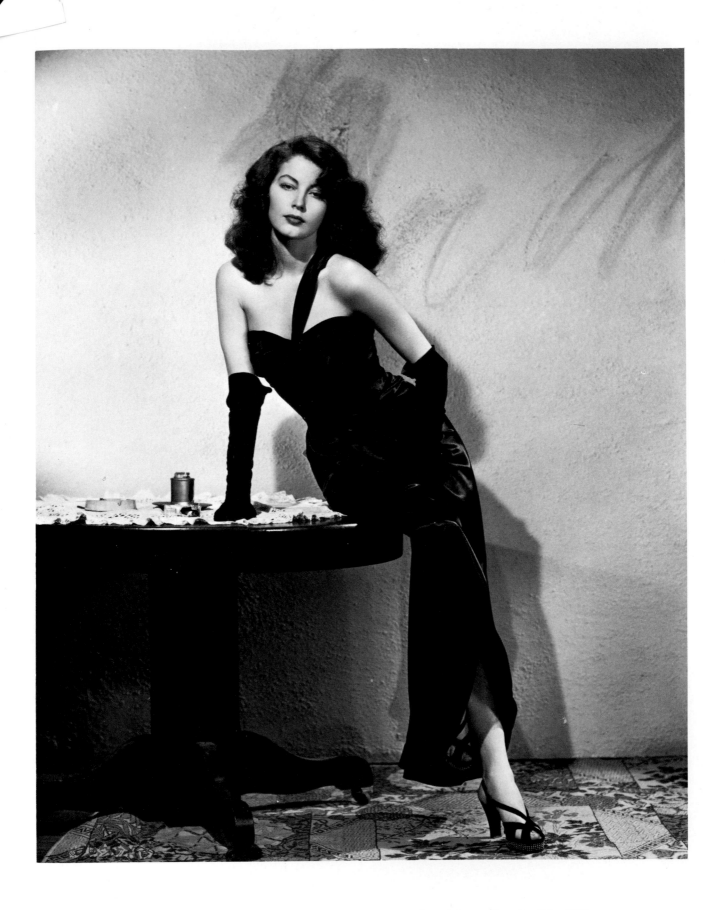

Ava Gardner, 1946. Photo: Ray Jones, for Universal. Publicity shot for *The Killers*.

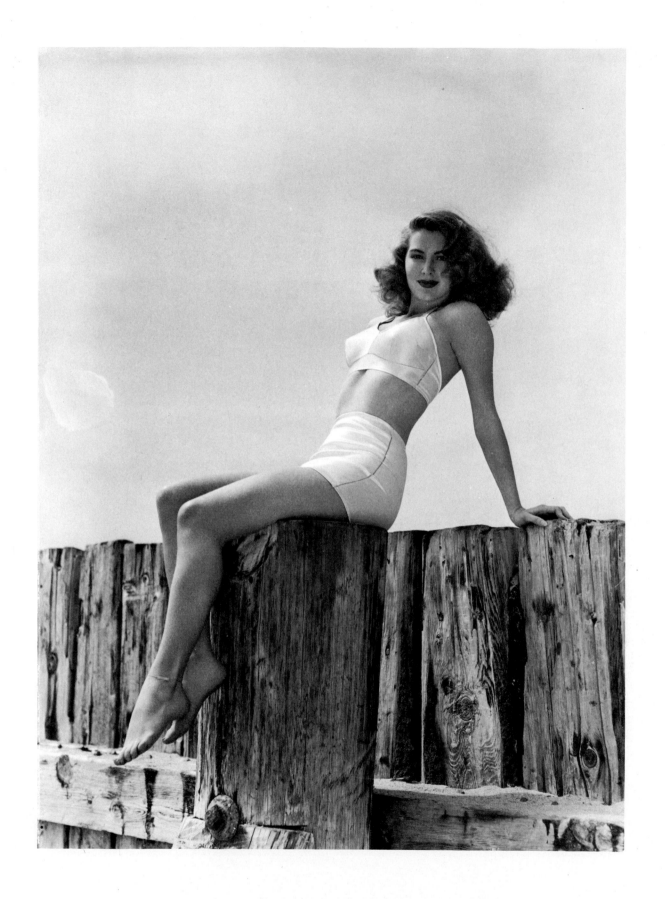

Ava Gardner, 1945. Photo: Eric Carpenter, for MGM.

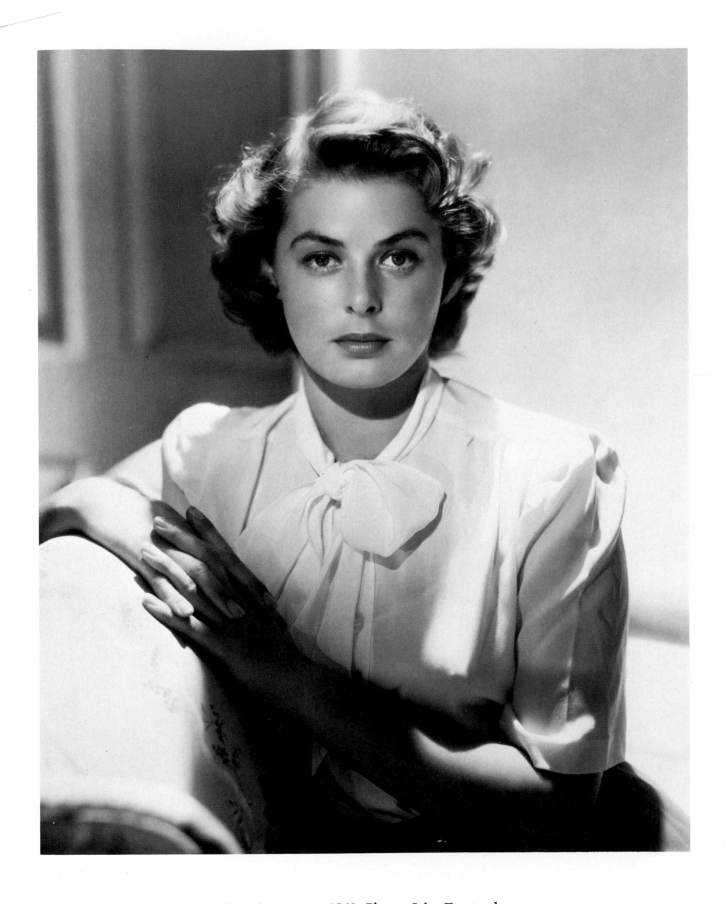

Ingrid Bergman, 1946. Photo: John Engstead.

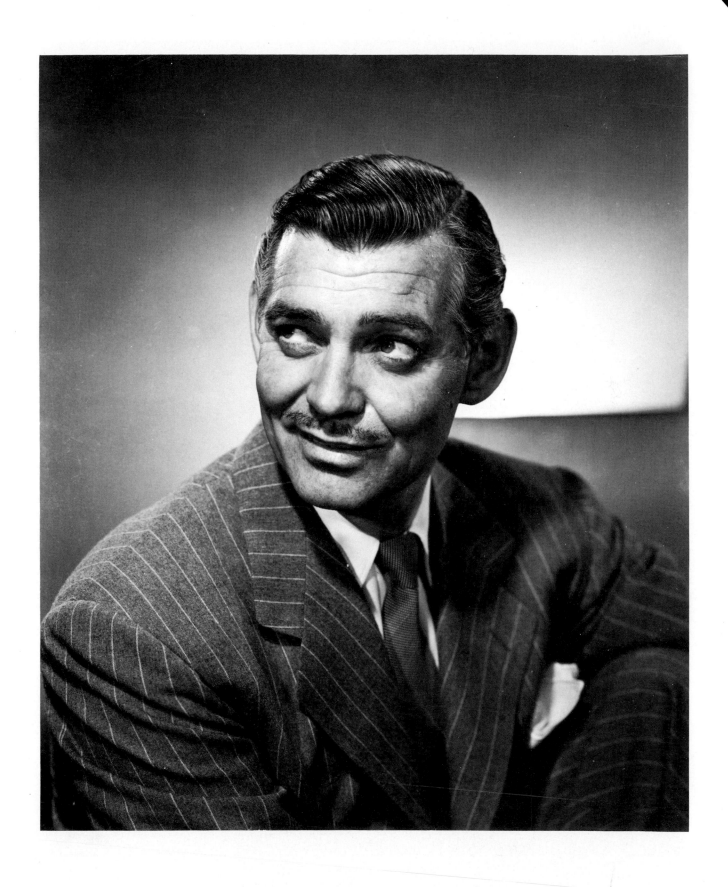

Clark Gable, 1946. Photo: Eric Carpenter, for MGM. Publicity shot for *Adventure*.

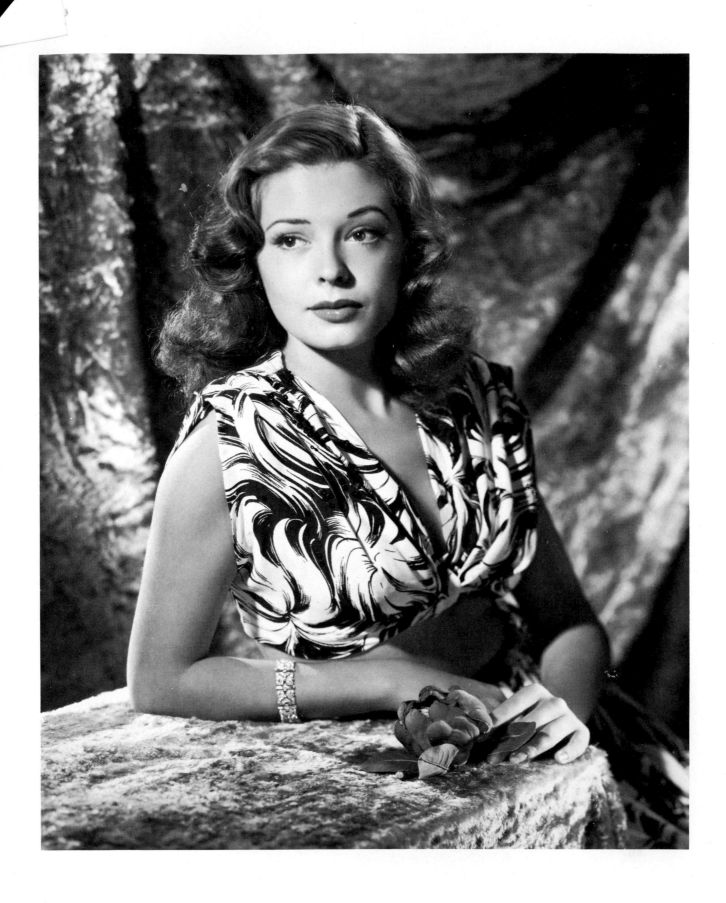

Jane Greer, 1947. Photo: Ernest A. Bachrach, for RKO Radio. Publicity shot for *They Won't Believe Me.*

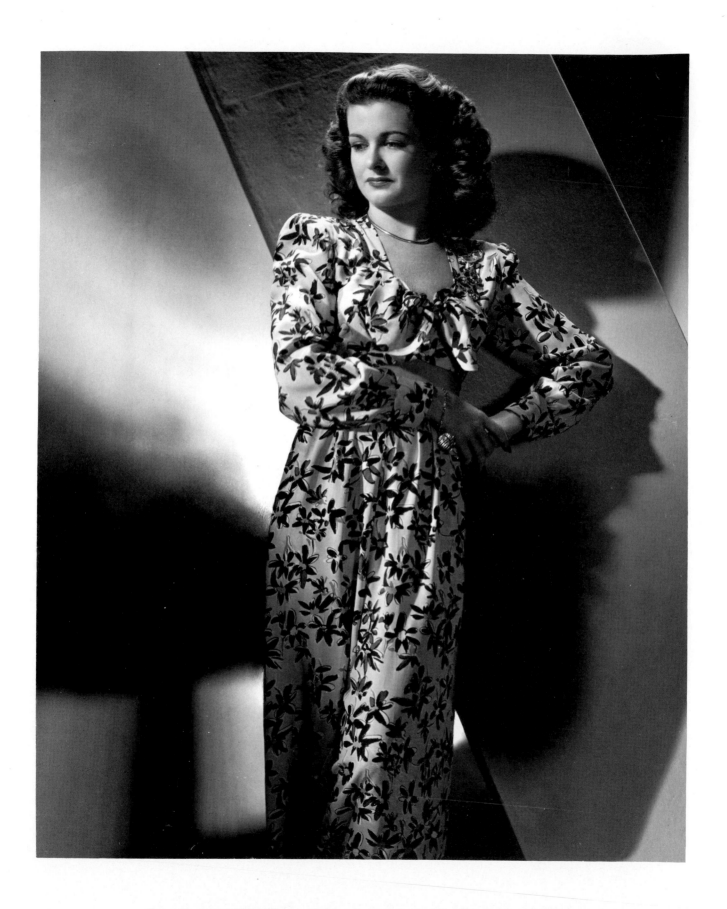

Joan Bennett, 1947. Photo: Ernest A. Bachrach, for RKO Radio. Publicity
shot for *The Woman on the Beach*.

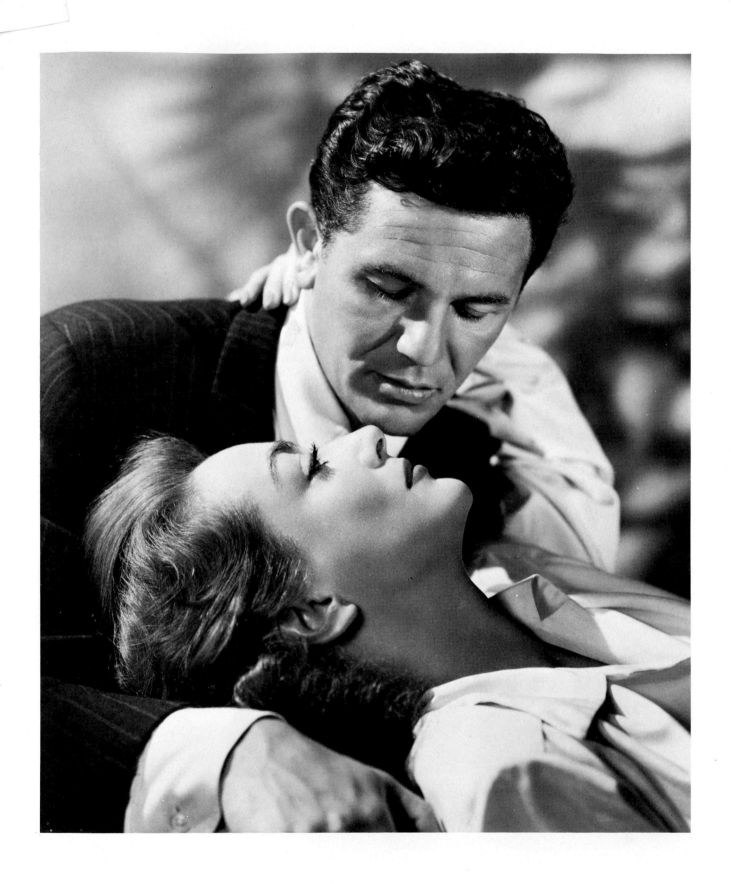

Joan Crawford and John Garfield, 1946. Photo: George Hurrell, for
Warner Bros. Publicity shot for *Humoresque*.

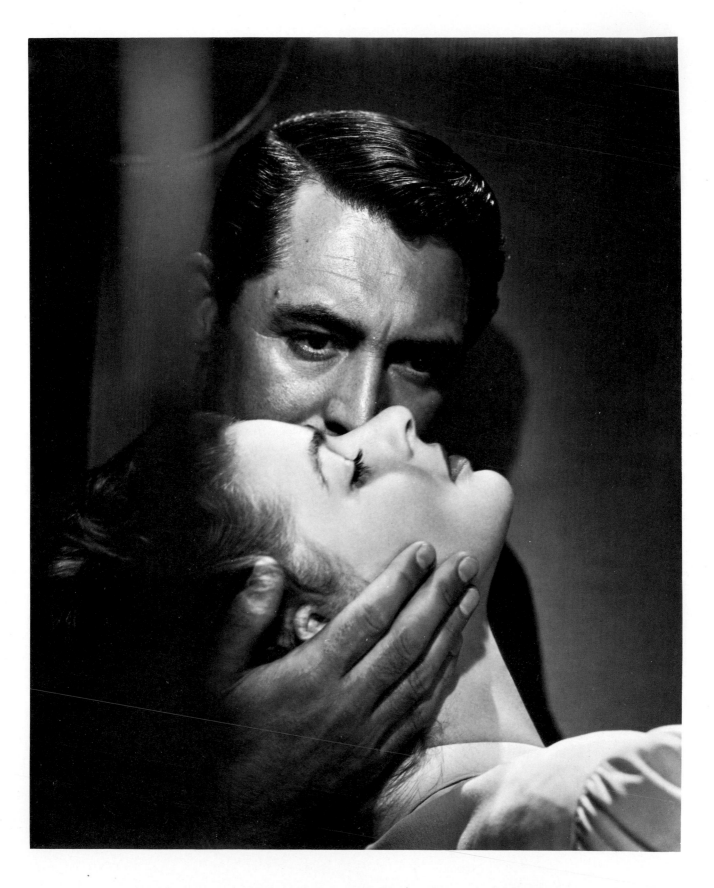

Ingrid Bergman and Cary Grant, 1946. Photo: Ernest A. Bachrach, for RKO Radio. Publicity shot for *Notorious*.

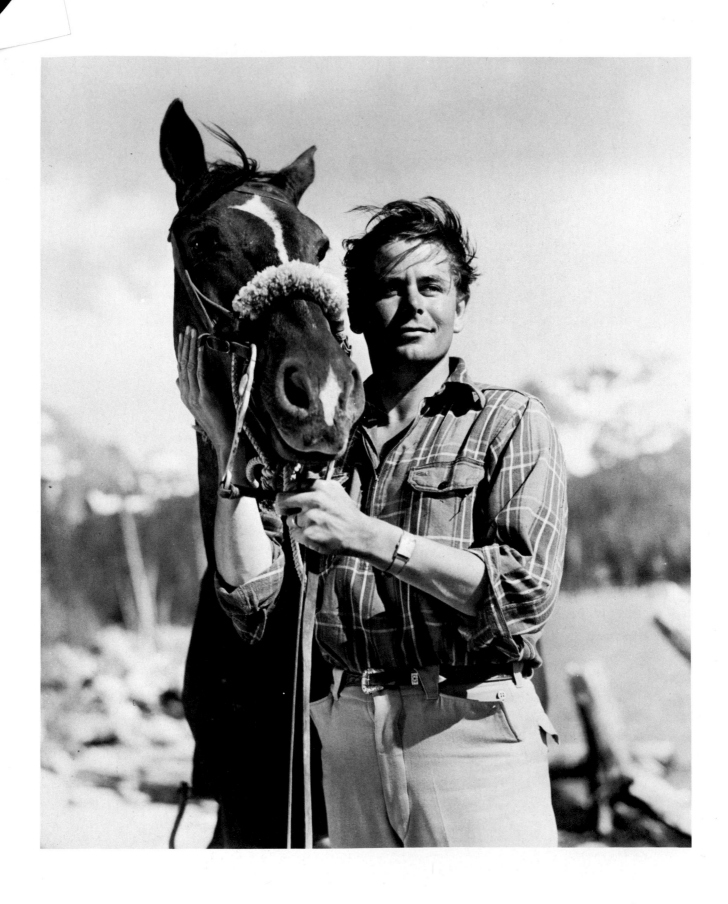

Glenn Ford, 1946. Photo: Edward Cronenweth, for Columbia.

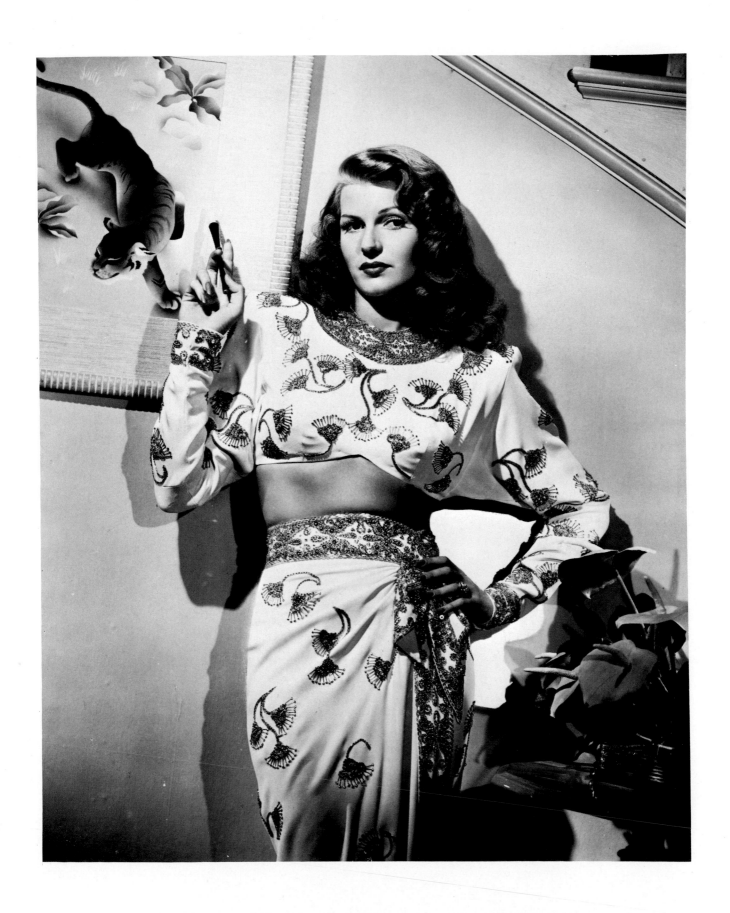

Rita Hayworth, 1946. Photo: Robert Coburn, for Columbia. Costume by
Jean Louis. Publicity shot for *Gilda*.

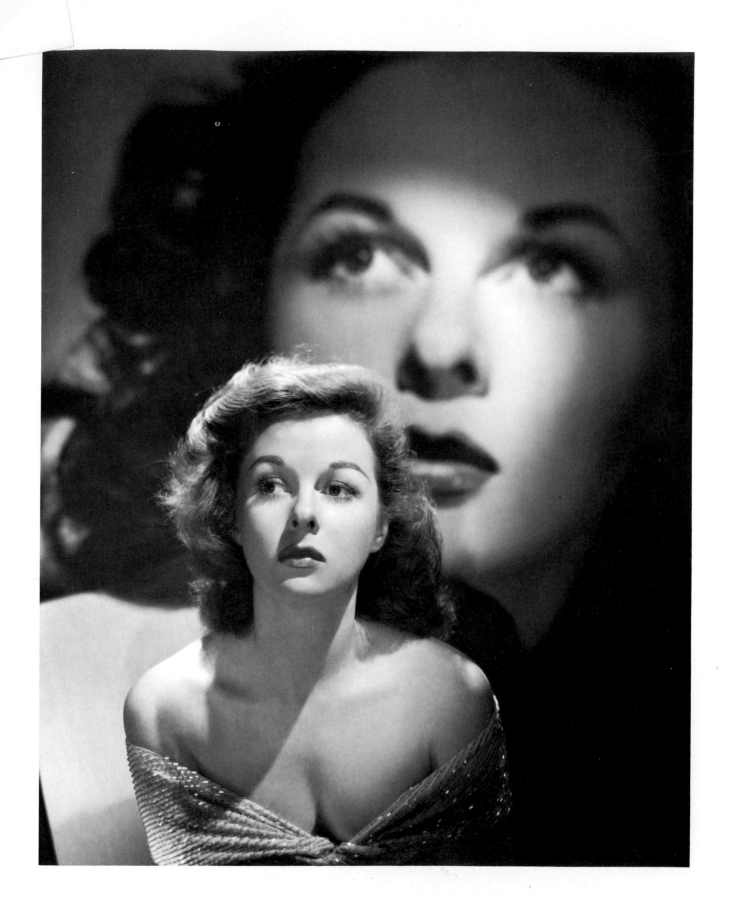

Susan Hayward, 1948. Photo: Laszlo Willinger.

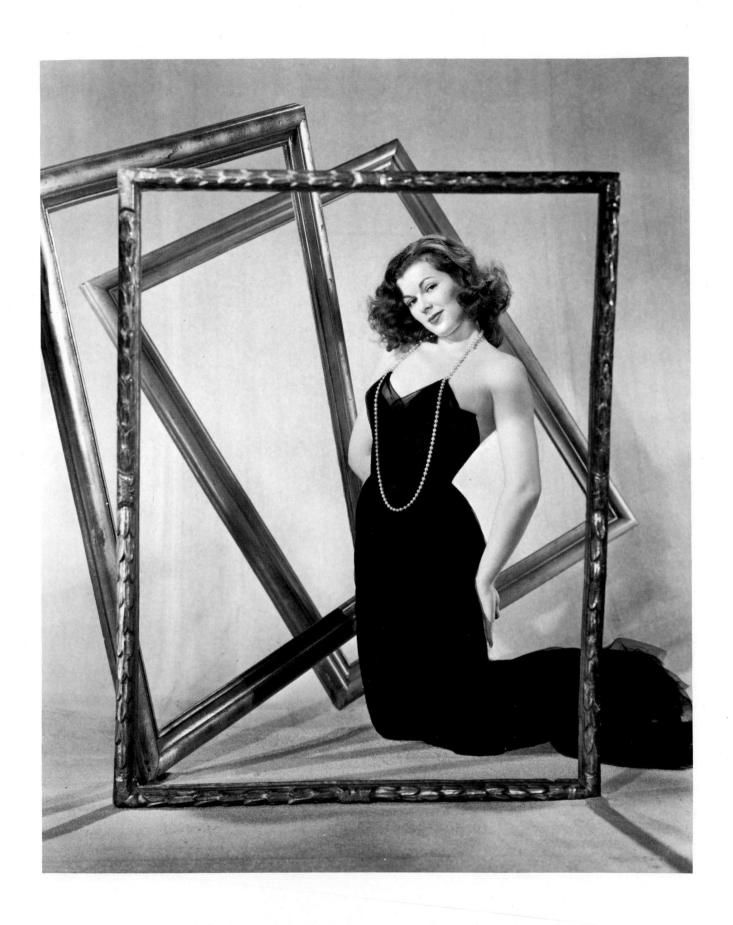

Barbara Hale, 1946. Photo: Ernest A. Bachrach, for RKO Radio.

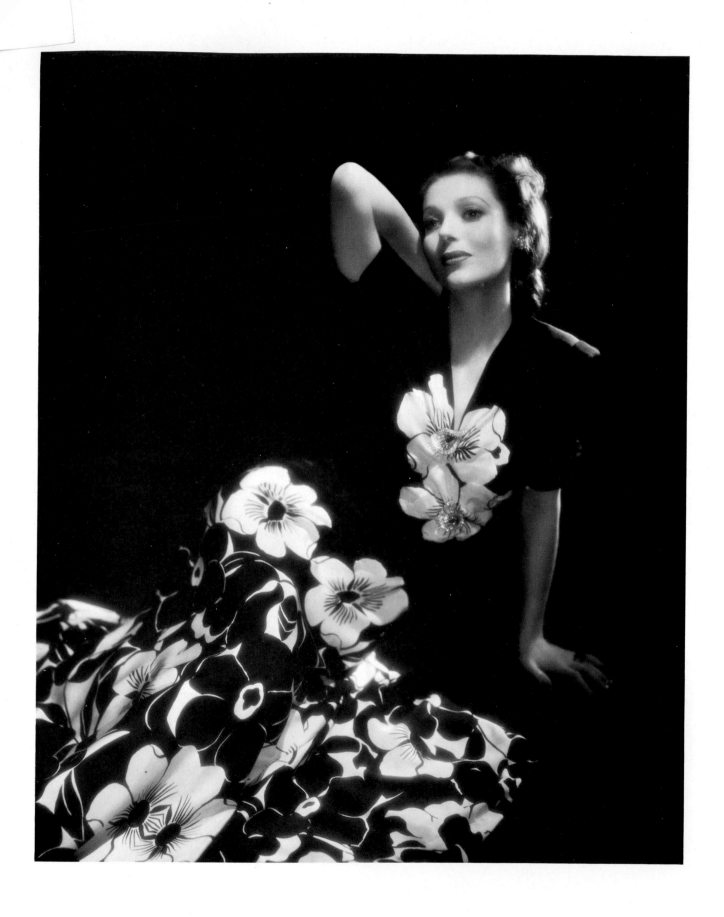

Loretta Young. Photo: John Engstead.

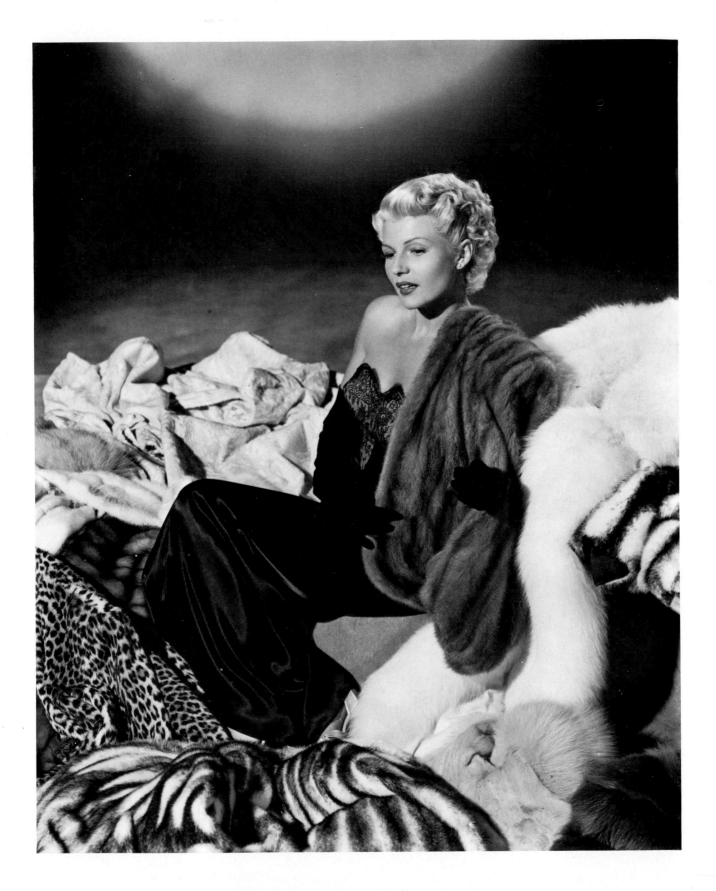

Rita Hayworth, 1947. Photo: Robert Coburn, for Columbia. Costume by
Jean Louis. Publicity shot for *The Lady from Shanghai*.

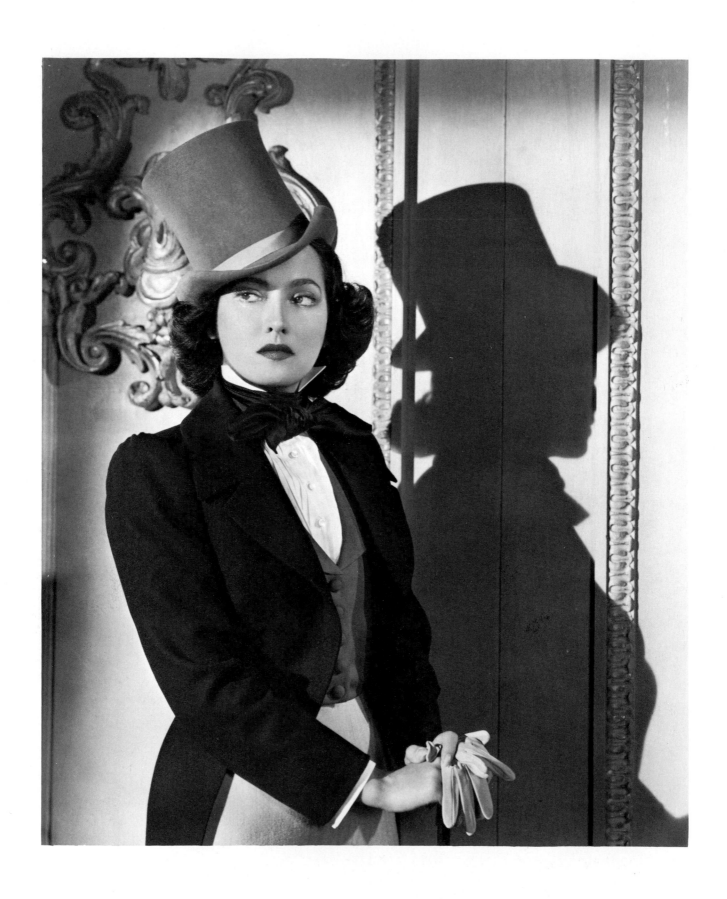

Merle Oberon, 1945. Photo: Robert Coburn, for Columbia. Costume by
Travis Banton. Publicity shot for *A Song to Remember*.

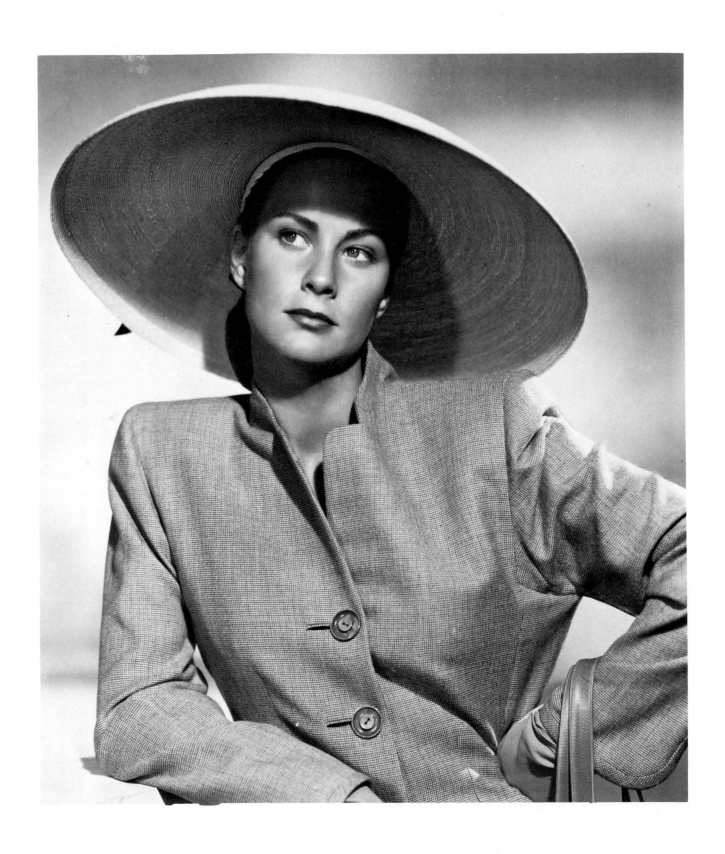

Alida Valli, 1948. Photo: John Miehle, for United Artists (Selznick). Publicity shot for *The Paradine Case*.

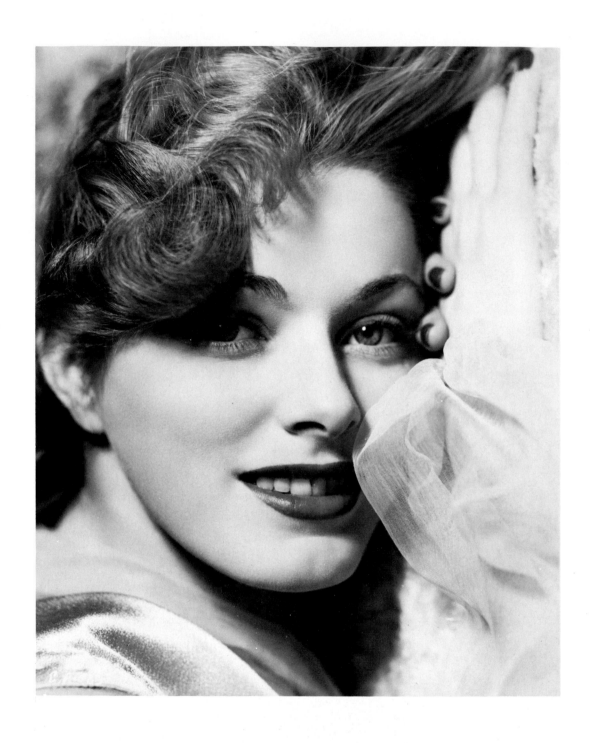

Eleanor Parker, 1948. Warner Bros.

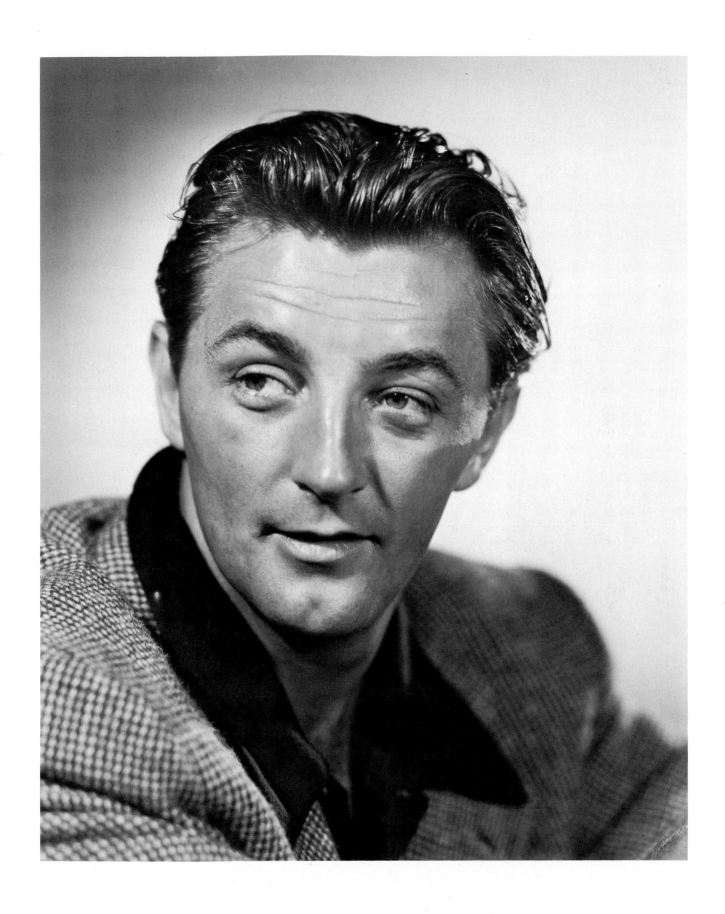

Robert Mitchum, 1946. Photo: John Miehle, for RKO Radio.

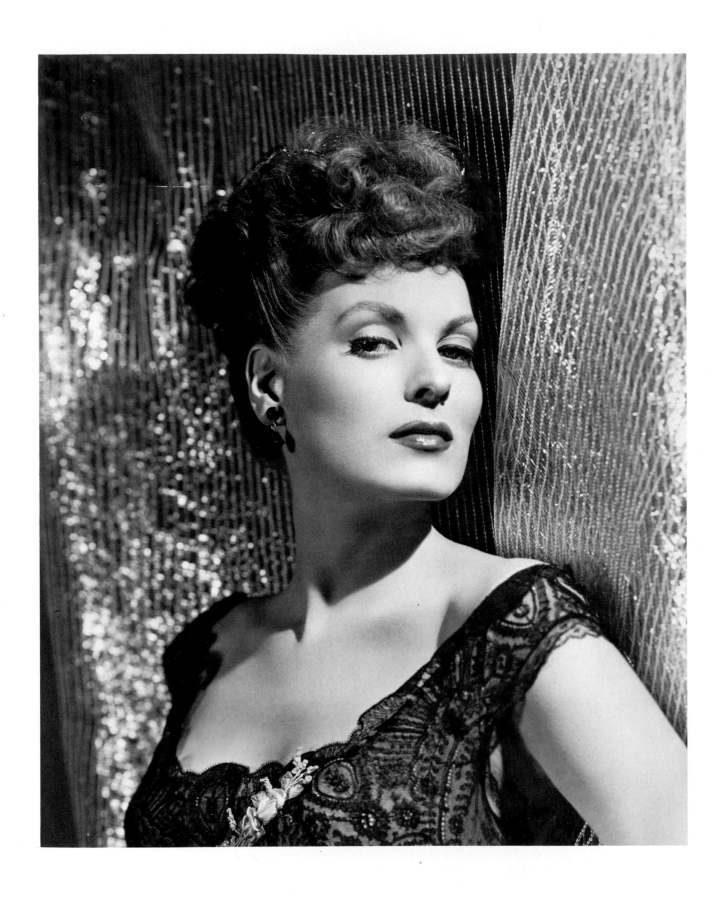

Maureen O'Hara, 1948. Photo: Frank Powolny, for 20th Century-Fox.

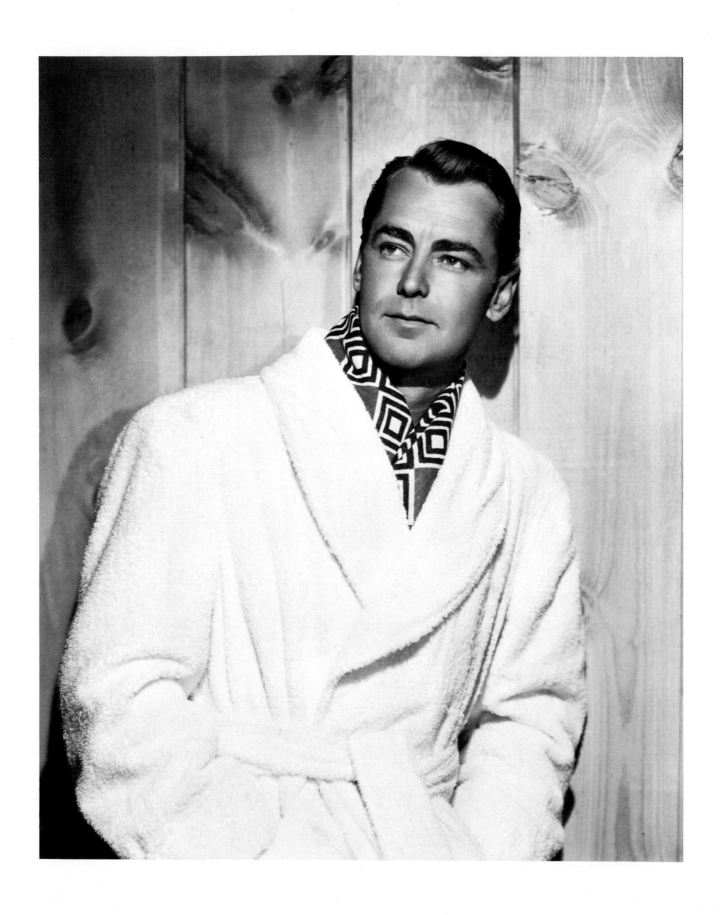

Alan Ladd, 1945. Photo: A. L. ("Whitey") Schafer, for Paramount.

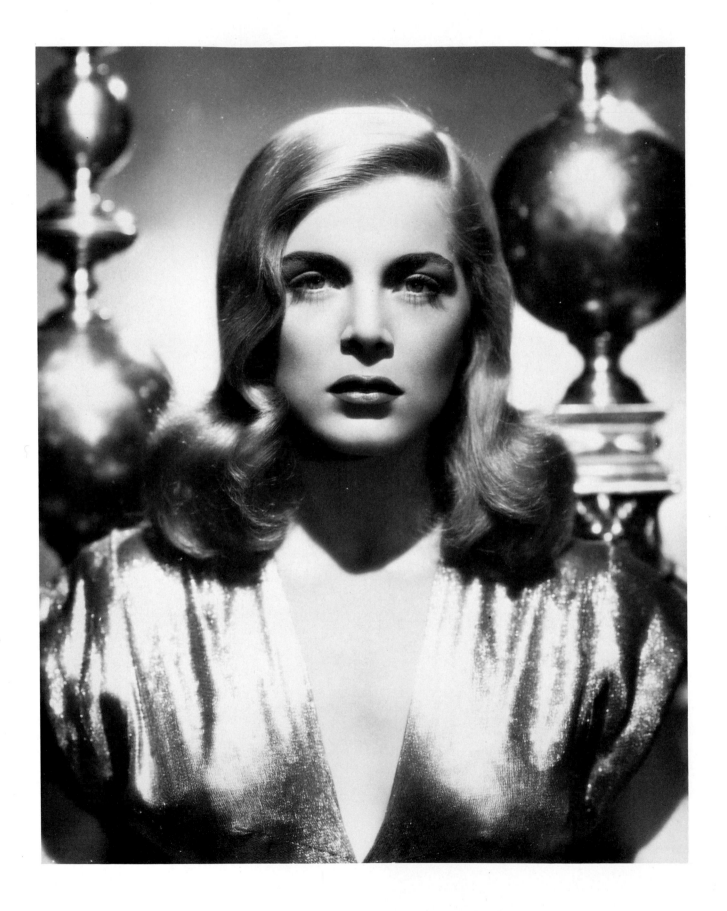

Lizabeth Scott, 1945. Photo: A. L. ("Whitey") Schafer, for Paramount.

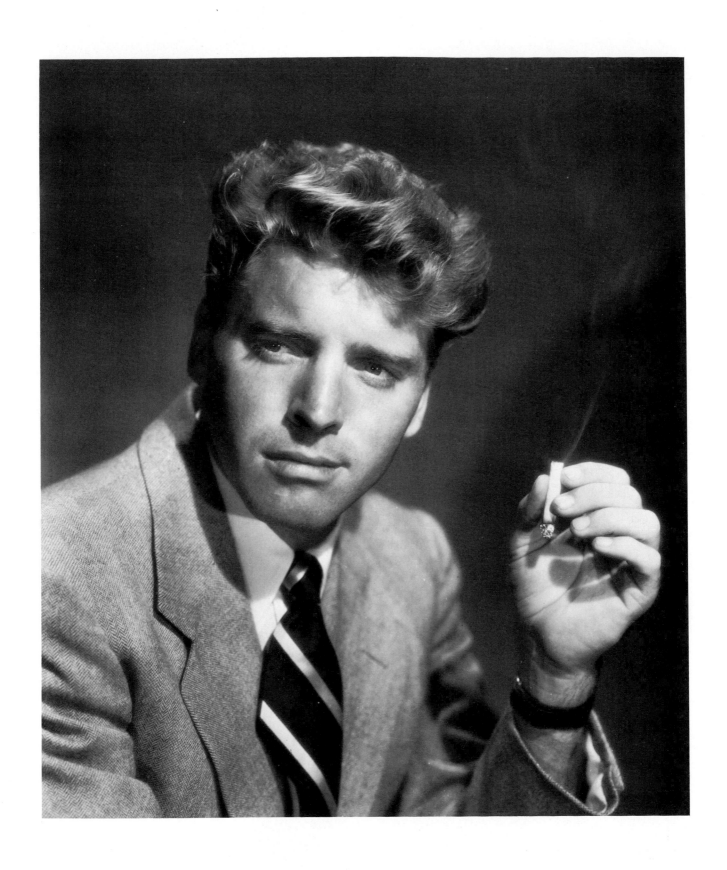

Burt Lancaster, 1948. Photo: A. L. ("Whitey") Schafer, for Paramount.

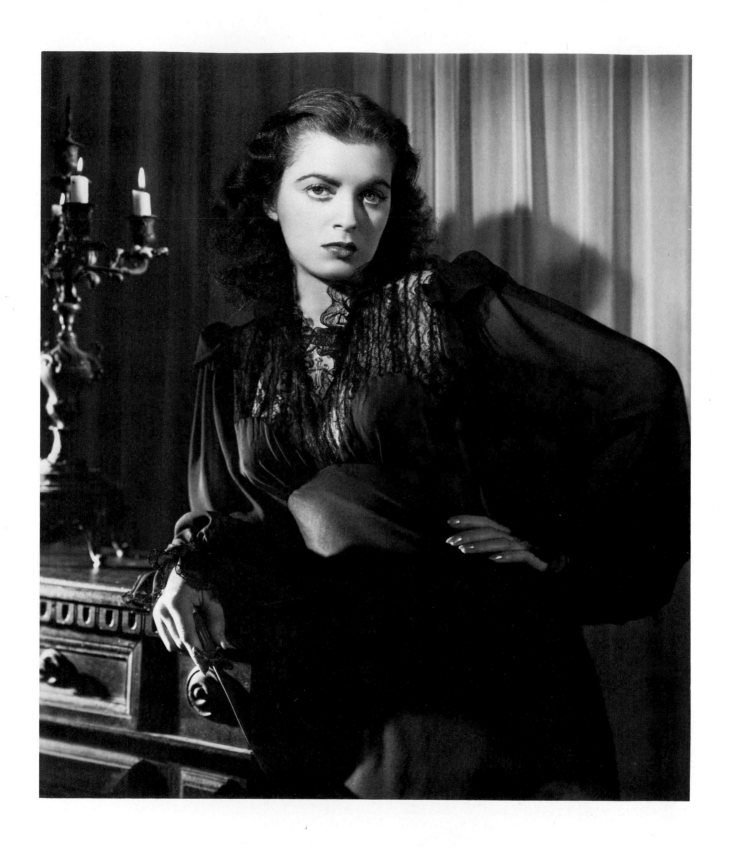

Faith Domergue, 1950. Photo: Ernest A. Bachrach, for RKO Radio. Publicity shot for *Vendetta*.

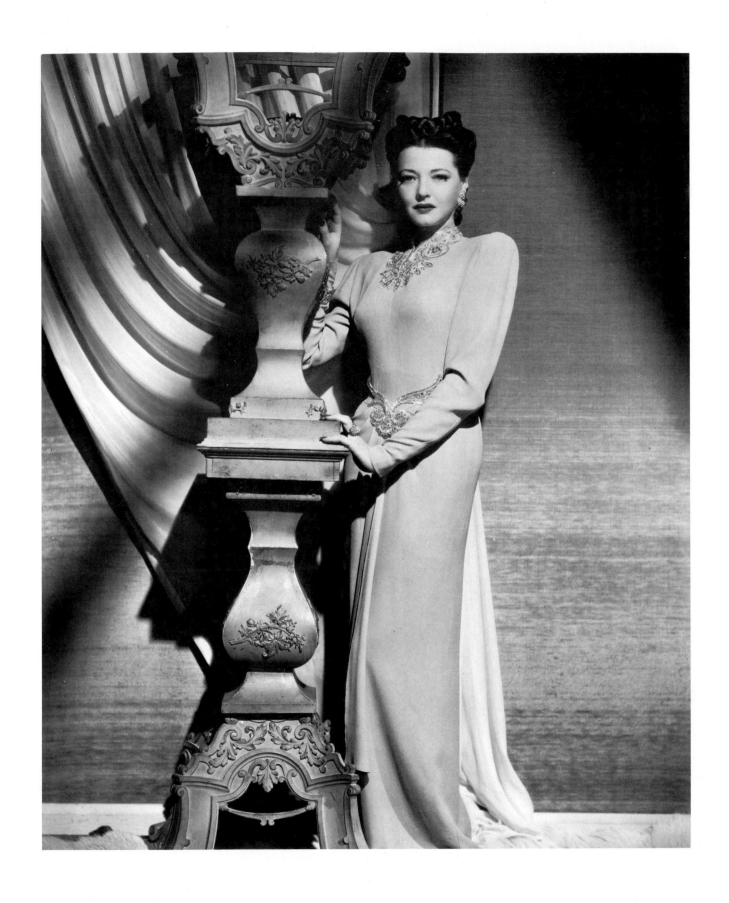

Sylvia Sidney, 1946. Photo: Frank Tanner, for United Artists. Publicity shot for *Mr. Ace*.

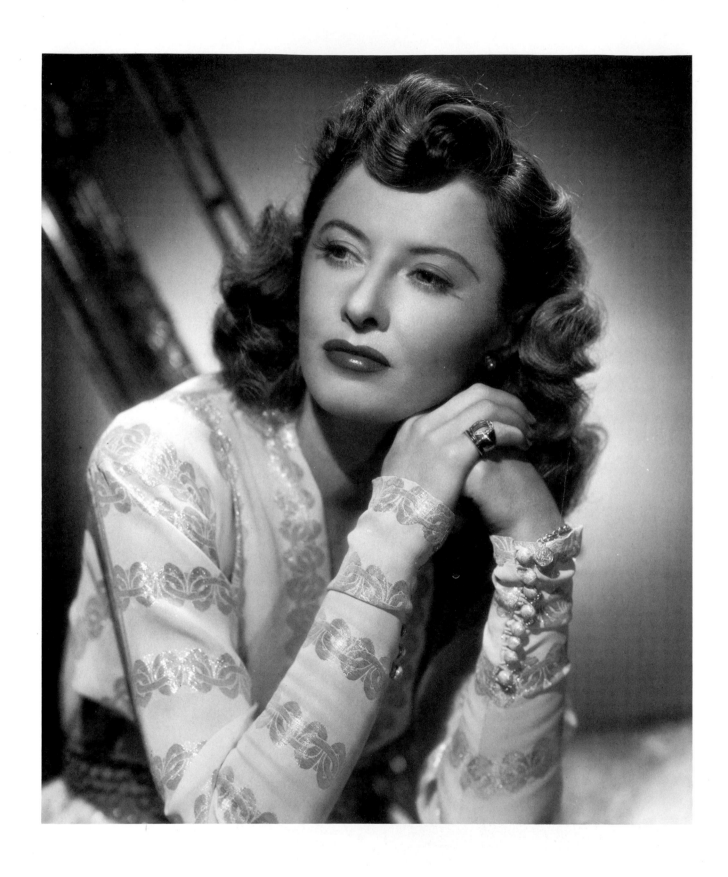

Barbara Stanwyck, 1946. Photo: A. L. ("Whitey") Schafer, for Paramount (Hal Wallis).

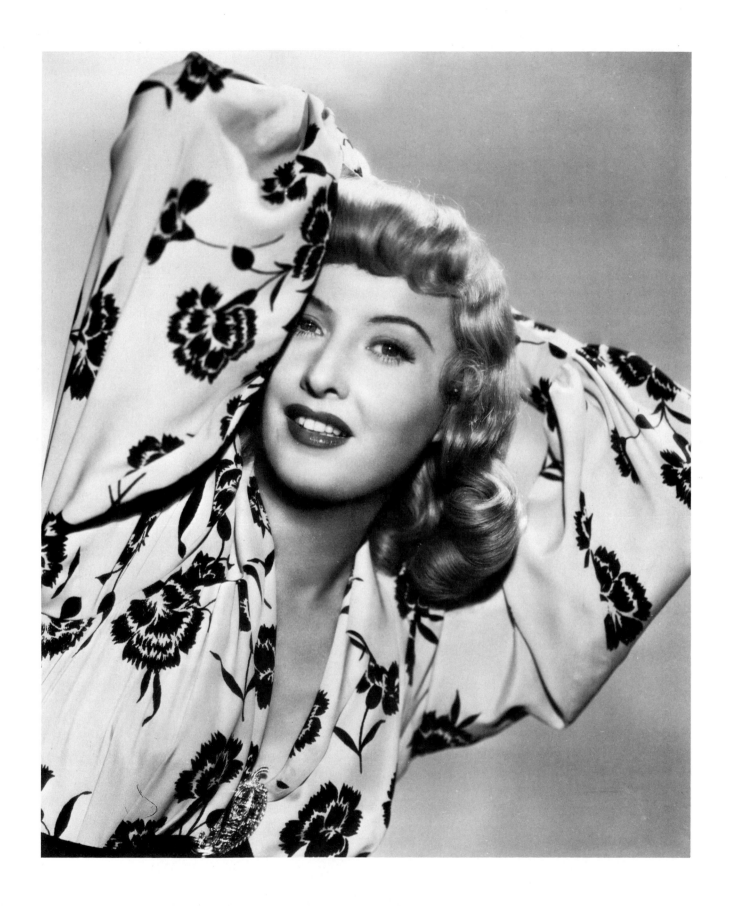

Barbara Stanwyck, 1944. Photo: A. L. ("Whitey") Schafer, for Paramount. Costume by Edith Head. Publicity shot for *Double Indemnity*.

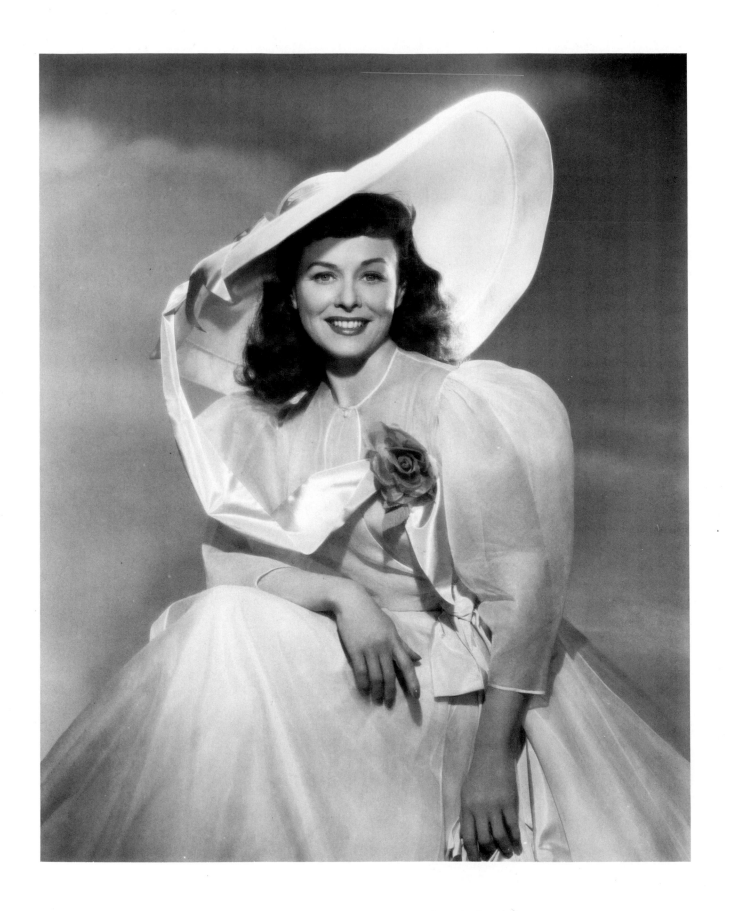

Paulette Goddard, 1947. Photo: A. L. ("Whitey") Schafer, for Paramount.

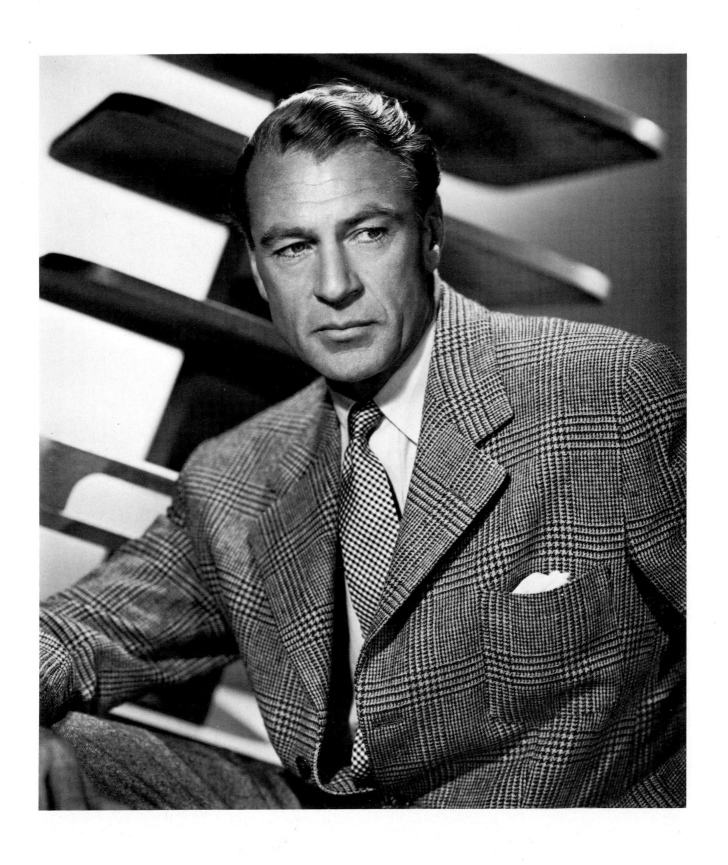

Gary Cooper, 1947. Photo: Bud Fraker, for Paramount.

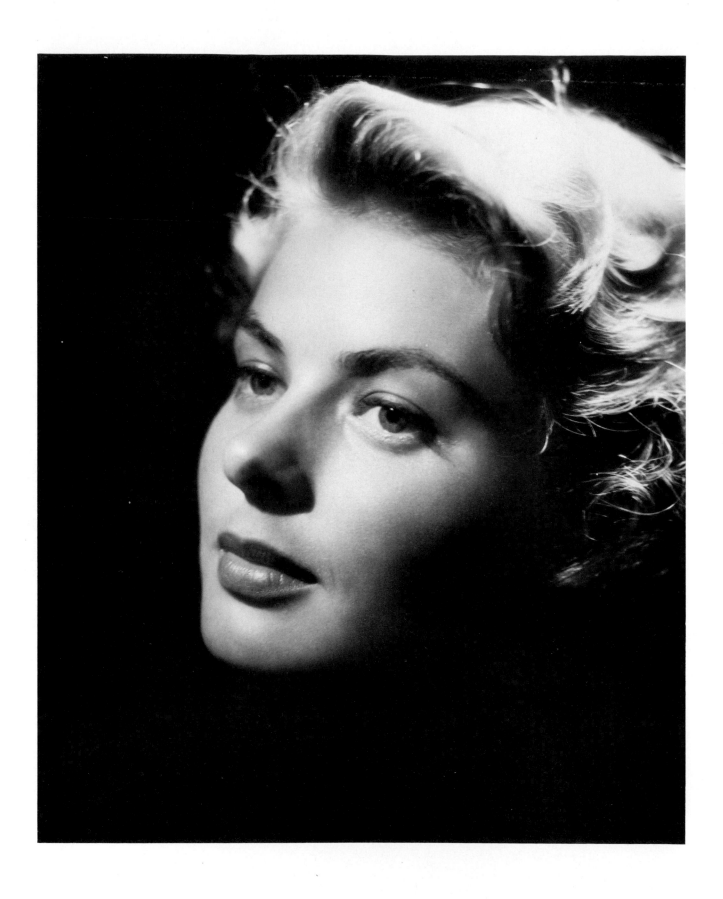

Ingrid Bergman, 1946. Photo: John Engstead.

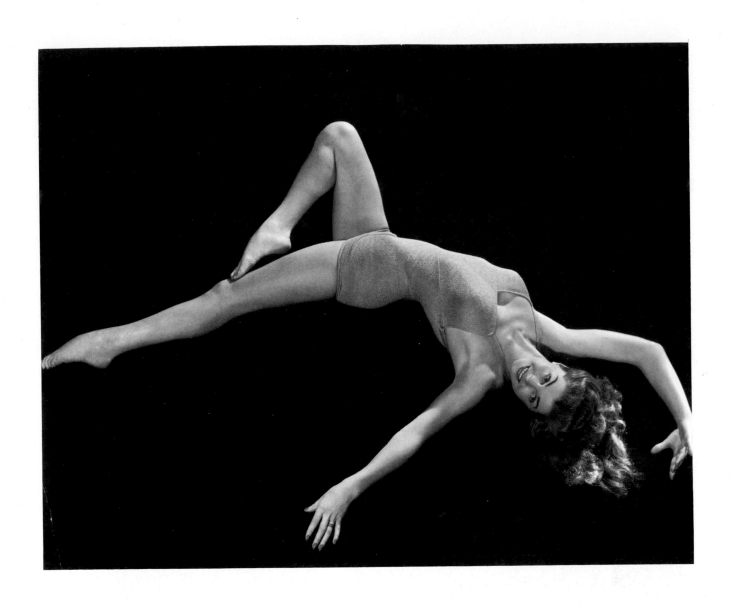

Esther Williams, 1949. MGM. Costume by Esther Williams-Cole of California. Publicity shot for *Neptune's Daughter*.

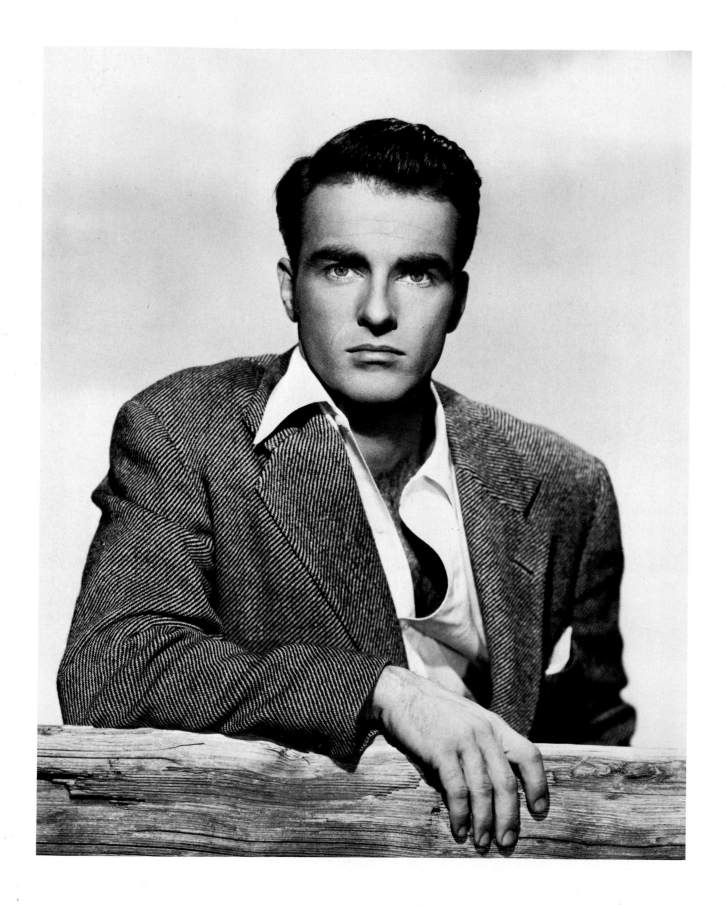

Montgomery Clift, 1949. Photo: A. L. ("Whitey") Schafer, for Paramount.

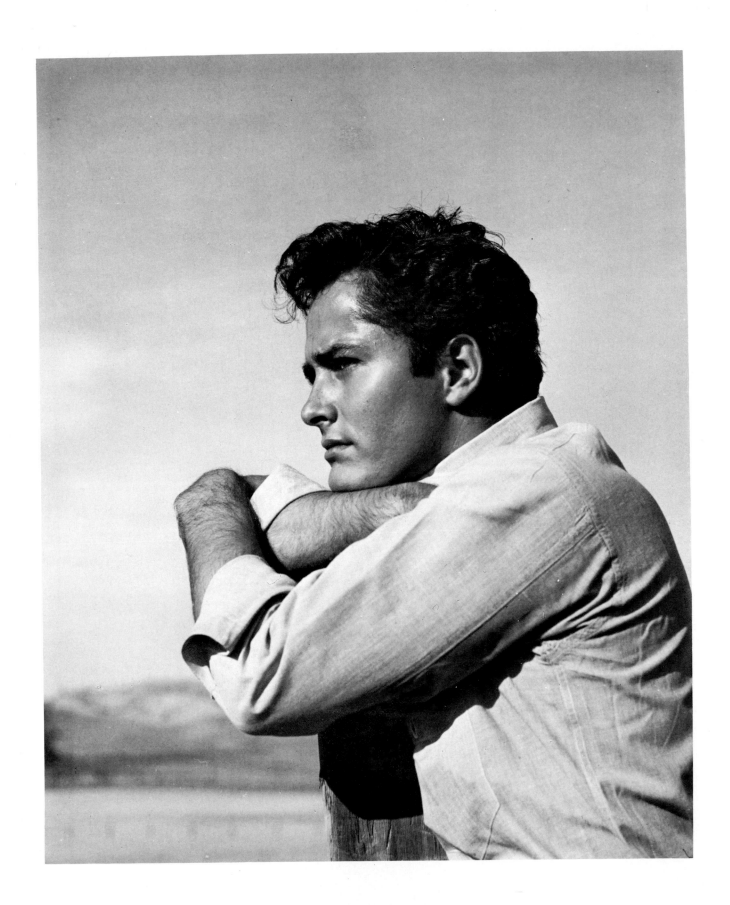

John Derek, 1949. Photo: Edward Cronenweth, for Columbia.

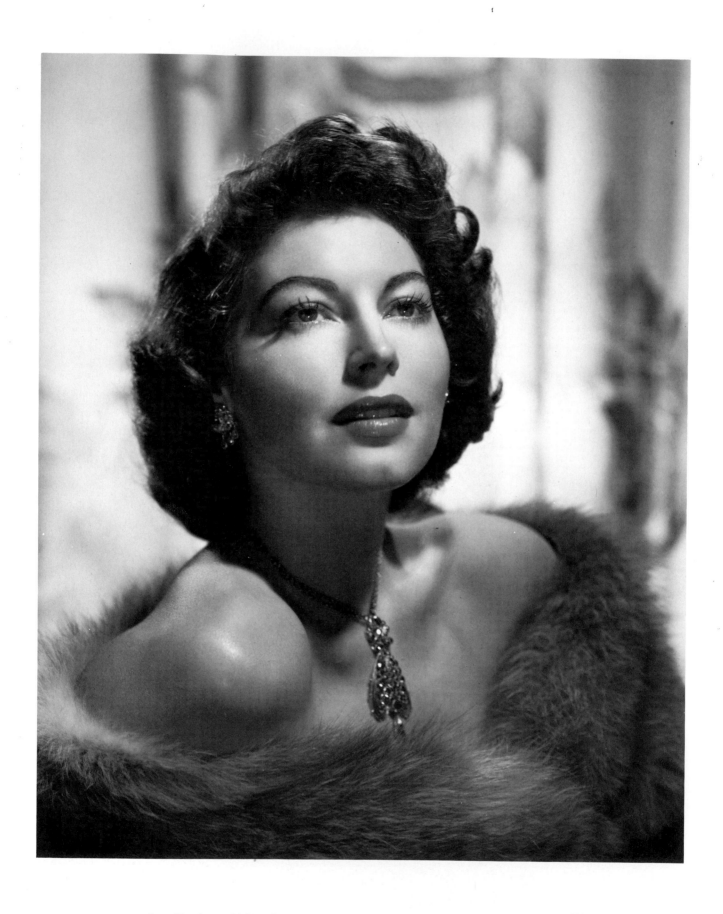

Ava Gardner, 1949. Photo: Eric Carpenter, for MGM. Publicity shot for
East Side, West Side.

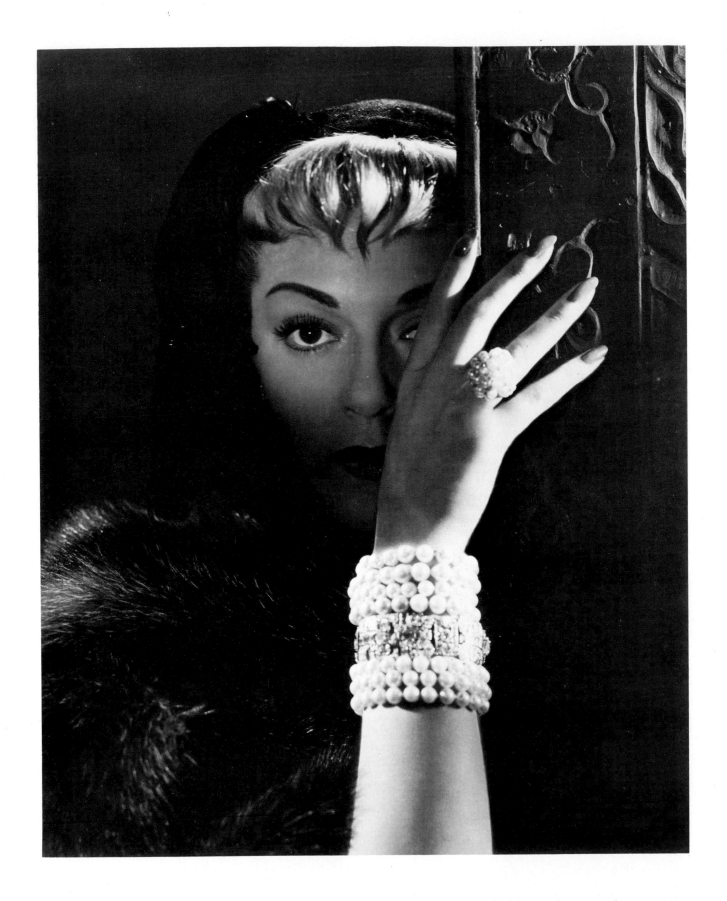

Lana Turner, 1950. Photo: Eric Carpenter, for MGM. Publicity shot for
A Life of Her Own.

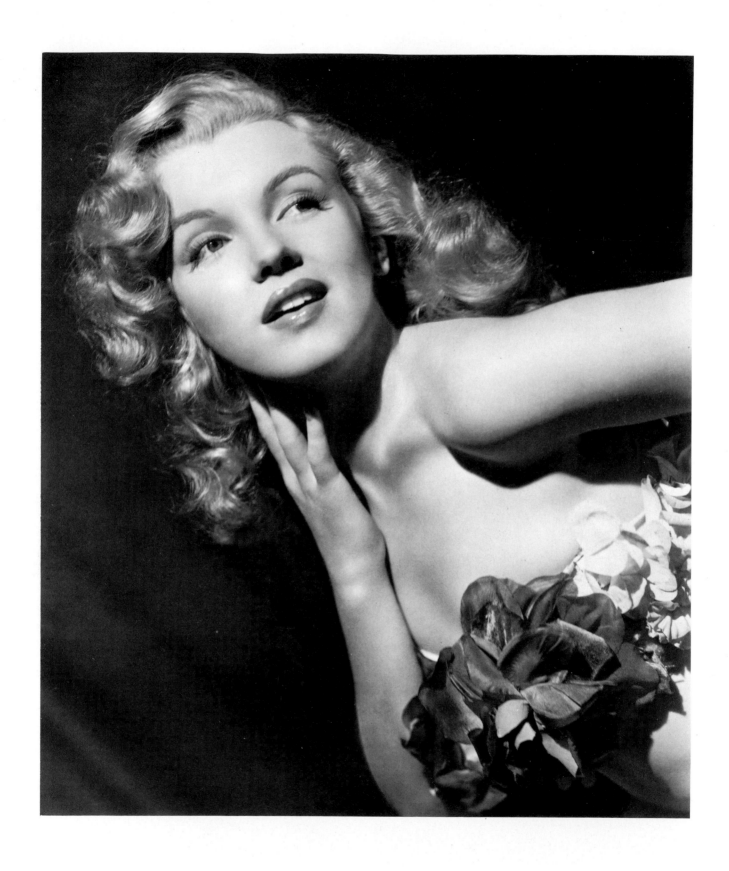

Marilyn Monroe, 1948. Photo: Madison Lacy, for United Artists.

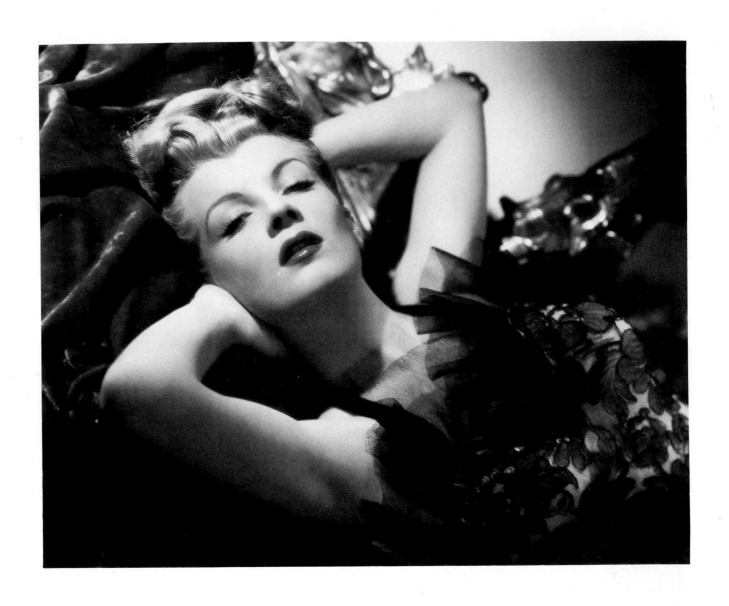

Corinne Calvet, 1949. Photo: A. L. ("Whitey") Schafer, for Paramount.

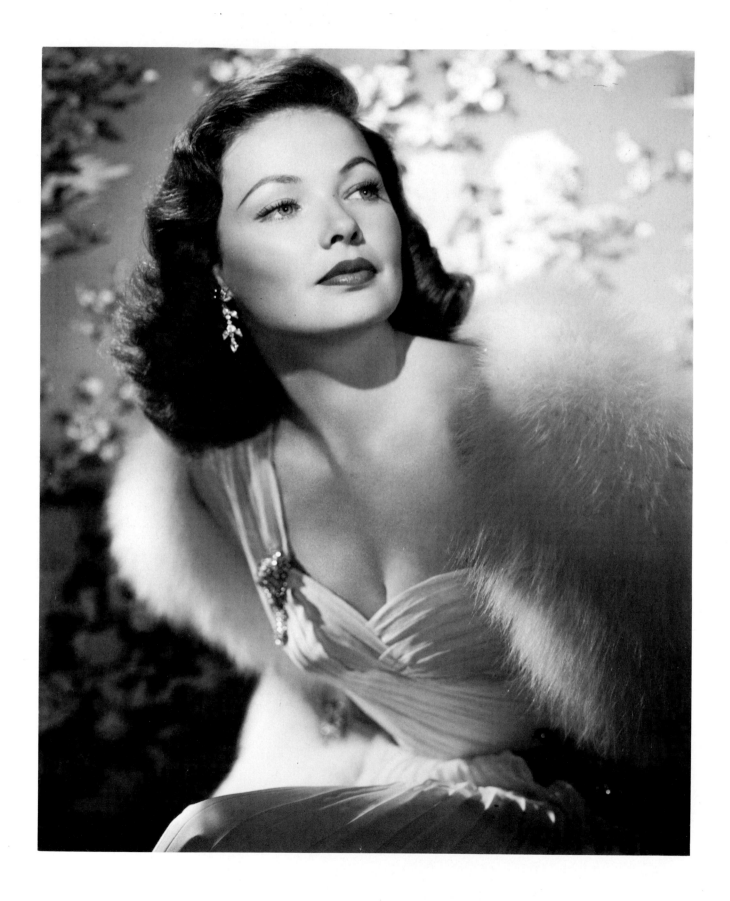

Gene Tierney, 1950. Photo: Gene Kornman, for 20th Century-Fox.

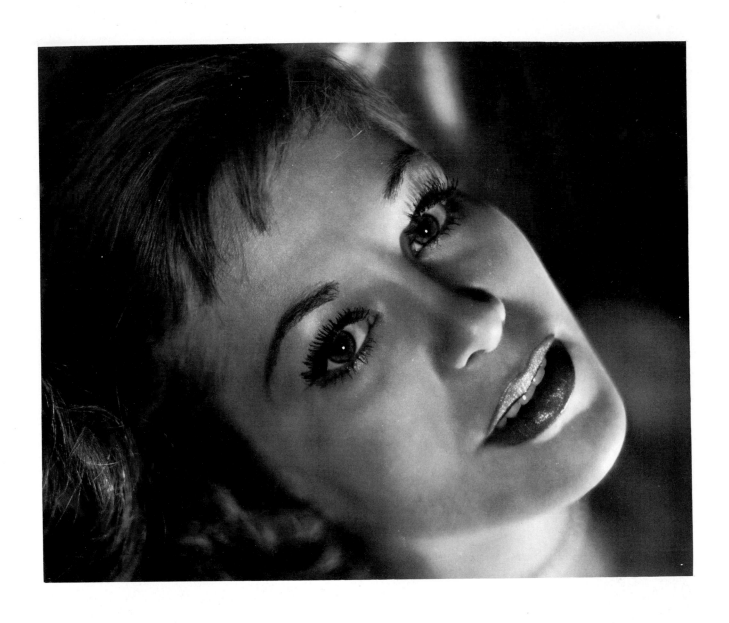

Hildegarde Knef (Neff), 1949. Photo: Laszlo Willinger.

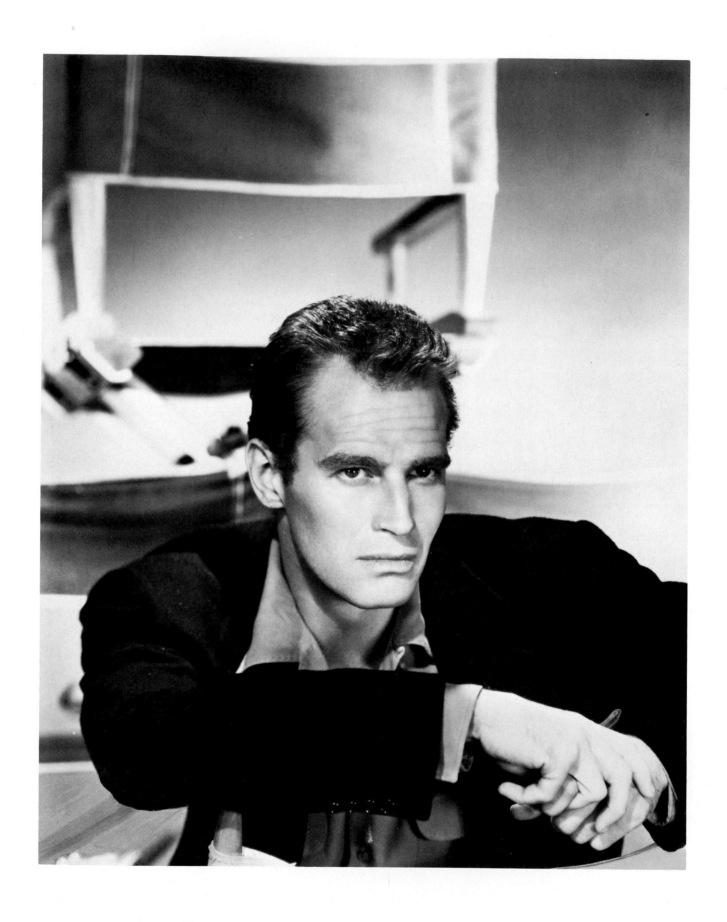

Charlton Heston, 1950. Photo: Bud Fraker, for Paramount.

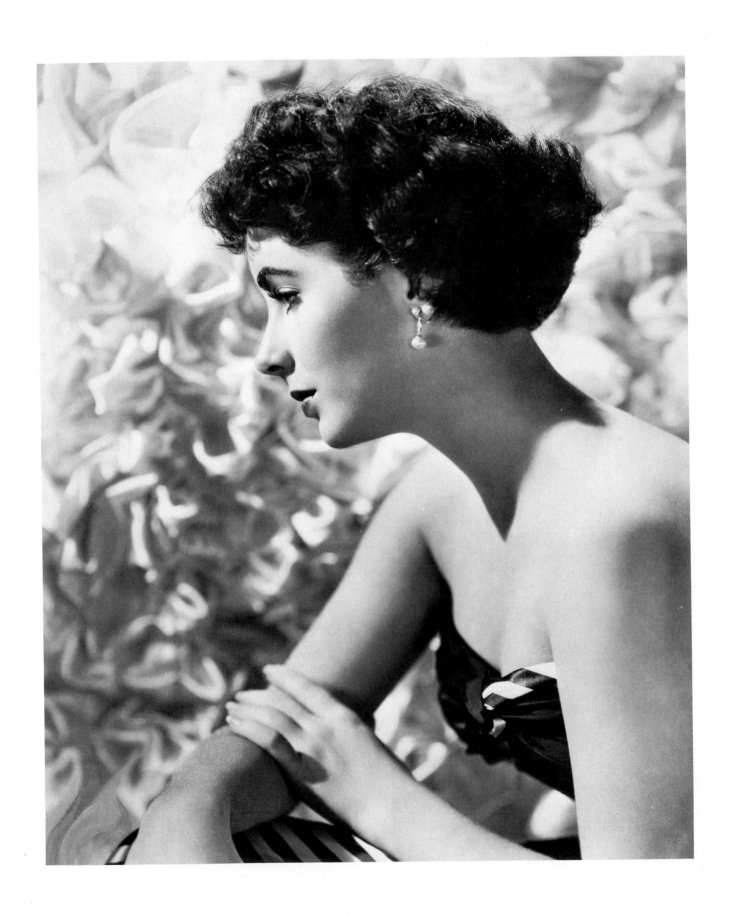

Elizabeth Taylor, 1950. Photo: A. L. ("Whitey") Schafer, for Paramount.

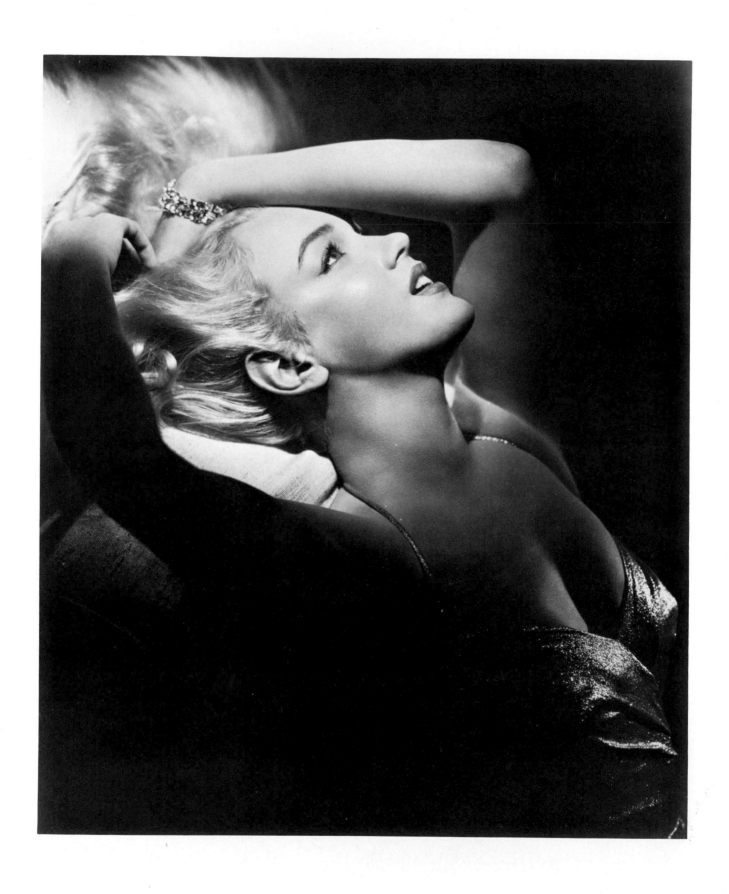

Marilyn Monroe, 1950. Photo: Frank Powolny, for 20th Century-Fox.

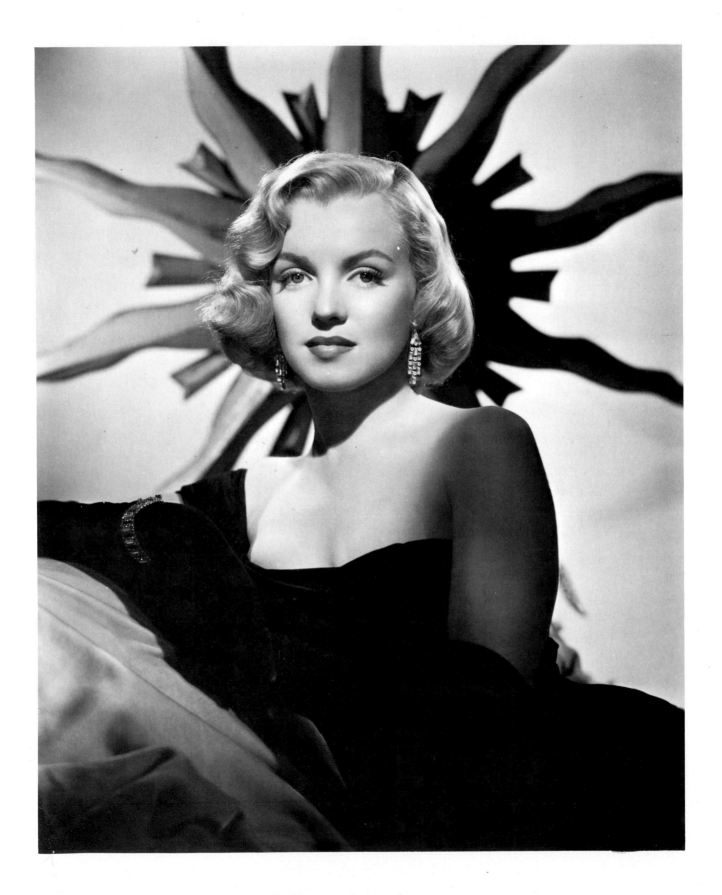

Marilyn Monroe, 1950. Photo: Frank Powolny, for 20th Century-Fox.

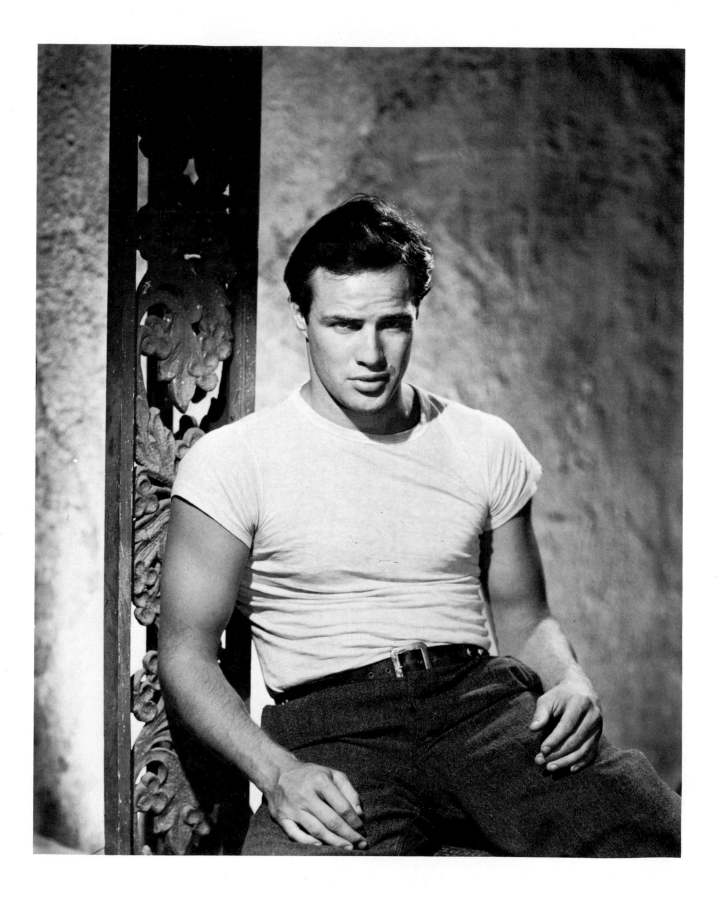

Marlon Brando, 1950. Photo: John Engstead.